Outdoor Watercolor Workshop

Outdoor Watercolor Workshop

by Tony van Hasselt, AWS

Watson-Guptill Publications, New York

To those whom I love and everyone
who shares my love for the outdoors

First published 1982 in New York by Watson-Guptill Publications,
a division of Billboard Publications, Inc.,
1515 Broadway, New York, N.Y. 10036

Library of Congress Cataloging in Publication Data

van Hasselt, Tony.
 Outdoor watercolor workshop.

 Bibliography: p.
 Includes index.
 1. Water-color painting—Technique.
I. Title.
ND2420.V3 751.42'2 81-21974
ISBN 0-8230-3424-0 AACR2

Manufactured in Japan

First Printing, 1982
1 2 3 4 5 6 7 8/87 86 85 84 83 82

A debt of gratitude is owed . . .

to all my teachers who showed the way

to all those students who over the years encouraged me to write this book

to those who offered helpful suggestions, especially Ruth Anderson, Frank Boles, Lorraine Soverinsky, Donald Holden, and my editors, Marsha Melnick, Lydia Chen, and Judith Royer

to Howard Gates, Tom Payne, and the Baker Gallery for their photographic assistance

to Charlotte Veith, Marcia Humphreys and Sharon Kittredge for their typing efforts and patience, and to Doug Humphreys for the usage of the CPT Word Processor

to George Stegmeir from Grumbacher for his technical know-how

to the owners of all paintings reproduced in this book.

Finally, a special thanks to my wife, Mary Jo, daughter Marianne, and son Chris for putting up with me during the winter of 1980–81.

Contents

INTRODUCTION

I fondly remember the first outdoor painting experiences I had in my native Holland. On a nice, sunny day, I'd head my bike out of town, packed with some painting paraphernalia and my set of Talens watercolors, anxious to find the perfect subject and worried about what onlookers would say. That was many years ago. Since then, I've painted with some of my adopted country's finest watercolorists and, for the last ten years, had the pleasure of teaching and working with hundreds of enthusiastic painting friends in the most picturesque parts of this country and the world.

It's fun to introduce beginners to outdoor painting and the watercolor medium at the same time. Many advanced painters, while quite adept at handling the medium inside the controlled atmosphere of their own studios, find that painting outdoors is a totally different experience. It requires a new outlook and different approaches to handling watercolor.

Although there are many books that tell you how to paint, upon closer examination they tend to gloss over how to actually paint outdoors. You might have wondered, for instance, how to paint fast enough to catch those ever-changing shadows. Or how to deal with the sun shining on your paper or the wind blowing it away. What to do about insects, onlookers, or a sudden change of the weather.

Since I love painting outdoors, I'd like to introduce you to it. In fact, I'd like to make you an outdoor painter—someone who knows how to look at nature and not be confused by its many details, someone who knows how to handle different weather conditions and problems. The problems that will crop up usually have solutions which are simple and logical, yet you only learn of them through years of outdoor experience, of getting into messes and saying, "Well, I'll never do that again." But why go through all those headaches if there's no need to do so? I've already done it, and I hope to pass my experiences on to you. I would like you to be well prepared when you first attempt to paint outside.

I know the joys and frustrations of the outdoor painter and am familiar with the wonderful, indescribable feeling of communicating with nature, of being amidst and part of its glorious beauty. No studio situation can duplicate that bond between the outdoor painter and Mother Nature. She is your greatest teacher, if you observe her with a discerning eye—an eye that is not overwhelmed by her, that simplifies and searches for good subject material. You should know what to paint and realize what can't be painted with the limited colors and values of your palette. You have to approximate, transpose, and translate nature.

If you're new to art, this book contains enough basics to form an introduction, and the bibliography will refer you to a whole education in representational painting. And if you're new to watercolor, have no fear—it's all fun if you have the right outlook. I will guide you through some of my outdoor methods which are logical and quick, and which take full advantage of watercolor's unique transparency. Together, we'll take a look at color, light, and shade and how they are affected by different weather conditions. Once you are thoroughly familiar with all that, I'll present several outdoor situations which require different approaches to the medium, and I'll discuss each step by step.

But no painting is completed in the demonstrations. I don't finish on the spot, so why do it in the book? I discuss and demonstrate the finishing touches in the last chapter, "The Indoor Aftermath." After you return to

the studio and take a fresh look at what you did outside, you can add some props or figures, change values, or remove unwanted sections, to pull the whole painting together. In fact, you can make all those changes which some people—those not familiar with the medium—believe are impossible to do in watercolor. But don't spread the word. Let's keep that just between us.

I want to introduce you to the outdoor landscape through the paintings I will discuss, but even more, I want you to go out and put brush to paper in your backyard, nearby park, or wherever. And do it now! Afraid of making mistakes? Stop worrying and look at them as stepping stones toward future success. You're after that euphoric feeling of doing a good one. Take a look at Chapter Five, where I discuss light and shade. See Figure 5-17 and try doing some of those shadow patterns right now. I know that once you get going, you'll become addicted. Just don't give up. Keep trying. You can do it, if you only give yourself a fair chance.

Come join me in nature's studio without walls!

Chapter 1
The Outdoor Studio

Although every book starts off with a list of supplies and equipment, such a list is of special importance to the outdoor painter, since the wrong equipment is generally what causes beginners to become discouraged with the outdoors. It handicaps you. It requires extra effort—effort which could instead be spent on painting problems. Of course, if you're going to "make do," it helps to be inventive. I fondly recall a delightful lady who, on a sunny but rather windy day, had forgotten her hat; so, she fabricated one, complete with eye shade, out of a grocery bag. Then, because that light paper bag was quite a wind-catch, she fastened it to her hair with two big clips. Complimenting her on her ingenuity, I pointed out that her easel was also in danger of blowing over and that she should perhaps suspend something heavy from its center. Her eyes lit up, wheels meshed into gear, and when I returned sometime later, she was happily painting away at her easel. From the center of it hung a sheer, familiarly shaped bag, filled with rocks. I couldn't believe it, but it was indeed—a pair of panty hose!

Time and again, students come to the workshops with brand new equipment, ideal for the studio but absolutely useless to an outdoor painter: easels which only work on level ground, miniscule folding seats which collapse on the first day, and expensive gadgets sold by uninformed clerks to inexperienced students. Boards are too big, clips won't reach, and papers flap in the breeze. Is it any wonder some students say, "This outdoor stuff is not for me"? Don't give up though, because Mother Nature has too much to offer. Consequently, you should spend much time with her and adapt your outdoor studio to her environment.

Naturally, every experienced landscape painter has his or her own ideal setup and equipment, developed through lots of trials and errors. Part of the fun I have when getting together with so many new students each year is in seeing the gadgeteer's contributions. There are a lot of good ideas out there, as well as inventions that are obviously too cumbersome or complicated. Over the years, my supplies and equipment have changed quite a bit. I started out with a flight bag full of equipment, carrying the paper and board separately. Then I added and discarded several types of easels, converted camera tripods and, satisfied, ended up with the French easel. As I get older and wiser and better things come along, my equipment will continue to change. In the meantime, however, I'll give a tour of my present outdoor studio setup and talk a bit about the supplies and equipment I have found most useful.

THE PAPER

Even if you are a budget-conscious shopper—and who isn't these days—don't skimp on paper. There are other items on which you can save money. Watercolor is too complicated to add an unwieldy surface to your problems. Some students have the idea that they should start on inexpensive paper, then graduate to a quality paper when they are more proficient. I believe it should be the other way around. Start on good paper, and once you have mastered the medium, you can paint on anything.

By "good" paper I mean a hand- or mold-made paper rather than machine-made, although the quality of machine-made paper is getting better and better. Your paper comes in a variety of surfaces: rough, cold-pressed (which is medium rough), and hot-pressed (very smooth). The two most popular thicknesses are the 140-pound and 300-pound weights. Although those

papers seem relatively expensive, they aren't when you consider that you have both sides to work on. If your art supply store does not carry good paper, there are several mail-order supply houses where you can obtain it at wholesale prices, even in small quantities. The 140-pound paper will always be less expensive, yet its surface is as good as or better than the 300-pound weight.

I generally work on Arches cold-pressed paper in both weights but have to remind myself not to get too attached to any one particular surface, for fear that the manufacturer will cease its production. This has happened! As a result, I now continually explore different papers and suggest you do the same. Give them all a fair trial to discover the good as well as the bad points of each surface—so you know what you can and cannot do.

Arches, Fabriano, Capri, and other hand-made papers have a protective coating or "sizing" which covers the sheet and resists dirt. If not removed, the sizing will resist paint as well. Microscopic "pinholes" of white paper will peek through your nice, colorful wash and have a neutralizing effect on it. Some artists soak their paper to remove that coating. I simply take a sponge and wash it off on both sides, usually some hours before going out on location so that it has a chance to dry.

Which brings me to another point: paper, when wet, expands quite a bit, and when you hamper that expansion, you have problems. That is the reason why I do not use or recommend watercolor blocks for my approach. The paper in blocks is glued on all four edges, which restricts its outward expansion. As a result, when you pre-wet the paper or apply your first big washes, the only place the expanding paper can go is up. It buckles in big waves, which leaves you dealing with uneven puddles of wet color. The idea of the block is good, of course, since it eliminates the need for a board and clips or, worse, the nuisance of stretching the paper with tape. I'm sure it is useful for those watercolorists who use a lot of white paper and work in small, restricted washes, or for making quick sketches.

BOARDS

There are basically three different methods to fasten a sheet of paper to a board. Some artists tape their paper down, some staple it, and if you're eager to get started, as I am, you simply clip your paper to the board. Each method requires a board of a different dimension or quality and, as a result, it is doubtful that you will find one at your art supply store. You will have to make your own or have one made for you.

It seems to me that for outdoor painting you should want to keep preparation time to a minimum, so that maximum time can be spent catching the fast-changing

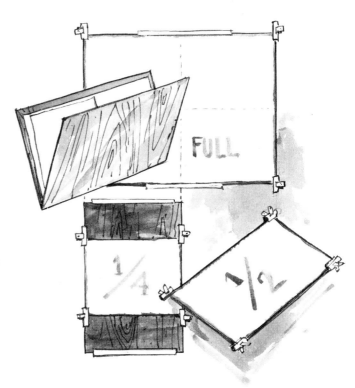

Figure 1-1. My folding board accommodates the three most popular working sizes and doubles as a portfolio for extra paper. Notice how the quarter-sheet is placed on the board, as well as how the clips are placed. On 300-pound paper, clip only a small corner to avoid having big white spots where a clip was fastened. You will have to use the whole clip for 140-pound paper, since that paper expands and contracts more.

scene while your early enthusiasm still has you in its grasp. You should be able to get your planning done, whip out a piece of paper, and get to work. Then, if you decide to start over or do something else, you turn your paper over or get another piece out. The clipping method allows you to do that quickly.

I have tried the other two methods. Both need a lot of advance preparation, plus the carrying of extra boards if you want to do several studies. Climatic changes, different from a controlled studio atmosphere, can cause your tape to pop loose at unexpected moments, and stretched paper can get damaged sliding around in the car or elsewhere on your excursion. Plus, I frankly believe these other methods may inhibit you from being as relaxed and free as you need to be. You might not only worry about ruining a good piece of paper but ruining a good "stretch" as well. However, we're all different and if your method works for you, by all means, stick with it. It's the end result that counts!

The clipping method requires a board that is about ¼ inch (0.6 cm) larger than the paper all around, so that the clips will reach and hold it down *at all four corners*. Too often, I see students painting on a piece of paper with one or two of the corners flapping in the breeze because the clips don't reach. Would you work under

those conditions in the studio? Of course not. So, to avoid headaches when painting outdoors, decide what size paper you're going to use and get a board to fit.

Generally, the board is made out of 5/16-inch (0.8 cm) plywood or Masonite and coated with varnish or shellac to prevent water from soaking in and warping it out of shape. Since a full sheet of paper measures approximately 22 x 30 inches (56 x 76 cm), the board will have to be 22½ x 30½ inches (57 x 77 cm). However, the most popular board size is 15½ x 22½ inches (39 x 57 cm), since it accommodates both the half- and, turned sideways, the quarter-sheet.

I always carried two boards until fellow painter Mike Zimmerman constructed a folding board. It consists of two half-sheet boards hinged together to make a full-sheet board, thereby accommodating all three sizes. That invention gave me the freedom to choose a size at the last minute without carrying an extra board along. An added feature of it is that extra paper may be carried between the folded boards.

As discussed earlier, your paper will expand when wet, so you'll need to adjust your clips a bit when you see a wrinkle develop, especially when using the 140-pound paper. After a while that adjusting becomes such

an automatic move, you won't even think about it. Naturally, once the paper has reached its maximum expansion, it'll start drying and shrink to a tight, flat surface.

WATER CONTAINERS

You'll need at least two containers: one with a good tight-sealing cap to carry the water in and one or two wide-based bowls with large openings so you can slop your brush around in them. The wide base makes the bowl all the more stable on uneven ground. I have seen all types of water containers. Some fold up, like hot water bottles or ice bags, and some "stack" like plastic bleach or milk bottles. Cut the top off a couple of the plastic bottles so that the bottom halves become mixing jars, while you carry the water in an intact bottle. Everything will stack together neatly that way.

Since I carry all my equipment inside a French easel, my water container is a very flat plastic bottle which fits inside the drawer. For a mixing bowl, I use a homemade gadget which actually is a collapsible water "sack," for lack of a better word. It was made out of a plastic freezer container from which I removed the bottom and cut a large hole in the lid. I then inserted a plastic freezer bag into the bottomless container, folded the

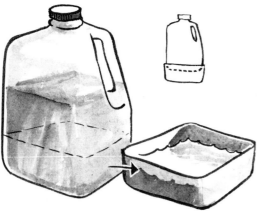

Figure 1-2 (above). A plastic bleach or milk bottle is ideal for carrying water. With the top half removed, it becomes a mixing jar which stacks for compact packing.

Figure 1-3 (right). My mixing "sack" is actually a freezer container with the bottom and a large portion of the lid removed. Slip a plastic freezer bag into the former box and fold the top half over the outside. Then snap on the lid and, with the help of a clip, attach the sack to the front of your easel, add water, and start splashing. Afterward, the sack collapses and fits compactly inside the easel.

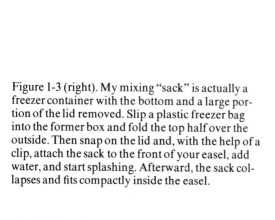

ends over, and clamped the lid down. The whole gadget is clipped to the easel. Naturally, I carry spare bags in case the present one leaks or gets too dirty. The advantage of this collapsible mixing sack is that it also fits compactly inside the easel.

THE PALETTE

In my opinion, a good outdoor palette should have some large mixing areas, unhampered by restrictive center ridges or wells; it should have a lid to prevent spilling or waste of pigments; and, it should not be made out of some flimsy material that will cause it to blow away at the first gust of wind. Before my Dale Carnegie training, I used to say, "A little palette reflects a little mind," just to goad someone into being bolder. I don't say that anymore—but really, it just doesn't make sense to stare at a half-sheet painting with one of those little round egg-plate palettes at your side, does it? Naturally, I'll back off if the results are fantastic, but too often, small wells suggest a paint-by-number approach: "This little well is for the blue of the sky; the green in this one is for the grass," and so on. That type of thinking might be fine for an opaque medium but does not take advantage of the full possibilities of a transparent medium, and that's what a watercolorist wants to do. I'll talk about that a bit later, though.

I use the John Pike palette because it is strong, sturdy, and, after a minor adjustment, fits into my French easel

(see Figure 1-4). The lid can become another mixing area, but I often use it to hold pencils and brushes so they won't wander off into the weeds. There are many uses to make of the equipment.

PAINTS

Watercolor paints come in cakes and tubes. Cakes are fine for very small sketches, while tubes are best for most outdoor work. The paints come in student and professional grades. Avoid the student grade, usually recognizable by the long, thin (#3-size) tube. The finest professional grade is best in the long run.

I use both Grumbacher and Winsor & Newton paints, and I buy the largest tubes available, which are the #5 or #6 sizes. Although the smaller, #2 tubes are more widely available, the larger ones offer a better value for the money. If you live in a small community where the art store does not carry large, professional-grade tubes, I suggest you special order them or order them by mail.

My personal palette is subject to change, but for a number of years now it has consisted of the colors listed below, arranged as explained in Chapter Five. The colors printed in italics are the ones I use the most, hence an extra supply of them should always be on hand.

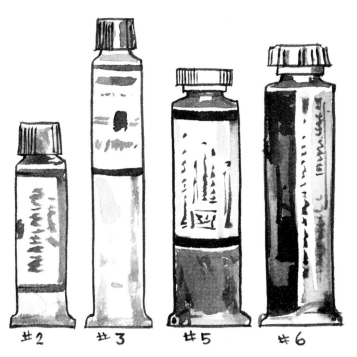

Figure 1-4. To fit the Pike palette inside the French easel, the little block that prevents the drawer from falling out when carried upright has to be removed. You guessed the drawback—if the palette is not in the easel, the drawer will fall out. If there is a better way to make it fit, let me know. I just learned to always have the palette inside the easel. Yes, the hard way!

Figure 1-5. Here are the actual tube sizes. Most widely available are the #2 and #3 sizes, because of their lower cost. The leading paint manufacturers use the #3 tube for their student-grade paint. The ideal sizes are the #5 and #6 tubes, available at the larger art stores or via special order.

Winsor & Newton's	Grumbacher's
new gamboge	*burnt sienna*
cadmium orange	burnt umber
scarlet lake	alizarin crimson
Winsor or thalo green	*cerulean blue*
Winsor or thalo blue	*ultramarine blue*

BRUSHES

You could spend a fortune on brushes, but that isn't going to guarantee better work. What you have in the brush is more important—what you are thinking is more important. The brush is just a tool to put paint on paper. I have met poor artists in foreign countries who fabricate their own crude brushes by taking a twig, some hair, and a bit of string wrapped around it. Those brushes work. You would do the same if suddenly no more manufactured brushes were available. You would always be an artist, right?

Manufacturers offer us a wide selection of brushes and hairs, all confusingly named and numbered. Briefly, let's look at the hair. Sable is the best and most expensive. Some manufacturers therefore mix sable with a compatible hair and sell it as a blend, under dif-ferent trade names. The next best hair is ox hair, which is much more economical. Recently, an extremely fine synthetic, hairlike filament was introduced in the manufacture of a series of brushes under trade names such as *Erminette* and *White Sable*. These brushes are quite good, especially the rounds. With the flats, I can't seem to drybrush very well. They don't skip and drag well.

I own one expensive sable brush. Even on sale, it cost me quite a bundle, and that was a number of years ago. I'm always afraid of losing it somewhere and have therefore taken it out of my outdoor kit. As a result, it does not see too much action. Figure 1-6 shows you my workhorses, which are grouped into three flats, three round brushes, and three special-effect brushes.

FLATS. The two short-handled brushes are actually sign painter's muslin or poster brushes. They seem difficult to obtain, so ox-hair flats in the 1½-inch (4 cm) or 2-inch (5 cm) sizes are easily found substitutes. Basically, you need a wide, soft-haired brush with "spunky" hair that will snap back into its original position after you've bent it. The next smaller brush is a 1-inch (3 cm) muslin. An Aquarel brush would be a good substitute. For the ½-inch (1 cm) flat, I depart from the muslins, as

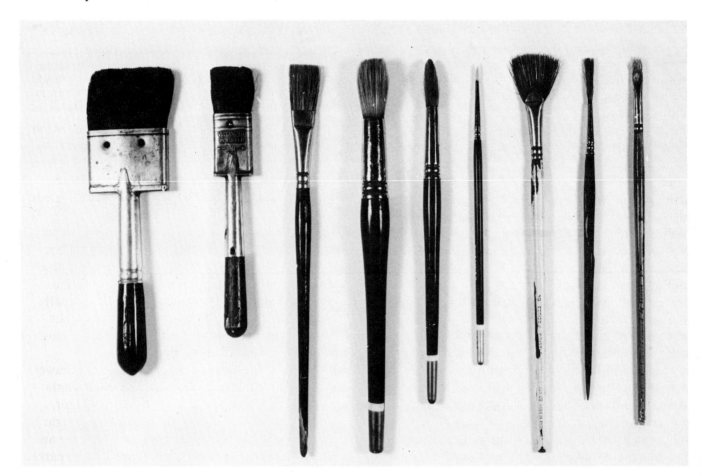

Figure 1-6. Here are my faithful friends: three flats, three rounds, and three special-effect brushes. They are all relatively inexpensive, since I use ox-hair, bristle, and the new synthetic-filament brushes.

you can see. It's still an ox-hair brush though.

ROUNDS. I use the rounds after the basic block-in of the painting has been established with the flat brushes; when I need to start concentrating on details.

All three of the rounds are made out of the synthetic filament mentioned earlier, starting with my favorite, the Robert Simmons Goliath #30 round; then dropping down to a #12 and #2 for a signature brush.

SPECIAL EFFECTS. For special effects, I have a long-haired brush which often is referred to as a "rigger," but actually that is a misnomer according to the brush catalogs. Lest I misname it as well, I'll describe it as a very long haired, round brush that does not end in a point. This brush is used for delicate lines, twigs, and so forth. I use a #6 and sometimes a larger size. Next is the fan brush made with bristle hair. It actually is an oil painter's brush, but I love using it for spattering effects. The spatters come out nice and uneven, as Figure 1-7 shows. Toothbrush spatters, for instance, are too fine and regular for my taste. And soft-haired watercolor brushes don't have the snap to spatter like bristle brushes. I also drag the fan brush to create the textural effects of wood grain or bark, making sure not to go overboard with it. Last is a small bristle brush I use for corrections, to scrub out an area or soften an edge.

THE FRENCH EASEL

Let me first explain the difference between an indoor and outdoor easel. The indoor easel does not need adjustable legs. It stands in the studio on level ground. An outdoor easel, on the other hand, *must* have fully adjustable legs since you should be able to set it up anywhere—on a hillside, in a dry creek bed, or anyplace else. I own several types of easels and have used them all, while searching for a more perfect one. When I finally bought my French easel, that search was over. Now if they could just trim its weight in half, I'd rush to buy the new model no matter what its cost. Let's take a look at this piece of equipment and my own added improvements on it. Then we'll go on to other types.

The French easel is really an oil painter's easel, which many painters have converted for use with watercolor. I must explain that almost all of my watercolors are painted with the paper in a vertical position and the palette placed on the pulled-out drawer in *front* of the board, as shown in Figure 1-8. Yes, vertical, for a very good reason, to be explained in Chapter Two. Naturally, you'll need to get used to this method of working, but even those who paint with the paper flat find the French easel useful after devising a way to place the palette to the side, as shown in Figure 1-9. (If the palette

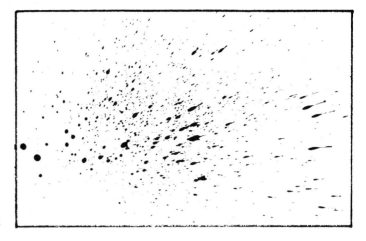

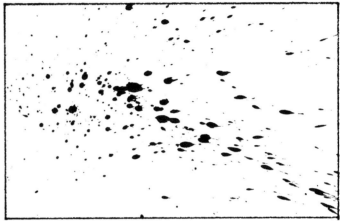

Figure 1-7. This illustrates my reason for using the fan brush for spattering instead of a toothbrush. The smaller spatters are made with the toothbrush, while the bigger ones in the other box are made with the fan brush. Do you see the directional possibilities?

is kept in front of the paper, the reach over it to the flat paper is too far.) Figure 1-10 shows you that some painters stand to the side of the easel instead of in front of it, keeping the palette on the pulled-out drawer. However, in that position the paper cannot be angled at all. It has to remain horizontal.

Figure 1-11 shows the packed kit with a full-sheet board clamped in the carrying position. Remember, this one piece of equipment holds everything for the outdoor studio, including the water. Naturally, it is heavy and you won't want to carry it too far. I usually place it in some central location and then circle out from it to search for a subject. Once the subject is located, I come back for my equipment.

Figure 1-12 allows you a closer look into the drawer and lower storage area. Notice that I have cut a hole into the drawer bottom to create a tissue dispenser, which comes in handy when you're painting upright. Granted, I do not carry much water, but I do have an extra container in the car which is almost always parked nearby. The brushes are rolled into a bamboo-placemat brush holder, as pictured.

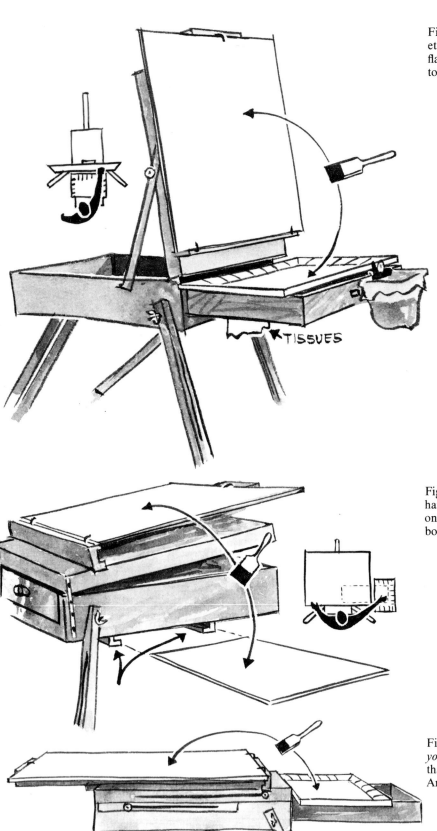

Figure 1-8. In my upright working method, the palette is in front of the paper. If the board was lying flat, the reach over the palette to the paper would be too far. Notice the tissues I keep readily available.

TISSUES

Figure 1-9. Painters who prefer working flat usually have their palettes to the side of the paper, placed on a board which slides into grooves attached to the bottom of the easel.

Figure 1-10. Another way to work flat is to place *yourself* to the side of the easel, but the drawback is that your paper will have to be absolutely level. Angling it as shown in Figure 1-9 is not possible.

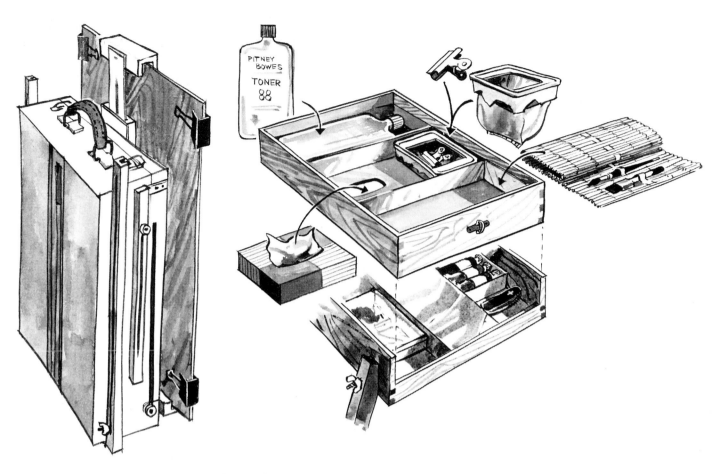

Figure 1-11 (left). Here is my complete outdoor studio, which can be carried with one hand. I prefer to carry *one* item instead of several bags and boxes. Since it is heavy, I don't carry my easel until I've found the subject to be painted.

Figure 1-12 (right). A place for everything and everything in its place! In the drawer of my easel, you will find a very flat water container. In the next, middle compartment, the collapsible water sack is stored, with a clip inside it. On location, the box of tissues can be turned over and, when the drawer is pulled out, dispensed through the opening. My roll of brushes is held in place with the help of an elastic band, woven through a bamboo placemat. This package is stored in the front compartment. The lower storage area holds the tubes of paint, the "whatnot" box of gadgets, postcards, trash bags, a pocket knife, pliers, extra clips, and so on.

The French easel is heavy and expensive, but if you plan to be a serious outdoor painter, it is a one-time purchase that will last for years. If you do plan to buy one, avoid the more economical French-type imitations. Those I have seen simply are not made sturdily. If you are going to spend a sizable amount of money, spend a little more for the real thing. It outlasts the less expensive models.

OTHER EASELS

Just because you don't own a French easel—or aren't willing to jump in and buy one right away—that shouldn't stop you from painting. Before I owned the ultimate easel, I worked for years on more economical types. They do, of course, require that you carry an extra bag with your equipment plus your board. You will be less compact. If you are already accustomed to working vertically, or would be willing to adopt this working method, any regular outdoor oil-painting easel could be used as long as it has a top clamp to prevent the board from blowing away. Most watercolor easels are a bit on the shaky side since a big board is balanced on a narrow support strip or small swivel head. I once converted a camera tripod into a painting easel and it was somewhat

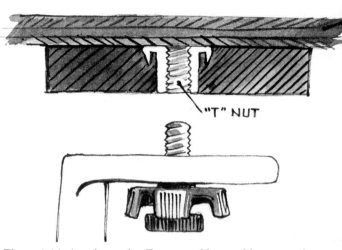

Figure 1-14. Anco's wooden Fanco easel has a wide support base which makes the watercolor board very stable once it is placed between the movable clamps.

Figure 1-15. A cardboard box makes a collapsible easel with a bit of trimming here and there.

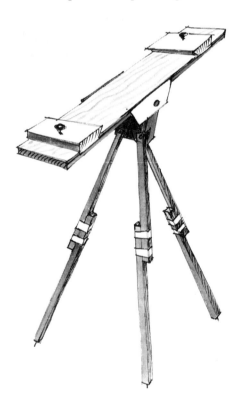

Figure 1-13. By attaching a properly designed watercolor board, any sturdy camera tripod can be converted into an easel. Take the tripod to a hardware store and find a T nut that will fit the fastening screw. Drill the proper-sized hole through a square block of wood and push the T nut into place. Then fasten the block of wood to your watercolor board and you're ready to go.

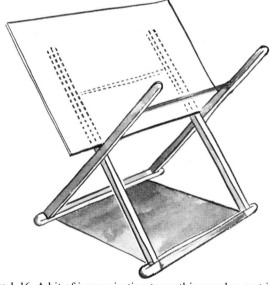

Figure 1-16. A bit of improvisation turns this wooden seat into a makeshift easel.

sturdier. Figure 1-13 shows how this can be accomplished. I do believe Ansco's wooden Fanco easel is the sturdiest, since it has a very wide base of support, as shown in Figure 1-14.

For the life of me, I can't imagine anyone setting out to paint outdoors or attend a workshop without adequate equipment. Yet, it happens all the time. In case you find yourself in such a situation, Figures 1-15 and 1-16 offer a few suggestions for makeshift easels.

FOLDING SEATS

Once, at a workshop in Spain, one of the students needed to buy a seat. I sent her to Gallerias Preciados, a large department store in Madrid, with instructions to go to the camping department, because that's where such equipment could be bought and also because the Spanish have adopted that English word. Well, I don't know what exactly happened, but she tried handling it in her own way. First she drew a picture of the seat, but somehow that didn't get the message across, so in addition, she played charades and acted as if she were going to sit down on this nonexistent chair. She was hastily ushered off the sales floor and shown to the ladies room.

At every workshop—you can count on it—someone's chair will suddenly collapse. Luckily, so far the only thing hurt has been a bit of pride, but it does point out that buying the right seat is important. There are too many flimsy ones on the market. With the wooden ones, the thin cloth rips off or becomes unglued. The tiny collapsible ones you used to be able to buy at the art stores are all off the market by now, I hope. At least, I can't find them in the art catalogs anymore. Those were designed for 30-pound midgets. Generally, the best place to buy a good chair is at a sporting goods store. Look for a fishing stool with heavy khaki canvas. Some even have a tackle box built in or pockets under the seat, which will tempt you to bring more gear. Remember, keep your gear as light as possible. You'll be the one carrying all that stuff.

One more bit of advice. Stay away from the aluminum armchairs. Those armrests impede free movement, and you'll be needing to swing that painting arm, as I'll discuss in Chapter Two.

ODDS AND ENDS

There are a variety of odds and ends you'll find useful to bring with you. Some of the more important items are listed below.

Clips: I use four binder clips, bought at an office supply store, but bulldog clips do the trick as well. Another two clips hold my sketchbook pages open. Since there's always a need for an extra clip somewhere, take a few more along. They come in handy.

Sponge: Take a regular, synthetic one, plus a small, natural one.

Trash bags: Paper ones for actual trash. Clip it to your easel. Then, a couple of big plastic ones to protect your equipment from a sudden shower and to make a dandy raincoat in a hurry. Lastly, the smaller, white, 11-gallon garbage bags measure a neat 24 x 30 inches (61 x 76 cm), which keeps your full-sheet paper spotlessly clean and protects your masterpiece after completion.

Sketchbook: Never do without this important painting tool. In it, you do all your advance planning for the painting. Besides that, you can use it to take class notes, keep your expense accounts, jot a name and address down, and so on. Any type of binding will do, as long as the book is around 8½ x 11 inches (22 x 28 cm).

Special tools: As I mentioned earlier, I carry mine in a small box and usually take razor blades, some plastic packages of salt from the local hamburger place, a good knife to scrape with, some sandpaper, postcards, and other miscellaneous items. You'll soon develop your own list, suitable to your particular needs.

This brings us to the conclusion of my outdoor studio tour. Just let me remind you once more that this is only my personal setup, developed through trial and error. Other artists have developed different ones which are more comfortable for them. You'll develop your own, picking and choosing from these ideas and adding your own as well. That's part of the fun. I've tried to pass on some basic advice, but there's nothing better than actual experience. Go out with your setup. Give it a few trial runs before heading to a workshop. See what the problems are and soon you'll find a solution uniquely your own. Then, when we get together, let's share that solution.

Chapter 2
Setting Up Outdoors

When painters plan to build their own studio, they often spend a lot of time and money to make sure the lighting is right. North light is, of course, essential, and a great deal of research is done to determine which fluorescent lights most closely approximate natural light—all to make sure the perfect lighting condition exists.

Yet outdoors, somehow, all that concern is thrown to the wind and forgotten in the haste to catch a subject before the light changes. Sometimes, students blind themselves looking at glaring white paper in full sunlight; other times they paint with half of the paper in shade and the other half in the sun; or they find shade under a tree, while the leaf shadows play a sun-dappled dance of distraction on the paper. No one would ever consider working under those conditions in their perfect studio; so why do it outdoors? There's no need for it.

In this chapter, let's look at some logical ways of setting up, learn how to take advantage of the lighting conditions outdoors, and learn how to cope with different weather conditions, as well as a number of other typical outdoor problems.

KEEP ARM MOVEMENTS FREE

I like to stand while painting, moving back and forth, getting distance and a fresh look at what I am doing. For years, however, I sat on a small seat, with the board between my feet. Both methods work, because in both cases you are separated from your board and have unrestricted arm motion. This gives you freedom to move with what you are painting, to become one with it. If a branch sweeps upward, this sweep is translated—acted out—in the motion of your arm as well. Therefore, that arm should not be restricted or hampered in any way.

Movement has to originate from the shoulder to be free and loose, to get flowing, rhythmic lines. All too often, students position themselves as if they were writing a letter. While writing, your wrist rests on the paper, giving you enough room to move for the small push-and-pull strokes required. While drawing and painting, on the other hand, it is best not to have the wrist supported. Turn your hand over, palm up (see Figure 2-1), and, taking a short pencil that will fit that palm, act as if the pencil is a natural extension of your fingernail. I often find myself making a few "dry runs" with my nails gliding over the paper before putting a line down. Brushes, too, should be held close to the end of their handle instead of like pens which are held close to the point.

Unless you are doing miniatures, *never* hold the board in your lap. Place it on the ground before you or on another chair or, better yet, on an easel in front of

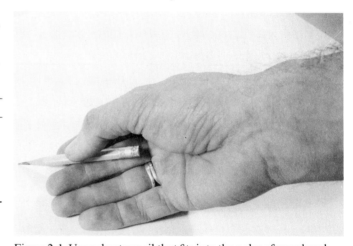

Figure 2-1. Use a short pencil that fits into the palm of your hand and hold it as shown. Drawing in this manner gives you free arm and body movement. Remember, you are not writing, you are drawing.

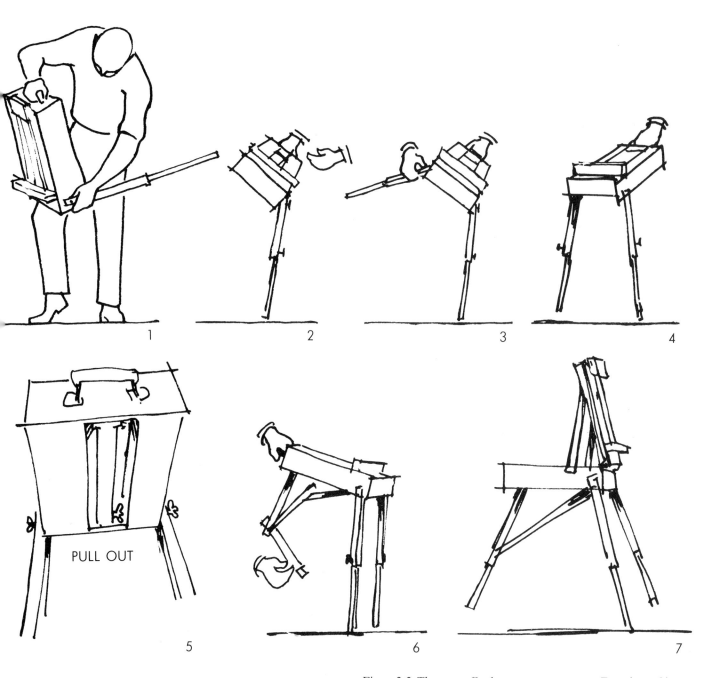

PULL OUT

1 2 3 4

5 6 7

Figure 2-2. The most effortless way to set up your French easel is to take it by its handle with your right hand and hold it in front of you—sliding support out and the folded center leg toward you. Unsnap the left leg at the top of the box, and, balancing the box on your right knee, proceed as shown: (1) Loosen the wing nut at the bottom of the box, so the leg can turn and fit into a cutout groove. Make sure it fits snugly into this groove and fasten the nut. Next, loosen and extend the telescoping leg and tightly fasten it. From this point on, you no longer need to lift the easel. (2) Balance the easel on its extended leg, switch handle hands, and unsnap, extend, and fasten the right leg in the same manner as the left one. (3) Now balance the easel on both legs. (4) Reach your right hand underneath the box and hook a finder behind the wing nut. (5) Pull the center leg out of its jackknifed position. (6) Extend and fasten. (7) Open the lid and you are ready to set up for painting.

Left-handed painters should reverse the order of setting up the front legs if that proves easier. Always set the front legs up first, then the back leg. For packing up, simply reverse the procedure. Start with the back leg and then concentrate on each of the front legs.

you. Too jittery for such a procedure? Good! Nothing is duller than a worried-over straight line. Shake it up a bit. Do you believe Renoir with his severe arthritis was able to draw a straight line? There is a danger of making tight, overworked paintings if you work with the board in your lap. Of course, if you're producing great work, by all means continue. I am talking in a general manner, but the generalizations come from a decade of observing students at work outdoors.

If you need to sit down to paint, find a seat without armrests so they won't restrict the free arm movement required for that swinging brush.

SETTING UP THE EASEL

Like any equipment, the more we use it, the better we get to know its good as well as its bad points. I believe I own every type of easel made and have worked with each. As long as it has adjustable legs for uneven ground and clamps to hold the board secure from gusts of wind, it will work. Read the instructions and familiarize yourself with the easel's full possibilities *before* taking off on that painting excursion.

The French easel, to the uninitiated, looks complicated to set up. Those familiar with it can set it up in less than a minute; Figure 2-2 explains my system step by step. The secret is to let the easel do the work for you. Start off holding it by its handle and, with one hand, loosen one of the front legs. Extend this leg to its maximum position and tighten the two screws. Now, simply

balance the box on that one leg while holding on to the handle. Switch handle hands to unfold the other front leg and fasten it into place. The back leg comes last, while the box is again balanced on the two front legs Fasten it and you're ready to go. There really is no need to turn the easel upside down to unfold the legs. Become friends with your equipment and it will do more for you.

A SUNNY-DAY SETUP

No matter what type of day it is, you should be as comfortable as possible in order to fully devote yourself to the demands of painting. Therefore, in selecting a spot, it is a good idea to look for comfort first; then for a subject that can be painted from that comfortable spot. On a hot and humid day, I'm most comfortable in the shade—and that's what you should look for unless you are a devoted sun worshipper. Find some solid shade below a tall building, under a porch roof, or inside a barn. In the morning, set up as close as possible to the source of the shadow because it will be in the shade the longest (see Figure 2-4). If you set up too close to the edge of a shadow, your paper willl soon be half in sunlight and half in shade. You wouldn't work inside the studio that way, and you don't need to outside either.

Earlier, I mentioned all the wrong lighting conditions, as illustrated in Figures 2-5, 2-6, and 2-7. "What then is the answer?" you may wonder, "There isn't always solid shadow available." Well, not for the artist perhaps, but for the paper, always. There are quite a number of outdoor watercolorists who decide to make their own shade simply by holding their painting surface in a vertical position (see Figure 2-9). Yes, watercolors can be painted upright, the paper doesn't have to lie flat. Outdoors, washes dry faster, so paint running down the paper isn't nearly the problem you may think it to be. It depends on the weather and type of paper, of course. Most artists paint in a rather dry manner any-

Figure 2-3. Cartoonist, fellow watercolorist, and friend, Ernest Smith contributed this commentary on a get-acquainted session with the French easel. Thanks Ernie!

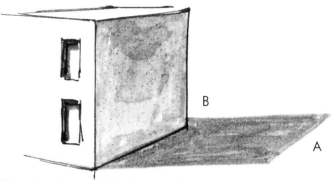

Figure 2-4. If you set up at the edge of a shadow (A), you will soon be in full sun, except in the late afternoon. In the morning, set up as close as possible to the cause of the shadow (B), since it will stay in the shade the longest.

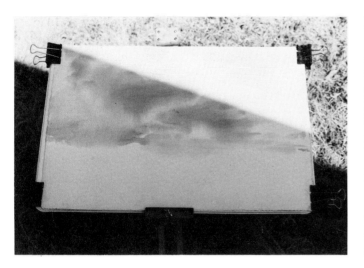

Figure 2-5. How will you be able to judge whether a value is correct in a half-and-half situation like this? Is it correct in the shadow area or in the sunny one? Although in this photograph the sunny side of the paper appears white, it has been painted on, as seen in Figure 2-8. This is what the drenching light of the sun can do, and why you should avoid setting up at the edge of a shadow.

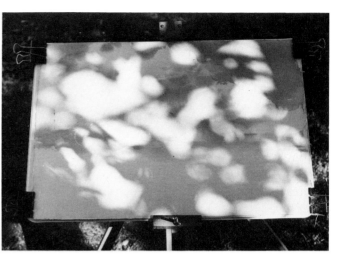

Figure 2-6. Students sometimes become so engrossed in trying to capture a scene that they seem totally unaware of the sun-dappled confusion caused by a tree shadow. Would you work under these light conditions in a studio? Of course not.

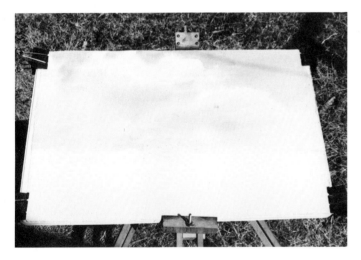

Figure 2-7. Painting in full sunlight is better than half in shade and half in sun. Due to the strength of the light source, however, values and colors will appear weak and you may be likely to overstate them. Your colors will look correct in full sunlight, but too heavy in the shade or indoors. Some painters suggest using neutral gray sunglasses. I prefer painting on a completely shaded surface.

Figure 2-8. When solid shade is available, you can paint with the board in a horizontal position and judge values correctly for eventual viewing in an indoor environment. Your surface is evenly lit and "quiet," so you can concentrate fully on the painting problems ahead.

Figure 2-9. If there is no shade available, you can still paint with the board in the shade—just place it in a vertical position.

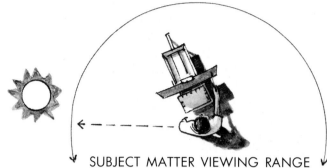

SUBJECT MATTER VIEWING RANGE

Figure 2-10. This is the way I set up outside. I align my shoulders with the sun and set my board up on a plane almost parallel to my shoulders. I have more than a half-circle viewing radius. In order to keep the paper in the shade, I don't mind turning my neck to see the subject.

way, so it is more of a mental adjustment than anything else. Oh, perhaps in the early, big wash stages of a painting, you may wish to paint flat. But drips can be caught before they run. Sometimes I even capitalize on the drip effects, as seen in *The Work Horse* (Figure 2-11). I also own a figure study painted by Charles Reid with delightful drips that were left untouched. Take another look at the paintings in this book. Would you have guessed that they were done in a vertical manner? I doubt it!

When setting up, my objectives are: first, to have the board in complete shade; and second, to see the subject matter—in that order of importance. Figure 2-10 shows how it's done. I align myself with the sun, so that either my left or right shoulder points to it, depending on how well I can see the subject from either the right or left side. Next, I set my board up along the same parallel plane as my shoulders, but angled slightly so that the sun is just behind the board. The paper will in this manner be in full shade, and any adjustments that need to be made in the the course of the painting will be very minor ones. You shouldn't paint for more than an hour

or an hour and a half on a subject anyway, because all the shapes and the color temperature of the shadows will have changed after that time.

Again, please notice that I set up with relative disregard for where the subject is. Art school trains you to look right over or next to the board for the subject. But why does it have to be there? To keep your board in the shade, this will not always be possible. However, your neck is able to turn, so it takes little effort to look to the side for the subject and to the front at the paper. Some artists even suggest turning your back completely on the subject so as not to put too many details in the painting; but in the early stages of development that might be a bit too much to ask.

Since I feel very strongly about having the board in complete shade, some demonstrations in Chapter Six also show how the easel was aligned against the sun. Working with the paper in the shade has another advantage: you automatically adjust your values and colors to an indoor environment. After all, your painting will not be hanging in full sunlight. It will be indoors, in a shaded area.

Some words of caution: do not set up so that you are looking straight into the sun. An obvious point, of course, but it is important to think of it from the start. Once you are involved with the painting, and the sun is in your eye, you may let it bother you in the excitement of trying to capture your subject. Finally, don't let the board be surrounded by very light areas because these too have a tendency to blind you.

AN OVERCAST-DAY SETUP

Time and again, I have set up on a very cloudy day, disregarding the sun's direction, only to find it suddenly shining directly on my paper. Now I have learned to anticipate this situation and set up in the same manner as on a sunny day, although it is at times rather difficult to find just where the sun is hiding. That way, you won't be

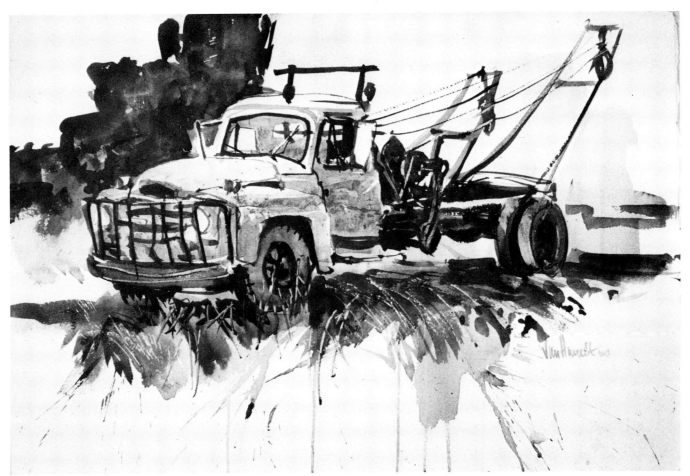

Figure 2-11. *The Work Horse.* 15 x 22 in. (38 x 56 cm). In a spontaneous, on-the-spot demonstration such as this one, the drips actually add to the feeling of spontaneity. If they don't, I could catch them before they formed or remove them with a razor blade.

in for a surprise and have to move in the middle of a painting. Of course, if there really is no chance that the sun will peek through, you can set up in any way you like—even flat. I would probably paint in a flat position if no sun were shining, but I'm so used to working upright that I do it even in the studio. Again, it's simply a matter of habit.

A RAINY-DAY SETUP

Whenever a dark, threatening sky appears, you'll hear "Let's pack up." And the minute a few drops come down, there is a mad scramble to head home. Why pack up at the first drop of rain? It might just be a short shower, over and done with in a few minutes. Just be sure to keep your easel dry so that the wood does not expand and prove impossible to fold up. This is where those big plastic trash bags, folded away in your painting gear, come in handy. Drape them over the painting and easel in case of a serious downpour.

Don't stop painting just because the sky looks threatening. In fact, just to make a point, I'll sometimes pick that time to set up and start a painting. The sunny, per-

fect day is not dramatic. For drama, you need adverse weather or light conditions. Sure, sometimes I get rained out, but sometimes I have good results, as seen in *Wet Gingerbread* (Figure 2-12). The gamble is well worth the experience. And, you'll learn some new working habits as well! Many times, students object to the spots that appear when rain hits a wet wash. But when you paint vertically, that possibility is reduced, especially when you look at the rain's direction and set up against it, as shown in Figure 2-13. Most easels allow the top clamp to be adjusted so that the board tilts forward a bit. Setting up this way gives you a chance to keep going for a while, until it really decides to pour.

The Onlookers (Figure 2-14) was done on a day of intermittent showers. Since I wasn't about to give up, a plastic trash bag was clipped to the top of my board and pulled down over the painting as soon as it started to pour. I took shelter and returned when it let up again. The trash bag, sticking to the wet washes, created just the right mottled effect needed on the bark of the trees. It turned out to be one of those lucky accidents I would not have known about had I given up and gone home.

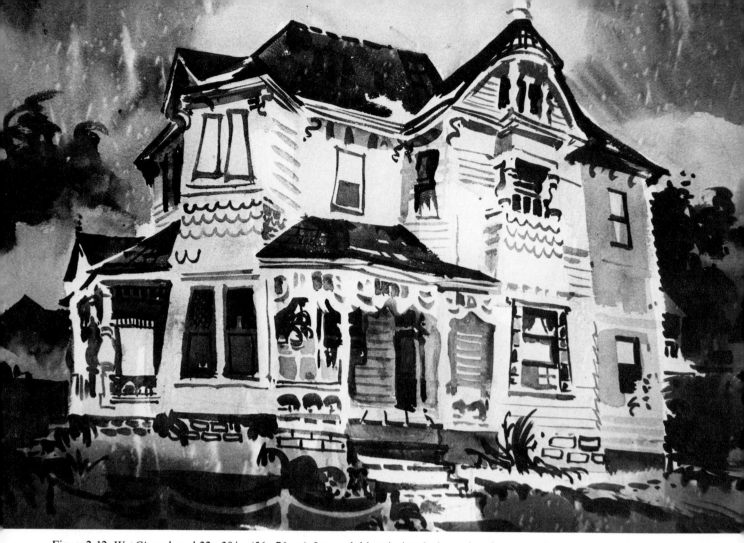

Figure 2-12. *Wet Gingerbread.* 22 x 30 in. (56 x 76 cm). I started this painting during a class demonstration which was rained out. I frantically painted outdoors for as long as possible, and then continued the work inside. I did plan to add some final touches, but now I don't think they're necessary.

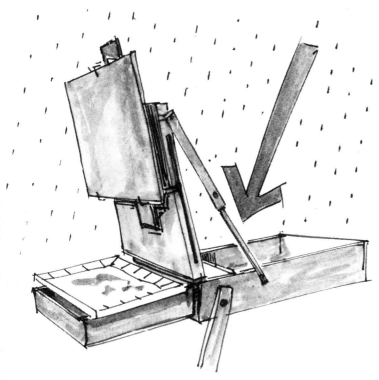

Figure 2-13 (left). A short, light sprinkle is no reason to stop painting. Just tilt the board forward and set the easel against the angle of the rain.

Figure 2-14 (below). *The Onlookers.* 22 x 30 in. (56 x 76 cm). On this painting, interrupted by rain, I discovered that the plastic trash bag I had pulled over it for protection stuck to the wet washes and created just the right effect for tree bark.

At all times, keep your eyes open for overhanging shelters—roofs, awnings, parking garages, any covered area—and see what there is to paint from those spots. That way, you'll know where to go on a rainy day.

DEALING WITH THE WIND

One drawback to painting vertically is that the board becomes quite a wind catcher. I refer to it as a "sail" and advise students to take their sails down when they're leaving their easel. Even on a quiet day, this is good advice since you never know when a sudden gush of wind will be up to its pranks. If you use a light aluminum or wooden easel, find some way to add weight to it, to prevent it from blowing over. Keep a mesh bag with your equipment and fill it with rocks or place your water container in it before suspending it from the center of your easel. As you have learned in Chapter One, even a pair of panty hose will do!

Another bit of common sense: the smaller the painting, the less it will catch the wind—so switch to a quarter-sheet. Or try sitting down. If all else fails, paint flat on the ground. It is better to paint than to give up; and your work will even show that windswept feeling.

WINTER OBSERVATIONS

Living in the sun belt, I have little chance to paint in snow and ice, but I have painted in freezing temperatures. You really don't have to worry about water freezing unexpectedly in the jar, because it'll freeze first in the brush and on the palette. There are, of course, additives such as alcohol or glycerin which will retard the freezing. Try them. I should have, while I was painting *No Longer* (Figure 2-15). That piece was painted with colored slush instead of colored water. It worked up to the point where I couldn't get anything down anymore because the paint froze in the brush before I even touched the paper. Then I quit and added some alcohol—to my insides. Working from a car or van is comfortable in such circumstances, but if I lived in snow country, I know I'd be out in it instead.

"Why go through all that?" you may ask. "Why not work from a slide?" Well, sometimes I do, but I tend to feel better about my outdoor efforts because they have a more direct feeling. That's personal, I'm sure, since I've seen some beautiful snow scenes painted from inside a comfortable, warm studio. Having done enough snow scenes outdoors, though, you'll be better equipped to pull off a successful one indoors.

DRESS FOR THE OCCASION

Never forget that you yourself are the most important ingredient in the success of your painting. So be as com-

fortable as possible. On a sunny day, wear a good shaded hat which will keep the sun out of your eyes. Your clothing should not be too colorful because the color will reflect onto your paper and influence your decisions. Wear grays, blacks, or dark colors. You should be able to pull off or add on garments as the temperature requires. The layered look is the proper look for an artist.

Whenever you travel to a different part of the country, be aware of its altitude and take a couple of extra sweaters along which, in a pinch, can be pulled on over each other. Loose-fitting clothing is preferable because it gives better insulation than tight clothing. For real winter weather, think of thermal clothing and warm socks. Earmuffs are a must. I find it difficult to paint with gloves on, and so instead, I follow a fellow painter's tip to use an old sock with a bit of the toe cut off. I then poke the brush through that small hole, keep my hand warm, and yet have the feel of the brush.

For a coat I like to stick to a lightweight plastic raincoat. On occasion I have had to use a trash bag instead, after cutting a head opening in the bottom. That keeps you warm, too. Necessity is the mother, you know!

COPING WITH ONLOOKERS

One Sunday morning, while the late watercolorist John Pike was demonstrating in a charming little square in Savannah, Georgia, a young man approached the group clustered around the master and politely asked if this was a religious meeting. John's wife, Zellah, standing in the rear, explained in a whisper what was going on—which greatly interested the curious young man. So much so, in fact, that Zellah was prompted to ask him if he too was an artist. "No, ma'am," he replied. "I'm a Christian!"

It is natural to feel a bit uncomfortable about having someone look over your shoulder while you paint, especially when you're not too sure of yourself. That's when there is safety in numbers. You somehow feel more at ease with a painting buddy along, and I guess that's why workshops are so popular. But, unless you are working right in a downtown center, you won't be bothered much except for the occasional kibitzer, with whom it just might be fun to talk a while. After all, painting should be a total experience. I fondly recall talking to a farmer while painting along some rural road. After telling me he was as old as his barn, I couldn't help but put them together in the same painting as seen in *Mr. Chmelka's Barn* (Figure 2-17). The painting just meant a little more after that. One of my fellow painters angrily snaps at anyone who makes the mistake of stopping, looking, or talking a few minutes. That, I feel, is

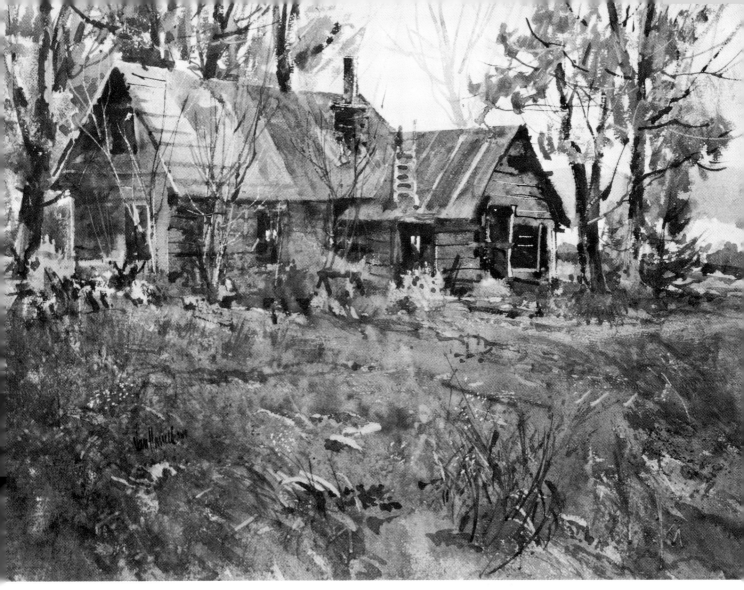

Figure 2-15. *No Longer.* 22 x 30 in. (56 x 76 cm). This demonstration, done during an early cold spell in Minnesota, was literally painted with colored slush. To prevent your colors from freezing, add some alcohol or glycerin to your water jar.

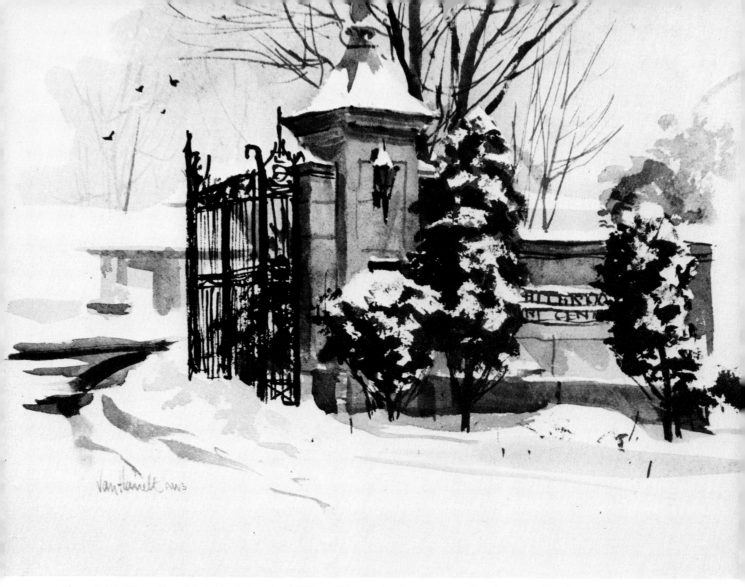

Figure 2-16. *Winter Gate.* 11 x 15 in. (28 x 38 cm). Where I live, we don't have much of a winter; so when it snows, I grab my gear and take a fresh look at my area's new painting possibilities. This view of the entrance gate to our local museum was painted from inside my van.

Figure 2-17. *Mr. Chmelka's Barn.* 15 x 22 in. (38 x 56 cm). Painting along one of Nebraska's beautiful byways, I couldn't resist including the local farmer who came up to chat.

not wise. Yes, there is the possibility that you lose some concentration, but you might throw away a chance to make a new friend or even a sale. Do keep involved with your work, but try to stop and say hello, or answer a few questions. If the talker gets too carried away, just get more involved with your painting and take your time responding. He or she will soon get the message that you are concentrating on your work. In all my years of outdoor painting, there have only been two aggravating experiences and that's not a bad record.

Most onlookers don't have any idea about art and whatever you have on the paper will look great to them. Of course, there was that time when I painted a downtown scene and one passerby asked another what I was doing. "He's practicing" was the deflating answer.

Children can be delightful and well behaved, but, if you pay a little too much attention to them, things can get out of hand. A painter friend told me that one time in Mexico he drew a circle in the dirt and asked the kids to stay behind that line. Luckily for him, they did.

COPING WITH VARMINTS

One of the most common objections to painting outdoors are the bugs and, granted, they can be a nuisance at times. Insect repellents, especially the ones that come in the towelettes and squeeze-bottle dispensers, are a must for the outdoor painter. Insect repellent in spray cans must be handled very cautiously, since the spray travels far and any particle that lands on your paper or palette will act as a resist, resulting in a speckled surface just where you don't want it. Great for rock textures perhaps, but in that pristine sky?

Perfumes and after-shave lotions actually attract insects, so avoid wearing them when painting outside. Mosquitos can be a pest at certain times of the year and in certain areas of the country. Any repellent containing diethyl toluamide, abbreviated DEET, is fairly effective against them. Some people claim that thiamine (vitamin B_1) taken orally in doses of 100 to 200 milligrams can fend off mosquitos and even those nasty sand fleas. Theoretically, the vitamin works to produce a smell at the level of the skin that mosquitos hate and people can't detect. Try it next time!

Another common fear is snakes. Yet, in all my years of outdoor painting, I have only seen two—who slithered away as fast as they could. Your chances of getting bitten, statistically, are so small that there really isn't much to worry about. Since snakes try to keep out of your way, the best advice to follow is to watch where you walk, and don't stick your hands into cracks and crevices, which I'm sure someone afraid of snakes wouldn't do in the first place. Woodpiles are a snake's

favorite hiding place, so at least announce your presence with some noisy stamping and kicking to give that poor creature a chance to get out of your way.

Talking about stamping and kicking reminds me of the time I set up just a bit too close to an anthill. Needless to say, it was a very quick demonstration. Oh well, artists have to suffer, they say. All in all, bugs are a relatively minor nuisance for the outdoor painter. You won't even be aware of most creepy-crawlies while deeply engrossed in your painting. And since animals are more afraid of you than you are of them, they'll stay out of your way, too. Don't worry about them, and get involved with that painting instead.

COMMON COURTESIES

There is a generally understood outdoor-painter's code of behavior which not only keeps you out of trouble but creates good will for the next painter as well. Let's go down that list of courtesies.

1) Ask permission to go on private land or paint someone's house. Sometimes that's hard to do, but at least give a good try to locate the owners so that when you are confronted by them, you can at least tell them you tried to ask permission. Neighbors are usually able to steer you in the right direction. "No Trespassing" means just that!

2) Put a gate back in the same position as you found it. If it was closed, close it again, If it was open, leave it open.

3) Don't smoke in or near a barn. Straw will catch on fire in seconds and endanger the farmer's property, as well as you and your equipment.

4) Make sure your matches and cigarettes are extinguished when you dispose of them, especially during a drought when grass fires are easily started.

5) Clean up after yourself. Keep a little paper trash bag on hand, and drop those tissues into it. Cigarette butts too. You may intend to clean up afterwards, but in the meantime, the wind will scatter the litter all over.

6) Park your car so it won't be in the way, hinder the operation of a business, or damage plant life. In some parts of the country they value their grass.

YOUR STUDIO ON WHEELS

There comes a time when either the weather or your physical condition makes painting inside your car or van a welcome change. You still see the subject but are protected from the elements.

If you plan to paint from a passenger car, you'll need to scale your equipment down a bit and work either in the sketchbook or quarter-sheet size, or even smaller. I

have set my French easel on the passenger seat without unfolding the legs and painted that way, but not too comfortably. It seems best to lean your board on the dash and your knees, or on the steering wheel, with your equipment on the seat next to you. Look for a way to fasten your water container to the dash or door handle. If this is the manner in which you will have to work, you'll find all sorts of ways to make it more convenient and comfortable.

When the weather is interesting and a few painting hours are available, I like to just jump into my van and take off, without first making a checklist of supplies and equipment. Consequently, it has happened that I was ready to paint but found that the paper or water, or some such essential thing, had been left behind. To remedy that problem, I bought a duplicate set of equipment which I keep in the van all the time. Now all I need to grab are my camera and keys; the rest is inside the van. When the day's painting is over, only the painting and sketches leave the van. Since having a studio on wheels is ideal, let me explain some considerations to keep in mind if you plan to use a van or camper.

My Volkswagen bus offers good gas mileage and roominess. Since the middle seat is removed, I can use! the French easel inside. On warm, windy, or rainy days, I keep the sliding door open and park the bus so the subject may be seen from it. Sometimes I sit on the steps and in the shade of the bus. At other times I place my easel in the rear, above the motor. That way, I can paint standing outside with the open door, which is swung up, acting as a sun or rain protector.

American-made vans and camper vans offer the same or more comforts as the Volkswagen, plus enough power for hard driving and heavy loads. Their disadvantage, however, is gas consumption.

On an extended painting and vacation trip with the family, a good combination seems to be a trailer pulled by a strong van. You'll have all the roomy convenience of the large motor home, plus the back-road maneuverability of the van. Gas costs should be balanced by the elimination of motel and restaurant costs.

It is great fun to outfit your studio on wheels and even greater fun to actually take it out on the road. Also, do look into its tax advantages if you're going professional!

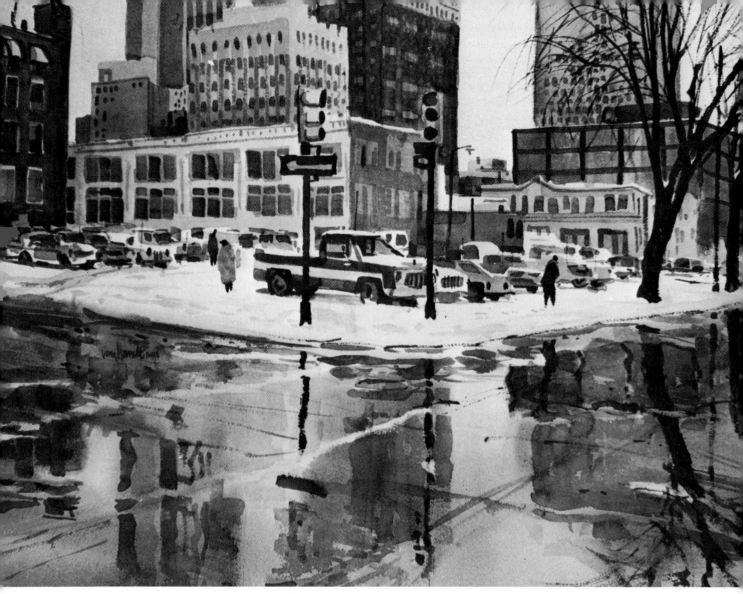

Figure 2-18. *Ice, Snow and Silence.* 22 x 30 in. (56 x 76 cm). This subject attracted my attention because of the wonderful wet street reflections, which I enjoy painting. I also had fun suggesting all the cars and rendering only one or two. Scenes like this can seldom be done in the open. You either work inside your car and take pictures to finish the subject back in the studio, which is the ideal way, or try doing the whole thing inside. The latter method has the inherent dangers of following a photograph too closely.

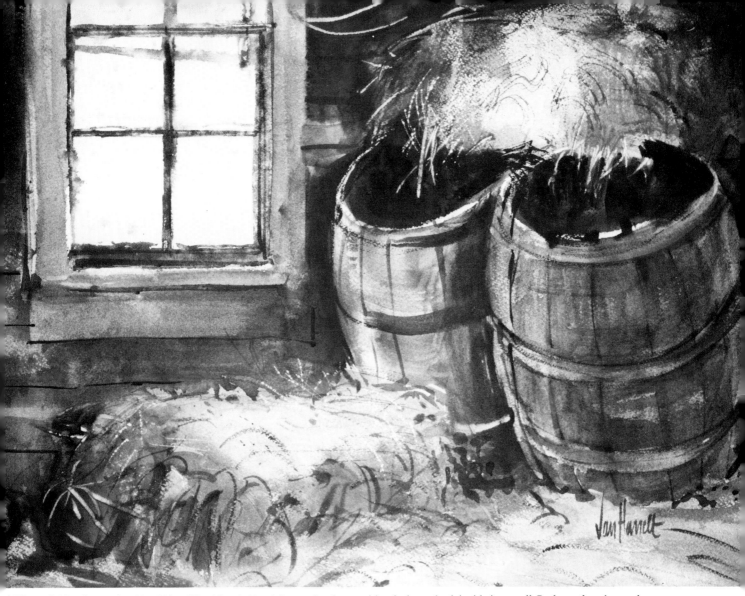

Figure 2-19. *The Corner.* 11 x 15 in. (28 x 38 cm). Don't just paint the outside of a barn, look inside it as well. Perhaps there's a real gem waiting for you there. Besides, in case of a change of weather, you can still continue painting. Here's a case where you wouldn't dare light up a cigarette!

Chapter 3
Finding the Outdoor Subject

How many times have you gone out looking for a subject, only to cover miles of territory without ever touching brush to paper? Chances are that you've been looking for the perfect subject and have passed by innumerable good painting possibilities. In this chapter, you'll explore first what to look for and where to find subject material, and then how to prepare yourself before committing any color to that blank sheet of watercolor paper.

Before all else, it's best to start with a proper attitude. In the beginning, you should listen to what Mother Nature has to say. Try to copy her verbatim, and then you'll learn how to *translate* her into a limited range of values and colors. Avoid being "arty"; be strictly analytical instead.

WHAT IS A GOOD SUBJECT?

Basically, in representational painting, a good subject consists of a few clearly stated, contrasting values, interestingly arranged. Next time you see a landscape at a museum or art gallery, ask yourself, "Would I have stopped and painted that scene?" Isn't it amazing how the most simple scene can be turned into a painting? My friend Jack Pellew, for instance, can be just about anywhere and start a painting because he knows the major ingredients for a painting are values and shapes, either copied from or superimposed on nature.

Over the years, I've found that outdoor students obtain best results when copying from nature as it is. But that means that you need to find subject matter that needs little or no rearranging of its value relationships and shapes. Once you learn to paint nature that way, once you know what the ingredients for a painting

should look like, you can then use your artistic license to change less interesting subjects into good paintings.

Since nature doesn't have any borders to contain it, you might find it helpful to fabricate a viewfinder, as seen in Figure 3-1, by cutting a rectangular opening in a piece of cardboard or using an empty slide mount instead. Moving the viewfinder closer or farther away from your eye, you will see more or less subject area and can decide how it will look best in this little frame. Thus equipped, let's try and find the right subject matter.

In Figure 3-2, for instance, you're at the edge of a little stream. There are rippled reflections in the water, the weeds are a nice warm color, and the background trees are equally interesting. Yet, just looking at the photograph, it doesn't seem the least bit exciting. And chances are that if you had stopped and painted this

Figure 3-1. Since nature doesn't have any borders to contain it, you may find it helpful to fabricate a viewfinder by cutting a rectangular opening in a piece of cardboard or by using an empty slide mount. By moving the viewfinder closer or farther away from your eye, you will see more or less subject area and can decide how your subject will look best.

spot, the painting wouldn't be exciting either, because there are no value contrasts. The whole subject is basically one value. So let's saunter a few steps farther and, in Figure 3-3, find this nice tree along the bank, with spotted, peeling bark and branches taking off at different angles. Outside, such surface details can be so enticing that you somehow forget everything about value contrasts and shapes. The most common problem is that you see too many details too soon. Yet, looking at the photograph, you'll agree that the subject as a whole isn't really that exciting. There are a few more vaguely stated values, but they don't really provide contrast. Squint at the picture if you disagree. In fact, so as not to get waylaid by surface details, keep your eyes almost closed while looking for a subject. That way, you'll only see general value masses and shapes instead of details.

So on you go and, in Figure 3-4, see a few value masses which are contrasting enough and pleasing in shape. You can still distinguish them clearly, even when squinting at the photograph. That's the idea! You've just found a subject that could indeed be painted just as presented by Mother Nature. Clearly stated value masses are like clearly spoken words. You can understand them. Our two earlier subjects can be compared to a mumbled speech. The speaker might have something important to say, but unfortunately, we can't understand it. The same problem happens with many student paintings, which feature lovingly handled details. Unfortunately, the details can't be seen by the average viewer, because they're painted in the same values as the surrounding areas (see Figure 3-5).

A good subject, therefore, is found with almost closed eyes, looking for a few clearly stated value shapes. Those shapes will form the framework upon which surface details are "fastened." Open your eyes and you can see details. But if you search for the subject with open eyes, the siren song of surface details will confuse your decisions. Jokingly, I have threatened to design a pair of sandblasted glasses so that students wouldn't be able to see too much. You can achieve the same effect by look-

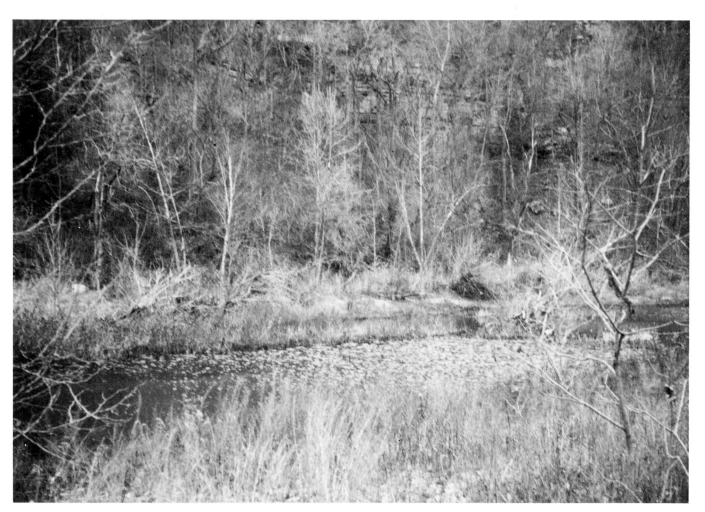

Figure 3-2. On location, this rippling stream may seem exciting. But for a picture to be "read," it needs a few clearly stated contrasting values, which explain what is taking place. This subject has no value contrasts.

Figure 3-3. Surface details can distract you from looking for values and shapes, the ingredients necessary for picture making. Here, the tree offers interesting details and textures, but as a whole, the subject still doesn't offer clearly stated contrasting values. Look for your subject with almost-closed eyes, to avoid seeing details.

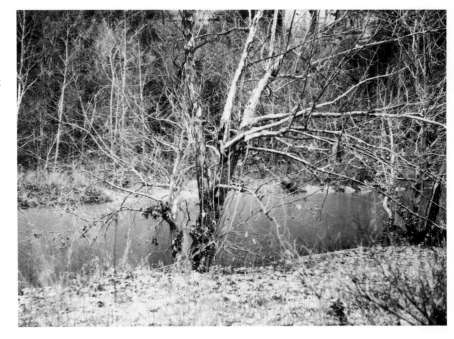

Figure 3-4. This subject matter has clearly stated value masses which remain visible even if you squint at the photograph, and so you can paint it just as nature presents it.

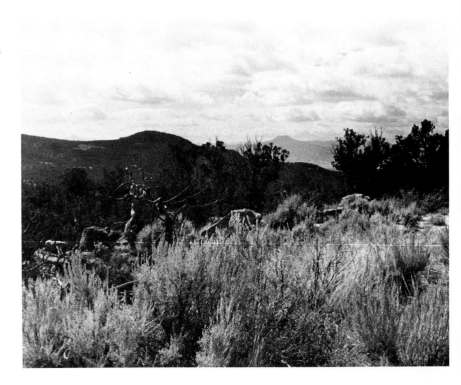

Figure 3-5. You can spend hours painting lovely details, but if they are all in the same general value, your painting is like a mumbled speech which nobody can hear or understand.

ing through the viewfinder of an out-of-focus camera. Luckily, with my eyesight, when I get "detail happy" I can take my glasses off and all details will be gone. It is a blessing in disguise to have eye problems like that, since you are better able to see the major shapes and values than the 20-20 painter next to you can.

Attitude plays an important role in selecting a good subject. If you go out with the idea of doing a painting for Aunt Minnie, because her birthday is coming up, you will naturally have to find the perfect subject and will have to succeed. But if instead you say, "I am going to look for some clearly stated value contrasts and some interesting shapes and I don't care what the subject is," then you have the proper attitude. In other words, don't look for a subject; look for the ingredients that make a painting work.

Interesting shapes also play an important role in subject selection. In Figure 3-6, for instance, you do have good value differences, but the shapes don't explain themselves clearly; in Figure 3-7, they do. Squinting is the answer to the selection of good subject material. If the subject explains itself while you squint at it, it will explain itself with your eyes wide open.

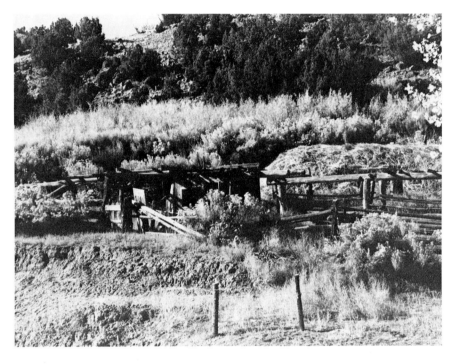

Figure 3-6. If your shapes don't explain themselves clearly, your viewer won't understand the painting, even if there are good value differences in the subject.

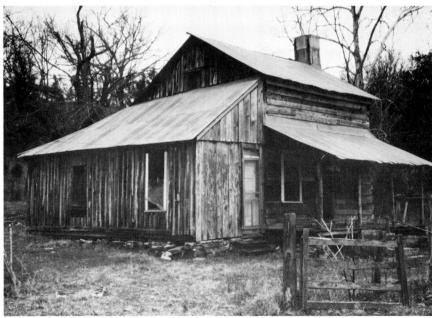

Figure 3-7. Search for a subject that explains itself while you squint at it, because it will then explain itself with your eyes wide open. Look for a few clearly stated value masses and shapes.

FINDING THE GOOD SUBJECT

Having shown you how to look for subject matter, let's next see where to look. Of course, artists are always looking, always seeing painting possibilities. You may not always follow up to actually paint the subjects you see, but as long as you exercise your value and compositional judgment, you're better off than so many who look but unfortunately never see.

If you're removed from your usual surroundings, all the daily distractions are gone and suddenly you can see much better. The ordinary item, blindly bypassed at home, becomes interesting and full of subject possibilities away from there. The distance traveled is immaterial, because really it is a distance of the mind. That's why you would be able to paint in your own backyard if you were not distracted by the daily chain of events. Recently, I assigned myself the task of painting my city. I set out daily with just painting in mind. The whole city offered new material and I looked at it with a fresh eye, instead of in my usual way of traveling from point A to point B in a hurry, with a hundred things on my mind.

As the founder of Painting Holidays, I used to conduct regular research trips, to see if an area would be suitable for holding workshops. Consequently, I can give you some first-hand advice on locating subject matter. Start by getting yourself the biggest, clearest map available. With a good one, it's like seeing the area from the air. I love those Corps of Engineers survey maps which locate each dirt track, watering hole, and shack beside it. The European Michelin maps are similar. Look for streams and lakes as well as at the topography. Learn how to read those maps so you can get a mental image of the general lay of the land. Maps of towns are also very interesting, especially when a stream or mountain messes up all those straightly laid-out streets. When those natural barriers are located in the oldest section of town, you're in for some great painting possibilities. Head first for a town's reason for existence because that will most likely be its oldest part as well. If it is a harbor town, look for the waterfront. If the railroad placed the town on the map, head for the tracks, and never overlook the alleys and backs of buildings. The fronts are usually spruced up and modernized, while the backs offer lovely add-ons, old signs, tin roofs, and broken windows.

Over the years, I have developed quite a nice library of travel books and research files. If I read something interesting about an area or see an exciting photograph, it goes in its proper file. I use those files extensively on long painting trips. By relying on what our good friends the photographers are excited about, I know about places that should interest me as well. Besides, I eliminate a lot of research through dull areas. Naturally, the danger exists that you will paint the obvious—the stuff everyone else has painted. But could you say it another way? How many artists haven't painted St. Mark's Cathedral in Venice? John Pike, facing it, chose instead to paint the cathedral's reflections on a wet surface.

It is great fun to head down a byway and discover your own private trove of painting material. Go explore that interesting barn scene. Don't forget to look inside it as well. But just remember, if you plan to do a painting, set yourself a mileage or time limit to find a subject. If you don't, you'll keep on looking and won't ever get anything down on paper. Believe me, I know!

BUILDING BLOCKS OF VALUES

Selecting a subject, you now know to look for a few clearly stated values. But there are an an untold number of values in each subject. If you try to see and record

Figure 3-8. *Phil.* 15 x 22 in. (38 x 56 cm). In this portrait, to avoid rendering details too soon, I started by laying in the overall color washes and shadow shapes, then modeled the forms, and finally added the features.

them all, you take on a task too big to handle in the early part of a painting. It is a tremendous hurdle to get past seeing too much and rendering too soon. But think of what sculptors go through when doing a bust of a person. They don't start by modeling an eye in midair. They start with an armature, a framework, and they first establish the big mass shapes of the head, neck, and shoulders. For them, it would be impossible to start with an eye. I wish it would be impossible for painters as well, since in the beginning stages, we all do tend to start with details, relating eye to white paper instead of surrounding values. While doing *Phil* (Figure 3-8), I started with the big shadow shape of the whole face.

Figure 3-9. Here are the building blocks of picture making: three basic values plus the smaller accents of white and extreme dark. The actual value range is more complex, but it is best to start out with just these few. Eventually, by adding details, you will create an infinite variety of values in your painting.

The painter's values are like the sculptor's clay. They are your building blocks, the framework for picture making. Figure 3-9 shows these blocks; a middle value plus a light and a dark value. In addition, there are two smaller blocks or accents of black and white. Look for these building blocks in nature. More than likely, they will be the sky, the ground plane, and upright planes

(see Figure 3-10). Within those three general values, there are countless other closer variations, but they average out to the three major ones. The many variations will reestablish themselves while the painting progresses, simply by the overlaps of brushstrokes. Start with a simple three-value plan and you'll end up with thirteen. But if you start with thirteen you'll end up with thirty, and that's just too much to keep track of. Keep everything as simple as possible.

The three values bring up an often overlooked point, namely that the sky is the light giver and the earth is the light receiver. Consequently, earth values are generally darker than the sky. This can easily be seen on an overcast day, but the principle even applies on a sunny day. Naturally, there are exceptions, primarily man-made ones, such as roads and buildings, but also natural ones, such as sunny beaches and snow. Reflections, although they belong to the earth, are just that; they reflect the sky and can be just as light. Figure 3-11 shows you how to make a handy little tool to check and compare values without getting trapped into seeing details.

On a sunny day, shadows and dark local colors give you the darks you are looking for. But on an overcast day, you have to rely on the values of the local colors only—the actual values of the items you are painting. Continue to look for the three big value differences, though. Or look for a nice white shape, such as a building, and use it as a center of interest to which you can relate other values. I look into puddles on overcast days, since the strongest contrasts of sky against dark reflections can be found there. See *Sky Reflections* (Figure 3-12) and *Stream Reflections* (Figure 3-13).

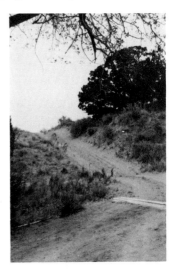

Figure 3-10. Here are four examples of simple value plans found in nature. Try to see your subject in three general values plus accents of black and white. If you notice a fourth value, squint, and you'll be able to blend it into the building-block value closest to it. In example three, I have included a man-made object, which can become as light or even lighter than the sky, especially if it is a horizontal plane such as this one, or if it is a white house with the sun shining directly on it. Compare your scene to these guideline examples with half-closed eyes to see its general value plan.

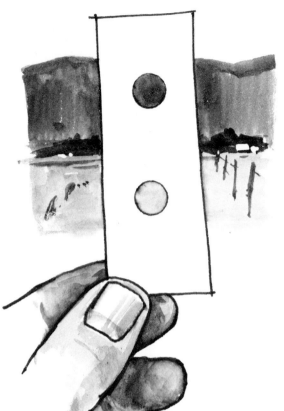

Figure 3-11 (left). Take a piece of stiff paper, preferably of a medium gray, and punch two holes in it, about 1 in. (3 cm) apart. By closing one eye and lining up one hole against one value range and the other hole against another, you can easily compare the two values because details will have been obliterated.

Figure 3-12 (below). *Sky Reflections.* 15 x 22 in. (38 x 56 cm). On an overcast day, you should still look for strong value contrasts. I found them in this little pool with its dark reflections.

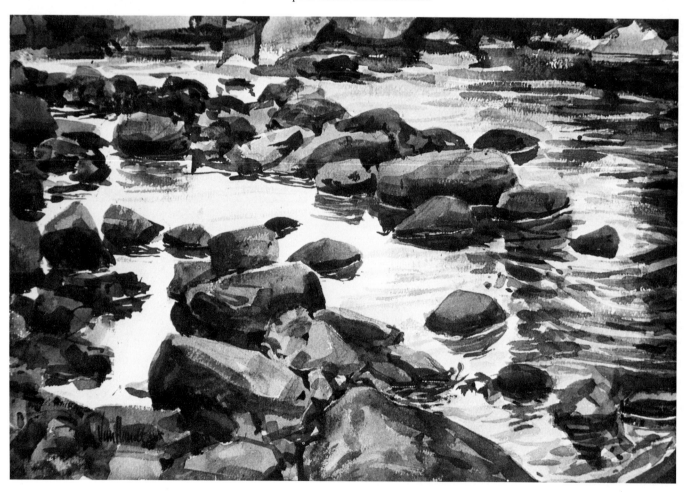

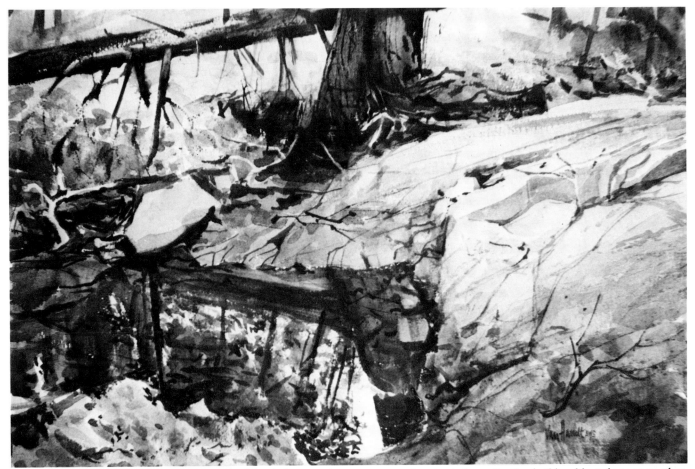

Figure 3-13. *Stream Reflections.* 15 x 22 in. (38 x 56 cm). Strong value contrasts again attracted my attention in this subject, done on another overcast day.

COMPOSITIONAL GUIDELINES

Earlier, I mentioned that values are the building blocks of picture making. Enlarging on that comparison, I could say that composition determines the shapes and arrangement of those blocks, which together, form the framework I continually talk about.

Good composition should make a painting perform two functions: from a distance, its interesting shapes should attract the viewer's attention and curiosity; upon closer examination, the viewer should expect good handling of detail within those shapes. I daresay that a painter who uses good composition but is poor on detail handling is better off than one who is good with details but poor in composition. Ideally, you should handle both equally well. Since there are a number of books written on composition and design, I strongly urge you to read those in the bibliography and do the assignments given in them. Compositional skill is developed by exercising it.

To keep matters simple, let me go over the major considerations when composing a subject. My primary concern is "the star of the show"—*what* I'm painting is *why* I'm painting. Think of your paper as a stage with

actors, with a star and supporting cast. You're the stage director. It is up to you to make sure that none of the supporting actors steals the attention away from your star. Figure 3-14 shows how that feat is accomplished by making the viewer look at:

1) the largest piece of light in a dark picture or the largest piece of dark in a light picture
2) the strongest contrast in values, darkest dark against lightest light
3) the sharpest edge quality
4) the most detail, the "in-focus" area

As you increase distance, away from the star area, you should lessen contrast of shapes, values, and color; soften edges; and reduce detail handling.

I think of the dark local colors, shadows, and cast shadows as compositional decision makers, because they hold the painting together and form a path for the eye to follow. These darks should be selected or rearranged so that they balance and link up with each other. *Balance* is a key word in composition. It not only applies to the darks but also to the lighter values, the hues, and even the chromas. Let's take a look, therefore, at what balance means.

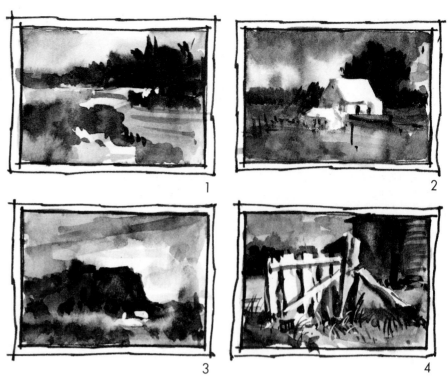

Figure 3-14. Your viewer will look at (1) the largest dark or light shape; (2) the strongest contrast of values; (3) the sharpest edge quality; and (4) the most detail.

In Figure 3-15, a dark shadow shape is placed to the side of the painting, causing it to appear unbalanced. Imagine that shadow shape cut out of sheet metal and glued to a framed canvas board. Hanging the canvas up, you would easily see that it tilts to the left. We therefore need to place another dark shape on the other side of the painting to visually balance it, as in Figure 3-16. Featuring two equal-sized darks in that manner, however, makes it difficult for the viewer's eye to land on one area and equally difficult for the painter to decide which area will be the star. You should try to have one major shape plus a medium and some small shapes in a painting. In Figure 3-16, the shapes are too equal.

Notice that by placing the original dark shape closer to the center of the painting, as in Figure 3-17, the balancing darks can be much smaller. That idea is best illustrated with the seesaw or scale at the bottom of each illustration. Moving the larger shape even closer to the center, as in Figure 3-18, you can reduce the size of the balancing shapes even more, while still retaining visual harmony. If you were to place the dark shape exactly in the center, you would not need any other shapes to balance it but would also create a "bulls-eye" effect—not recommended for good composition.

Figure 3-19 shows that a large mid-value shape may be balanced by a small dark shape. The same holds true for color. A large piece of neutral color may be balanced a small, more intense piece of that same color.

Figure 3-15. A dark shadow shape on one side of a painting will cause it to appear unbalanced, much like a weight would affect a seesaw.

Figure 3-16. You can balance the painting by placing another dark shape on the other side, but then the viewer doesn't know which shape to look at first. You might have to hold it upside down to see that effect.

Figure 3-17. Aim for one major shape in a painting, balanced by a medium shape and some smaller ones, so the viewer knows where to look first. Again, try viewing this illustration upside down.

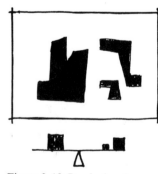

Figure 3-18. By placing the major shape close to the center of the painting, you can reduce the sizes of the balancing shapes. If you place the major shape exactly in the center, however, the composition will not be pleasing.

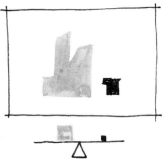

Figure 3-19. A large mid-value shape may be balanced by a small dark shape. Likewise, a large area of neutralized color may be balanced by a small, more intense piece of same color.

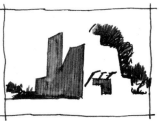

Figure 3-20. Create a good introduction from frame to subject by touching an edge here and there. Also try linking your lights and darks throughout the painting, or at least make them seem to do so.

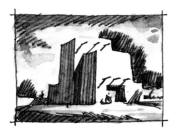

Figure 3-21. Other darks touch, balance, and direct the viewer through the painting.

Figure 3-22. To emphasize the building, glaze light washes over the other white areas, subtly darkening them and thus highlighting the building.

Keeping these thoughts in mind when outside, look for a nice big shadow shape, and judiciously place it on your sketch. Then, looking for balancing possibilities, try to touch an edge here and there, as in Figure 3-20. This creates a good introduction from frame to subject. Try also to link lights and darks throughout the painting, making them touch each other, or at least seem to do so, as seen in the cast shadows above the door area. To create an interesting path for the eye to follow, you can introduce other darks which touch, balance, and direct the viewer through the painting, as in Figure 3-21. Finally, to tell the viewer that the building is your center of attention, you can place light values over the other white areas, subtly darkening them and, by contrast, making the building stand out, as in Figure 3-22.

You have just seen some abstract shapes turn into a realistic subject. Compositional thinking has to be done

in an abstract manner. Details only confuse and sidetrack. Take another look at all the pattern sketches used throughout the book. Most would make nice abstracts, wouldn't they? You may not be an abstract painter, but the abstract is your framework which will be decorated with realism. "Realism is but the icing on a good abstract cake," a better mind than mine has proclaimed.

Dominance is another major concern in my compositions. It means that one shape, value, or color predominates. You should avoid a half-and-half approach. The horizon line in the middle of a picture, for example, is familiar to everyone (see Figure 3-23). You should decide on a dominance of either land mass or sky mass. Avoid vertical, diagonal, or free form half-and-halfs.

Besides shape dominance, other dominances should be kept in mind—for instance, dominance of color and temperature, as shown in *Artist's Point* (Figure 3-24). Dominance of texture can be seen in *Waiting for Progress* (Figure 3-25); dominance of edge quality in *Mist Over Jenny Lake* (Figure 3-26); and dominance of value in *Forgotten Corner* (Figure 3-27). The word *dominance* implies the presence of a subordinate, accentual relief that makes the dominant even more outstanding, much like a cold day that makes us appreciate the warm week. Look at the paintings just mentioned and find the relief. Think of a city scene: straight lines and blocklike shapes dominate, while the accentual relief may be found in the sweeping branches of trees in the park. *Waterfall Impressions* (Figure 3-28) shows a curvilinear dominance and accents of straight lines.

I apply the principles of focal point, balance, and dominance—my major compositional concerns—with freedom, occasionally changing and ignoring them for the good of the painting. Take it all with a grain of salt. Keep your eyes open and never follow a rule blindly.

Since the same problems keep cropping up at each workshop, I've illustrated them as dos and don'ts, in

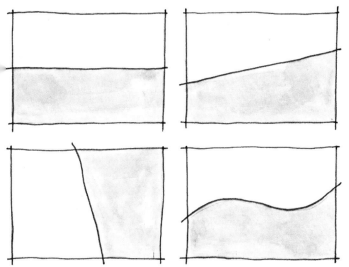

Figure 3-23. Dominance of shape means avoidance of half-and-half compositions. Everyone knows not to place the horizon line in the center of the picture, but here are three other examples of similar mistakes. The solution is always to make one area larger.

Figure 3-24. *Artist's Point.* 22 x 30 in. (56 x 76 cm). This is a good example of warm color and temperature dominance, despite the fact that this painting was done on a very cold day.

Figure 3-25. *Waiting for Progress.* 22 x 30 in. (56 x 76 cm). A former local park, which has since been destroyed and replaced by an inter-urban dispersal loop, featured dominance of texture. The composition is held together by the solid accents of distant buildings.

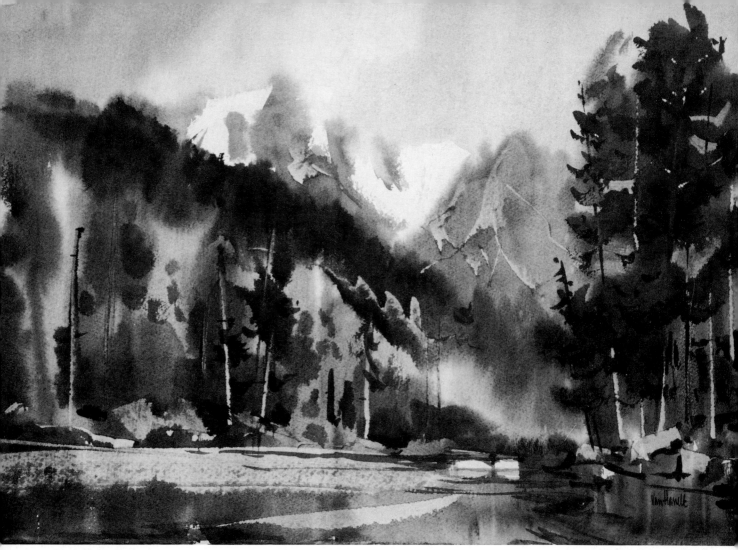

Figure 3-26. *Mist Over Jenny Lake.* 15 x 22 in. (38 x 56 cm). This "quickie" demonstration provides a good example of soft-edge domi-
nance. I basically used a wet-into-wet procedure, starting on dry paper. Hard-edged shapes, such as the two patches on the water, were
unplanned areas of dry paper, which I then transformed into rocks.

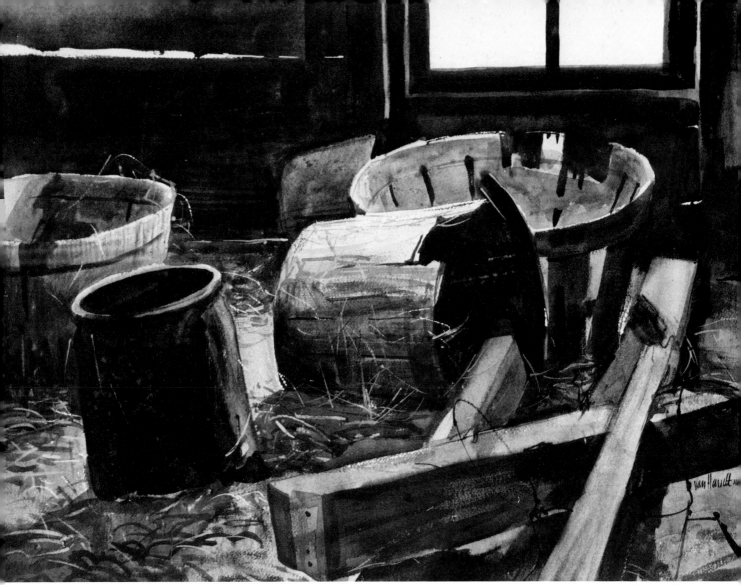

Figure 3-27. *Forgotten Corner.* 22 x 30 in. (56 x 76 cm). Since the scene is inside a barn, the value dominance is dark and the lights form well-composed accents. I enjoy painting naturally arranged still lifes such as this one more than "posed" objects in contrived setups.

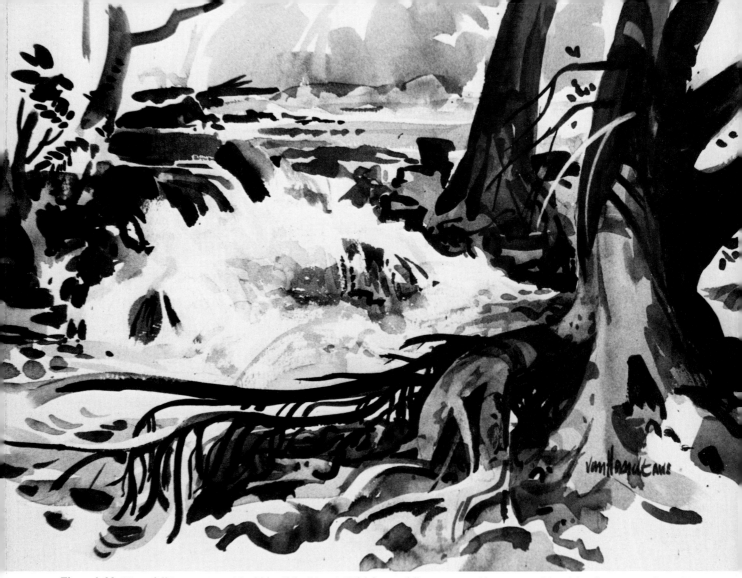

Figure 3-28. *Waterfall Impressions.* 14 x 20 in. (36 x 51 cm). With its tumbling water and bent trees, this subject has a natural curvilinear dominance, accented by a few straight, horizontal lines which solidify the composition.

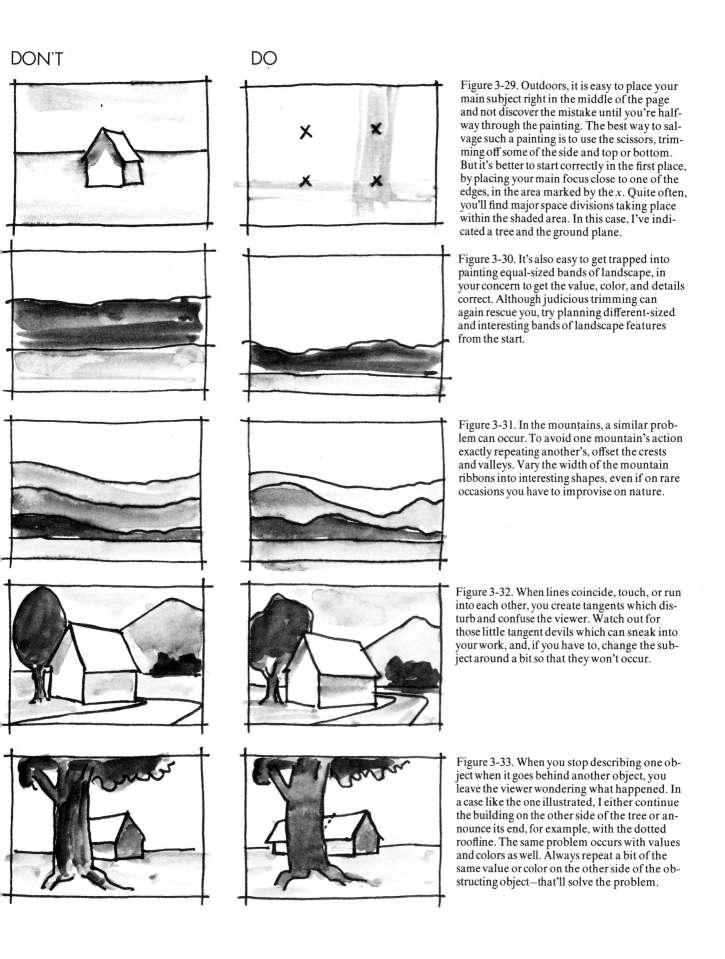

DON'T

DO

Figure 3-29. Outdoors, it is easy to place your main subject right in the middle of the page and not discover the mistake until you're half-way through the painting. The best way to salvage such a painting is to use the scissors, trimming off some of the side and top or bottom. But it's better to start correctly in the first place, by placing your main focus close to one of the edges, in the area marked by the *x*. Quite often, you'll find major space divisions taking place within the shaded area. In this case, I've indicated a tree and the ground plane.

Figure 3-30. It's also easy to get trapped into painting equal-sized bands of landscape, in your concern to get the value, color, and details correct. Although judicious trimming can again rescue you, try planning different-sized and interesting bands of landscape features from the start.

Figure 3-31. In the mountains, a similar problem can occur. To avoid one mountain's action exactly repeating another's, offset the crests and valleys. Vary the width of the mountain ribbons into interesting shapes, even if on rare occasions you have to improvise on nature.

Figure 3-32. When lines coincide, touch, or run into each other, you create tangents which disturb and confuse the viewer. Watch out for those little tangent devils which can sneak into your work, and, if you have to, change the subject around a bit so that they won't occur.

Figure 3-33. When you stop describing one object when it goes behind another object, you leave the viewer wondering what happened. In a case like the one illustrated, I either continue the building on the other side of the tree or announce its end, for example, with the dotted roofline. The same problem occurs with values and colors as well. Always repeat a bit of the same value or color on the other side of the obstructing object—that'll solve the problem.

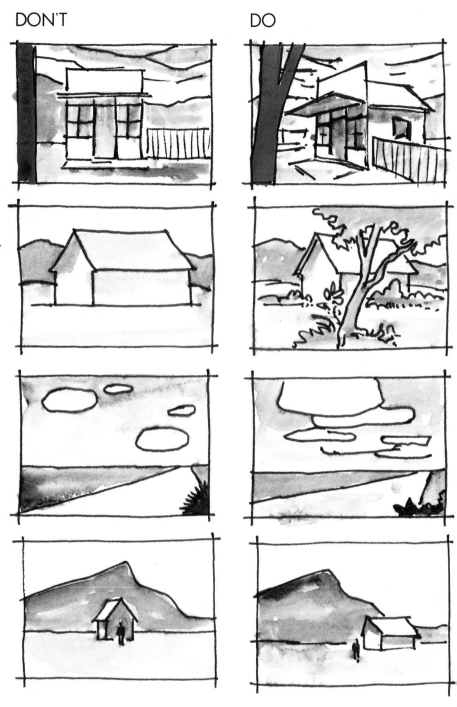

Figure 3-34. You can't do anything to change the horizontal and vertical lines of your frame, so why repeat them in your painting unnecessarily? In nature, as in portraiture, the best angle usually is the three-quarter view, which enables you to at least avoid most horizontal lines. Also try to avoid vertical lines too close to the side of the frame. For example, tip and angle a tree shape.

Figure 3-35. Although a house may be two stories high, students often draw its roof absolutely parallel to the horizontal edge of the paper, disregarding perspective angles. It is better to overstate such an angle than to understate it. Mental alarms should go off when you look at that large, uninterrupted roof and side of the building. Could you perhaps step to the side a bit and break up those dull shapes with an overlapping tree? Then, is the baseline of the house really that straight or do you see weeds, barrels, fence posts, and bushes interrupting the line?

Figure 3-36. Here is a nice space division, but the road runs right into the corner of the painting. To avoid the same thing on the other side, the artist quickly added a bush. The bush wouldn't have been a bad idea if its horizontal measure was different from its vertical one and did not create too equal a triangle. In the sky, depth is destroyed by the equal-sized cloud in the distance. You can create the feeling of depth by keeping a big shape up front and overlapping the others.

Figure 3-37. Avoid stacking the interesting parts of a painting right above or in line with each other. The last illustration shows a more interesting disbursement of points of interest throughout the painting.

Figures 3-29 through 3-37. Most of them you already know, but somehow, in the excitement of painting, we all forget the most basic things. Think of painting as a juggling act. You start with one ball named drawing and learn to catch that one. Then you add another one named values, and you have two going at the same time. After that, you add color, composition, texture, edge quality, and so on. Soon, there are a lot of things to keep track of, all at the same time. It's normal to drop a ball or two, especially outside, where you also have to be concerned with changing light conditions, tides going out, gnats, and other fun things.

The more you paint, the more mistakes you make, the better your juggling act becomes. Remember the very first time you drove a car? How concerned you were about giving it gas and steering, not to mention changing gears? Now, you can hardly remember how the car got from point A to point B, because you were driving automatically while thinking other thoughts. Once that happens, you can concentrate on an even higher plateau of art, adding yet another ball to your act. Isn't it wonderful that your growth as a painter is never-ending? That's how artists stay young!

SAY IT WITH THE SILHOUETTE

I've always admired those turn-of-the-century artists with scissors who, snipping away at black paper, created lovely silhouette portraits and even created scenes which told a complete story with utter simplicity. If you have a chance to view some of their works, do so.

Everyone is geared to recognize silhouettes. At a distance, for instance, you recognize a person by his or her identifying silhouette, long before facial features confirm the person's identity. Soldiers are trained to identify airplanes and ships by their silhouettes. It is important, therefore, that you tell the story with the silhouette. Figure 3-38 shows two silhouettes of a pear,

but which one clearly identifies it as a pear? Somehow, you may forget the importance of silhouette messages, in your involvement with detail rendering and getting the drawing and painting correct as *you* see it rather than as it is best seen.

Figure 3-39 gives you some masterful examples of clearly told silhouette stories done by commercial artists. To become more aware of silhouette importance, take a bottle of India ink, a small round brush, and some bond paper. Now, make a few clear, storytelling silhouettes of everyday objects around you: a coffee pot, a mug, a lamp, the telephone. Next, take a figurine and rotate it to select an angle which clearly explains its

Figure 3-38. Which one of these two silhouettes tells you the subject is indeed a pear? It is important to select your subject's best story-telling angle.

Figure 3-39. Here are some excellent examples of storytelling silhouettes found in newspapers and advertisements. Commercial illustrators are well aware of the importance of silhouettes.

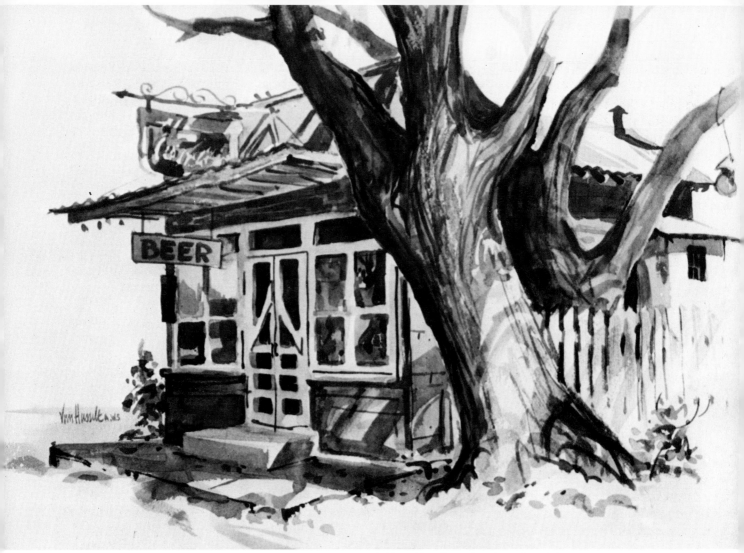

Figure 3-40. *Hill Country Friends.* 15 x 22 in. (38 x 56 cm). I pictured this subject from the selected angle because the silhouette clearly explains the overhang's function. A frontal view, as diagramed in Figure 3-34, would not have been a good storytelling silhouette.

message in silhouette. How would you silhouette a person digging a ditch? Think of other examples and look for good silhouettes in the newspapers.

Out in the field, this practice and awareness pays off. You will want to become fully acquainted with your subject by walking all around it and exploring all its angles and outlines. Select the best angle, the one that tells the story, as seen in *Hill Country Friends* (Figure 3-40). Would it be better to eliminate a confusing background shape? See Figures 3-41 and 3-42 for examples.

Figure 3-41. Here's a typical example of how one part of a subject can rob another part of its interesting silhouette. In such a case, don't copy nature verbatim. Instead, I suggest eliminating or reducing one shape, the dark tree, to allow the other, the balcony, to be well displayed.

Figure 3-42. This lovely subject of an abandoned house is robbed of its storytelling silhouette by the distant mountain shapes. What is your solution to this one?

PLANNING AHEAD

Let's assume you have found your subject and you're excited about painting it. You are eager to whip out a piece of paper and start throwing paint. Unfortunately, however, when you start that way, chances are you'll become frustrated quickly by some error in drawing or composition or placement of the focal point. You know better, but it's still easy to get trapped. But with watercolor, once you begin, you are committed; you either have to go on or start over.

It is wise, therefore, to do some advance planning. You're used to planning when it comes to other things—a dinner, a trip, a decor, a house, a campaign. Yet, somehow, when it comes to painting, most beginners just expect to sit down and create a masterpiece without any prior plans whatsoever. That really is rather silly, if you think about it. I often hear, "Oh yes, but if I do all that planning, I'll never get around to painting." That sounds familiar, because yours truly said the same thing for too long. Every painter I had ever studied with emphasized some form of advance planning, but somehow, that didn't apply to me. I just wanted to paint. Slowly, however, I came around and even developed my own quick way to preplan, so I could maintain that original excitement when I actually started painting.

Before I explain my method, however, have a look at my sketchbook, shown in Figure 3-43. Which page reads the clearest? I hope you'll agree that it is the left one, the page with the nice white border around the sketches. They are enclosed by a containment line, as I call it. The border acts as a frame or mat around the sketch. The sketches on the right run into each other's dark and light patterns and blend directly into the background, not allowing any breathing space or rest area.

Figure 3-43. Start with good habits. Place a containment line around your sketch so that it looks as if it were in a mat, as shown on the left-hand page of my sketchbook. The right-hand-page sketches don't have borders, and so their compositional patterns run into each other. This is a frequently made mistake.

"That's a minor thing," you may say. But all those little things add up and can confuse your good compositional sense. Try a containment line around your sketch. It is a good habit to get into!

For my preplanning sketches, I use a big round brush. The #30 round white sable Goliath, manufactured by Robert Simmons, is such a big brush that I can't possibly render details with it on a postcard-size sketch. I cannot be trapped into rendering wood textures, bark, leaves, blades of grass, or window panes. If I did my sketch in pencil, I might be tempted to do just that. The paint I use is either a gray or black, or a mixture of burnt umber and ultramarine blue, all diluted to a mid-value gray. By not going to full color, you avoid the danger of doing cute little miniature paintings. Instead, you should be after a road map for the entire painting—a blueprint of what needs to be done where. That's after all the purpose of the preparatory sketch. Timing is important as well. Keep that sketch to five minutes and you can't possibly be tempted to render details.

Basically, I have two approaches, and which one I use depends on the type of day it is. Both are quick because I like to keep the preparatory time to a minimum so that excitement and enthusiasm remain for the actual painting. Too often, students labor over a preparatory sketch all morning and become too tired to even begin the actual painting.

THE PATTERN SKETCH

For the sunny day, I developed what I thought a rather original approach, then found that artists have used this method for centuries and called it chiaroscuro. So much for originality. At any rate, I squint at my subject, Figure 3-44, and with a medium gray value, I factually record all shadow shapes, as in Figure 3-45. I don't bother with details within those shadows but treat the whole shape in a flat manner. All sunlit areas are ignored and left as just untouched paper. There will, of course, be some questionable areas, such as sunlit foliage against the sky. Although these areas may be in sunlight, they should also be recorded in a medium gray wash because of their dark value.

Actually, what we now have is similar to a high-contrast photograph, except that the sketch is at mid-value instead of black (see Figure 3-46). Compare the subject, the high-contrast photograph, and the pattern sketch of the same subject, and you'll see the similarities.

Most of my pattern sketches are done directly with the brush, but for the more complicated ones, I use a bit of pencil drawing just to indicate where things go. The more you draw directly with the brush, the easier this

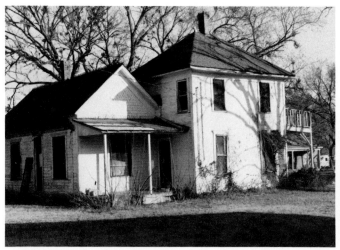

Figure 3-44. This subject contains the three basic building blocks, arranged in a pleasing manner. With some readjustments, it could become an interesting composition.

Figure 3-45. On a sunny day, the pattern sketch freezes the sun's action, so you know what shapes your shadows had at the start of your painting. In a flat, medium gray wash, I indicate all shadow shapes, completely ignoring the sunlit areas. Sticking to that flat mid-value, I can't indicate any confusing details within the shadow areas. Dark local values in sunlight, such as the windows and distant foliage, must also be indicated in this flat, mid-value wash.

method gets and the more aware you become of the interaction of positive and negative shapes.

THE VALUE SKETCH

Since the pattern sketch relies on shadows and cast shadows and since those don't exist on an overcast day, on that type of day you will need to use a full-value sketch, as seen in Figure 3-47. I still start at mid-value, and then I add the lighter and darker tones where needed, as well as adjust the mid-values to form correct relationships with each other. Squint at your subject and at your sketch. They should look alike.

Figure 3-46. Here is a high-contrast photograph of the scene. In your pattern sketch you should record the same thing at mid-value.

Figure 3-47. When there are no shadows, such as on an overcast day, I resort to a full-value sketch instead of the mid-value pattern sketch. I still start with the mid-values but add lighter and darker values, while readjusting some of the mid-values. Squint at your subject and at the value sketch. They should look alike.

THERE'S MORE THAN ONE VIEW

By using a big brush and indicating only general values and shapes, not rendering details, these sketches can be done quite rapidly. Try to do one in five minutes, and never limit yourself to doing just one. After the first one, take another look and see if there is a more unusual and different way the subject can be presented. Don't be too quickly satisfied with a portrait of a building. How would it look pushed back a bit and featuring a larger foreground? Or if there is an interesting sky available, how about featuring it and making the building a bit smaller? What would happen if you just showed a section of the building and its exciting textures? See Figure 3-48 for examples.

At five minutes per sketch, you're facing a fifteen- to twenty-minute preparatory period which acquaints you with the subject's framework and how different value shapes lock together. If you think five minutes per sketch is an impossibility, mix up some mid-value gray, and on any kind of ordinary paper, *do* a pattern sketch with that big round brush. First copy mine, Figure 3-45, and then take a pick of the best photographs in this chapter and do more sketches. You'll soon be convinced that five minutes is a realistic goal, and you will still have enthusiasm for the actual painting.

THE INFORMATIONAL SKETCH

With the open landscape or simple barn shape, the pattern or value sketch does not present any major problems. However, many students experience difficulties using that big round brush when facing a complicated architectural construction such as the example used. That type of subject may not give enough structural information in the pattern sketch.

Although you can see the construction on the spot and can take photographs, I suggest that you make a simple line drawing. Figure 3-49 shows direction, size relationship, and information that clarifies what actually is going on—how pieces join and fit together. Don't be tempted into modeling with shade and shadow; you have your pattern sketch for that. A sketch of this nature can be extremely helpful in case you get rained out and have to continue the painting in the studio. Being involved with the linear construction of whatever you are painting makes you understand it better than depressing a button on a camera. Unless you take Polaroids, the photographs of your subject won't be ready immediately—yet you are in that excited stage where you just have to continue working on your painting. A linear sketch is quite a help at such times. The more you know about a subject, the better you can paint it and, more importantly, the more authoritatively you can eliminate the unessential.

If you wish, you may combine the linear sketch with the pattern or value sketch by first drawing all the linear constructions and then switching to a round brush for the shadow patterns falling on the subject. Figure 3-50 explains the procedure.

WHY PREPLAN?

Let me explain why I preplan and the benefits received from those plans:

1) I "freeze" the sun's action by recording the shadow shapes exactly as they are when starting, and I stick with them throughout the painting process.

Figure 3-48. Don't just do one preparatory sketch; try some more imaginative compositions as well. Try a foreground painting, or if an interesting sky is available, incorporate it. How about a closeup view? Already you have four compositions from just one angle. Imagine the number of possibilities if you consider the different sides of the building, times of day, seasons, and weather conditions—and that's not even considering different painting styles or mediums.

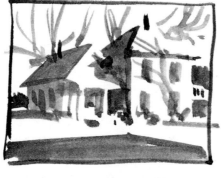
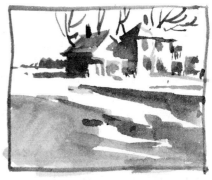
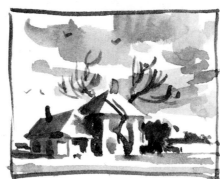
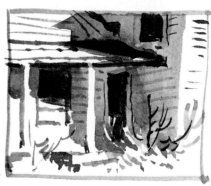

Figure 3-49. When a pattern or value sketch is not clear on details, a simple line drawing will give constructional information. In case you suddenly have to stop painting on the spot, such a sketch is invaluable for reference later on inside. Don't add penciled shading to this drawing, since that information is already on your pattern sketch.

Figure 3-50. If you wish, you can combine the linear sketch with the pattern or value sketch by painting tones over your pencil drawing. When a pencil is used for shading, it is easy to get sidetracked into rendering small details, which are not needed in a preparatory sketch.

2) My sketch functions as an early warning system for problem areas ahead. How will I be able to handle that big empty area? How can I create a difference between masses if their values are equal? Is this really the best viewpoint or should I use another approach? Those are some of the questions I ask myself while looking at the sketch.

3) The sketch becomes a first-impression view of what the final picture will look like. Is the composition balanced? Is it spotty? How can I eliminate that problem?

4) My sketch can stimulate excitement and enthusiasm for a subject or area where, on first contact, I didn't see much to paint. If an area isn't exciting, I still do some planning sketches and see how shapes develop interest on their own. Before I know it, I've found a composition that indeed inspires me to go ahead and get started.

5) The planning sketches are mine to keep. I might sell the painting, but with the help of my sketches and photographic backup, I can redo that subject . . . or try another approach.

HELP FROM THE CAMERA

The camera can be a wonderful assistant as long as you remain in charge and don't become a slave to it. It can recall details, but you must decide if such details add or detract, or if they are needed at all. I try to take photographs of all my subjects, but more as a security blanket than anything else. I seldom paint from them in the studio, since most of my paintings are done outside and only finished inside. I refer to slides only if I have a problem area where I don't know what to do. I then consult the photograph to see what it suggests.

Too many amateurs use a photograph as if transcribing a text verbatim; they copy a slide without having personally seen the subject. There has to be some direct involvement, some dialogue between the subject and the artist. Often, we see paintings with large dark shapes rendered in a flat black tone, only because the reference photograph had no information to offer in that underexposed shadow area. If you feel like painting at home, it would be more valuable to set up a still life than to project a slide. That would be direct contact: the still life and your eye. With a slide, on the other hand, it would be the scene, the camera, the length of exposure, the film, the development, the projection method, and then your eye. There would be too many chances for something to get lost in translation. To sum up, use the camera but use it wisely. Let the camera gather information for you, but it is your own involvement that means the most.

TYPES OF CAMERAS. Since I'm not mechanically inclined, I need a simple camera. Previously, I used a Polaroid with black-and-white film, but only for quick records of shadow patterns. Don't even think of using instant color film as an accurate color guide—a lot more research is needed in that area.

At present, I use a good 35mm single-lens reflex camera with all the most complicated features, but with its automatic setting, it is easy to use. It has given me good results since I became acquainted with what the automatic setting would and would not do. Now, I just focus and shoot. However, I do take two shots: one according to the automatic setting as well as one with an overexposure setting, so that I can see what happens in the dark shadow areas.

There are many good cameras on the market with all types of fancy features. For an artist, I would recommend one like mine, making sure that the automatic setting has a shutter-speed priority. You seldom need a flash unit, but a telephoto lens is great for zeroing in on areas or taking unobtrusive photographs of people in action poses.

Since slides seem more economical to develop than prints, I use them almost exclusively with a rear-projection viewer. Once in a while, I make prints from a few select slides, if they are really needed.

SOMETIMES, DIVE IN DIRECT

Although I do stress preliminary work and firmly believe in it, there are times when I like to be freewheeling and dive directly into a painting without preliminary studies on paper. However, let me hasten to explain that the studies are done in my mind. I walk around slowly, observing everything, looking at value contrasts, becoming aware of compositional problems, dominance, and balance. In short, I'm *mentally* painting the scene.

That approach is backed by years of experience and years of making mistakes. If you have been through enough problems, you learn to spot them early. You learn how to cope with them. You even learn that some subjects just cannot be painted. In short, if I dive into a painting without a preliminary sketch, I take a chance but not as great a one as I took when I was a beginner. And if I fail, it is no big deal. A flop is not a life-and-death matter; if you have had enough successes, a flop can be taken in stride. You pick yourself up once again, take another look at just how the subject ought to be approached, and—you guessed it—do some preliminary sketches. I consider my freewheeling flop a preliminary sketch as well. A mistake is never a loss if you learn from it. Somewhere I read that the best writers have the largest wastebaskets. Similarly, I could say that the best

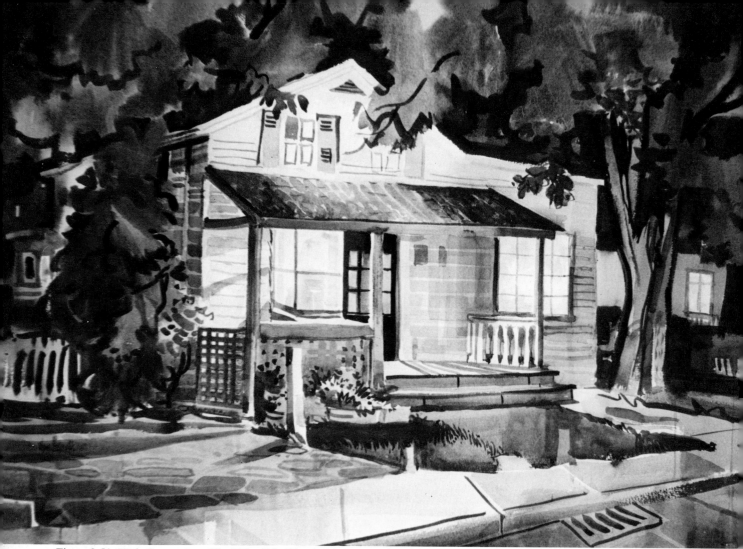

Figure 3-51. *Night Impressions.* 22 x 30 in. (56 x 76 cm). It is fun to paint night scenes on the spot, if there's at least some available light. Being thoroughly familiar with your palette setup, knowing what color is where, will certainly increase your chances of success.

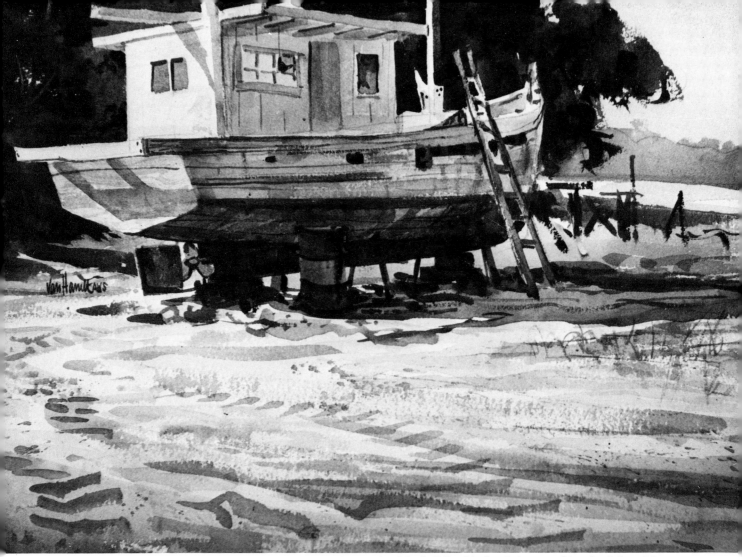

Figure 3-52. *The Price Is Right*. 15 x 22 in. (38 x 56 cm). Here's a good example of the building blocks of picture making. Look for subjects that have these strong, clearly stated value contrasts, arranged into interesting patterns of light and dark.

painters own the largest stacks of mistakes. So, relax, dive in, and make mistakes—and please make some honest whoppers.

Watercolor and spontaneity are synonymous. Granted, a professional's spontaneous effort may be more polished than a beginner's. Sometimes, however, the slick, well-handled approach actually lacks the spontaneity observed in the works of less experienced painters. While judging shows, I've noticed that the well-painted works actually blend together unless the subject matter is truly outstanding. The less pretentious paintings that still have a spontaneous message are the ones I remember, even if they are more awkwardly handled. I would rather see a direct statement with obvious errors than a beaten-to-death mumble of details.

In conclusion, therefore, don't feel guilty if you want to get something out of your system. Do it! Spend thirty minutes on a "quickie" to keep it direct and spontaneous. But keep in mind that it is just a quickie, nothing serious. If it comes off, great! If it doesn't, so what? You've only lost thirty minutes and have lots of time to more carefully evaluate everything. Try a pattern or value sketch for the more safe-and-sure approach. But don't ever let it become a drag. Watercolor is too much fun for that.

Chapter 4
Outdoor Techniques and Attitudes

I n the comfort of the studio, you can place a wash over an area, think about it, have a cup of coffee or a cigarette, and then place another wash over some other area. You work from sketches, slides, or a still life, and light conditions have either been established or are constant. Outdoors, on the other hand, there is little time to mull things over. You need to act and *move*, because the sun moves. Shadows constantly change, so you need an approach that enables you to quickly catch the subject. Watercolor gives you such an approach, if it is used in a manner suitable to the outdoors. Don't get stuck rendering small details, but instead, quickly establish the big relationships of areas, values, and colors all over your paper. Once those relationships are established, you then add modifying washes and details on top and, in that manner, bring the total painting to a finish at the same time.

If you start "embroidering" a small area while most of the paper is still untouched, your subject's shadows will have changed completely by the time you are ready to tackle another area. Besides that, you can't judge if a finished section is correct by relating it to white paper. That can only be done once the colors and values next to it have been established. Never finish one area first and then go on to begin and finish another one. Keep all your areas at similar stages of progress.

In this chapter, I would like to clarify the difference between an opaque approach and watercolor's transparent one. Then, you'll explore some major guidelines which take advantage of that unique transparency and help you establish a logical method for painting outdoors. You'll take a look at drawing, use of the brush, and some special techniques, as well as typical problems and solutions to them.

THE TRANSPARENT DIFFERENCE

The major difference between an opaque medium and watercolor is the latter's transparency which enables you to use a different and faster working method. Let's, for example, take a simple adobe building and paint it in a typical opaque manner as well as with an ideal watercolor technique (See Figure 4-1). When painting opaquely, it is logical to mix a basic color for an area and apply that mixture only within that area and similarly colored areas—but nowhere else. Another color is mixed and placed in the area next to the first, until a patchwork of colors and values is established to complete the painting.

In comparison, transparent watercolor should be thought of as layers of different glazes *on top of* each other. Painting the adobe in watercolor, therefore, you mix the lightest tone and place it *over the entire* building, adding darker glazes over this first tone. Look again at the last few italicized words, because they are the key. Opaque paint places mixtures next to each other, a section at a time; transparency means the mixtures are placed *on top of* each other, *over large areas*.

Sure, you can paint watercolor in sections, the same way an oil painter works or the way you used to paint in coloring books, slowly making sure that two color areas meet but don't overlap. But why miss out on watercolor's transparent advantage? It enables you to face the painting in a bolder manner and automatically unifies colors for you. You don't have to tightly paint little sections. Instead, you can place a loose transparent wash ove the entire painting. You don't have to worry about losing your drawing as you would with an opaque medium. Because of watercolor's transparency, your drawing will show through your washes. There's no need to

OPAQUE

WATERCOLOR

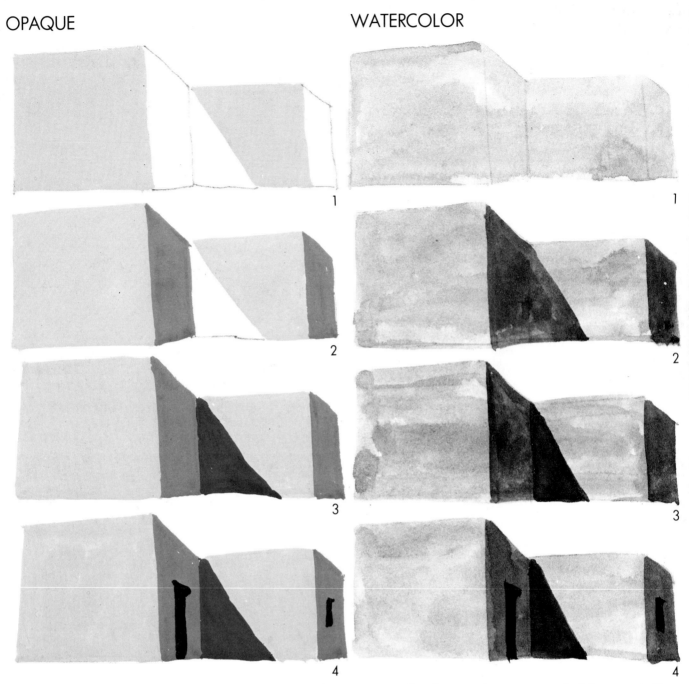

Figure 4-1. This diagram shows the method of a painter working in an opaque medium in comparison to a watercolorist's approach. Although I have oversimplified the opaque approach, both techniques are logical for the medium to which they apply.

1. The opaque painter mixes the sunny adobe value and places it just on the areas in sunlight. The other areas remain untouched.
2. The darker shadow value is mixed and applied in the shadow areas. The cast shadow remains untouched since it is even darker.
3. The cast shadow value is mixed and applied in its proper place, next to the shadow and the light area.
4. Darker details are added on top.

1. The watercolorist mixes the sunny value and washes it over the entire building.
2. The shadow value is mixed and glazed over both shadow and cast shadow areas.
3. The cast shadow is glazed over the earlier established shadow.
4. Darker details are added on top.

paint to the outline of a dark tree and stop there, as seen in Figure 4-2. Paint over everything first, and then state the dark tree with a glaze on top. Transparent watercolor enables you to think big—to wash a sky tone right over an area where you will later establish a tree or mountain range. In a transparent medium, does it hurt to have a blue wash continued underneath the green-clad mountain? Probably not, since green is partly made from blue anyway.

Figure 4-2. There is no need to paint exactly to the outline of a dark tree. With transparent watercolor, you won't lose your drawing, so paint your first wash over everything and state the dark tree with a glaze on top, as seen in the bottom diagram.

So, don't make watercolor more difficult than it is. Instead, paint in a logical outdoor manner, which means that you constantly ask yourself, "Can I take this wash over a larger area than I had planned to, and would it hurt to have it underneath the other colors?" In the Southwest, for instance, mesa-topped mountains erode into valleys and plains where people, in turn, add straw to the earth and make adobes for their home. Do you see how unity of color is established in such a case?

Could you therefore take the lightest warm-orange glaze and wash it over the entire land area? If you do, chances are that you will have a more unified watercolor than someone who approaches it all piecemeal, rendering each section one at a time. I know that as a result you'll paint more loosely and more rapidly, because you're painting in a logical manner suited for the ever-changing outdoor scene.

FOUR GUIDELINES

Be wary of someone who gives you rules and absolutes in art. There are few rules and even they can be broken. There are, however, some approaches which have so many applications and are so often used that they can safely function as guidelines. For painting outdoors, I suggest four guidelines and will discuss them in the order of their importance.

TWO MAJOR GUIDELINES. *Paint from light values to dark ones*. You simply can't start out with a dark tone and glaze a lighter tone over it to make the dark lighter. But you can put down a light tone and add layers on top to darken it. This is almost a rule, but some painters like to start with a few small dark areas so that they can relate other values to them. If you have white paper on one end of the value scale and your darkest dark on the other end, you are better able to judge the intermediate values. Painting light to dark is a safe guideline and logical in watercolor because of the medium's transparency. This is basic, so let's go on to the next guideline which needs to be applied in conjunction with this first one.

Paint from large areas to small ones. Take another look at the adobe building in Figure 4-1. In the first step, the lightest tone covered the whole building. That's a large area. In the last step, on the other hand, the door is a small area, as well as a dark one. The guideline here is a crucial one if you want to have better color unity, be less tight, and increase your painting speed. Begin to work all over the paper instead of embroidering in one area. See how the two major guidelines work in conjunction with each other. Look at Figure 4-3, where first the lightest water reflection is painted all over, then the smaller, darker areas, and finally, the darkest and smallest areas. On the tree in Figure 4-4, a light wash is placed over the *whole* silhouette, establishing its identifying character. Then the darker, smaller tones give you an idea where the light is coming from. The darkest areas are again the smaller ones. Many beginners tend to paint a tree as it grows; first the trunk and branches, then adding leaves. That is logical for a botanist but not for a painter, because a painter

Figure 4-3. Paint from light values to dark ones. The lightest water reflection is painted all over. Then the smaller, darker areas are added on top.

Figure 4-4. Paint from large areas to small ones. A large light wash is placed over the whole silhouette of the tree, establishing its identifying character. Then the darker, smaller areas are glazed on top to give you an idea of where the light is coming from. The darker areas are the smaller ones. In summer, don't paint the trunk and branches first. The foliage is the largest and lightest area.

deals with exterior volume. In summer, the largest area of a tree is the foliage, while the trunk and branches are smaller and more than likely darker. Paint large to small, light to dark!

These guidelines can also be used in painting figures. Figure 4-5 shows that you can take the lightest tone and paint the entire silhouetted action pose of a person, then come back and paint in the smaller and darker pieces.

The cup in Figure 4-6 uses the same principles with the exception that it cuts around and saves the highlights. After that, the darker and smaller pieces are laid on top of the first big wash.

In summary, get into the habit of locating the lightest value in an object or in your total painting. Take that first wash over the largest area possible and lay successively smaller and darker layers on top. I use this quick and logical working method almost every time. See *Calle Fernandel de Madrid* (Figure 4-7) and *The Saw-*

mill (Figure 4-8). Only on a very damp day, when washes are slow in drying, do I change this approach, as seen in *City Reflections*, the demonstration painting of the rainy-day subject in Chapter Six.

TWO MINOR GUIDELINES. *Paint from soft edges to hard ones.* When working in a fluid, big manner, this third guideline is, again, rather logical. When you are in the big wash stages, everything is wet. As soon as another stroke of paint is added, it diffuses into that wet area. That's how you make a soft edge. *The wetter the paper, the softer the edge.* Hard edges occur when the paper is dry. See Figure 4-9 for an illustration of that point. Since you don't have the same textural quality in watercolor as in oil, edge quality is very important. Use both hard and soft edges to express the item you are painting. Think of clouds and you know most of their edges should be soft. Rocks should be hard; trees and shrubbery, soft; buildings, hard; and so forth. How

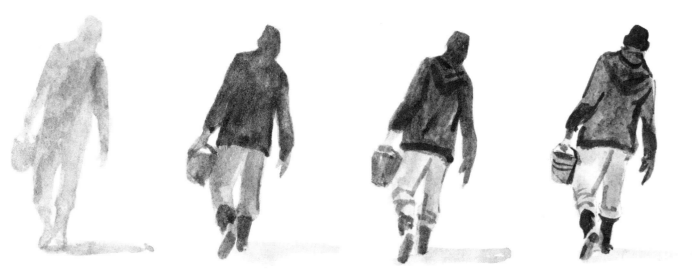

Figure 4-5. The first two guidelines apply to painting figures as well. Find the lightest value within a figure and paint the whole silhouetted action pose with that first wash. Then come back to paint the smaller and darker pieces.

Figure 4-6. Paint from soft edges to hard ones. Although the first light wash cuts around the highlights of the cup, it also serves as a wet base in which you can float darker values, which diffuse softly to form the cup's roundness.

about water? Grass? A boat? With some items, you'll have to use both hard and soft edges.

The center of interest is affected by how soft or hard an edge you use. The hard edge has a sharp, in-focus look. This is a great device to tell the viewer what is the focal point, the star of the show. The rest of the painting could be the less-in-focus, softer-edged supporting cast.

To progress from soft edges to hard ones is natural if you use the first two guidelines. When you paint the lightest value, the sky for instance, you can immediately establish your soft-edged shapes, the cloud forms. Distant tree shapes can be softly stated within the big, wet mountain shape. When the surface is wet, soft-edged items diffuse. The more the paper dries, the less the colors diffuse, and the harder your edges become. From the diffused blur to the crisp edge—a logical procedure for the outdoor watercolorist.

Paint from beautiful colors to dull ones. The fourth guideline is a minor one but not because it does not apply often. It is more an if-the-shoe-fits thought to keep in mind. What does this guideline mean? As beginners, you may tend to look too carefully. You may spend too much effort analyzing exactly what colors you are seeing. You may not know how to mix that precise color and dab back and forth between wells. You may over-mix and start off with too neutral a wash. Using a strike-off sheet—trying the color on a white sheet of paper— does not help either, because you relate the mixture to its white surroundings instead of the colors that will actually surround it.

We're all quite good at making dull, muddy colors. So let's save the easy part, the part we know how to do, to the last and try starting with pleasant colors instead. Take another look at those nice, fresh tube paints and remember that watercolor is a glazing medium. You don't need to mix an exact color on the first try, because

Figure 4-7. *Calle Fernandel de Madrid.* 11 x 15 in. (28 x 38 cm). With the first washes in this painting I indicated the lightest shadow areas on the white wall. I added darker, smaller washes on top and, lastly, the figure.

Figure 4-8. *The Sawmill.* 15 x 22 in. (38 x 56 cm). I first established the light outside washes over the whole painting surface. Next, I painted the lightest values and colors within the dark over all of the inside areas. Successively smaller and darker areas were added on top.

Figure 4-9. When the paper is wet, paint will diffuse, creating a soft edge. When the paper is dry, a sharp, hard edge will result. A hard edge can be softened by adding clear water only while the stroke is still wet. Once the paint is dry, the edge can be softened by scrubbing with a bristle brush.

any glaze on top will alter that color. I have a tendency to overstate my colors in the early part of a painting and then, as the work progresses, take a neutralizing glaze to kill an overly bright spot. That bright jewel will still glow under its tempering veil however. Remember, you can always muddy up a nice color but seldom brighten up a muddy one.

As in *It Had to Go* (Figure 4-10), I may start painting a dull, gray house with a mauve mixture, on top of which I paint successive layers to modify the attractive first color. Why start off with a dead gray, if you can obtain a richer one by overlapping two or three colors? The result will be much livelier. That is why I am against tubes of gray. Too many students depend on gray to neutralize, and lifeless paintings result.

There are two opposing camps in representational painting: the colorists and the value painters. Value painters argue that any color will do, as long as the values are right. They are correct. Colorists, on the other hand, contend that if a color is right, the value has to be right. Also true. However, colorists have a tendency to get so enthralled with their color modulations that they forget the carrying power of values. I suggest you stay somewhere in the middle, trying to get attractive colors and strong values at the same time.

THE DRAWING STAGE

I have been known to confiscate pencils from the students who so masterfully draw all details on every section of their paper. Commercial artists and architects often fit into that category, but anyone good in drawing has a tendency to overdraw. While painting, the draftsmen tend to be too careful, filling in between the lines—treating areas piecemeal instead of unifying the whole painting with a few basic washes, much as sunlight spreads over a whole landscape.

Draw as little as possible with the pencil. Instead, draw with the brush. That's painting! The demonstration pages in Chapter Six show you how little I draw—only the essentials. Draw where things go, rather than what they are. Sometimes I'll place a line to remind myself to save a white or to indicate the side of a house or a window space, but I never draw the small details. Those will be painted in. Please remember that every time you touch the paper with the fingers or heel of your hand, a slightly oily film remains, which can act as a resist for future washes. This is another reason for holding your pencil as explained in Chapter Two.

On the other extreme are the unsure beginners, who face the paper with ruler and eraser, "worrying" a drawing onto it. They fuss and erase and, in the meantime, thoroughly damage the paper's surface. Everyone goes through that stage of learning. It is a normal stage in artistic development. The only way you learn to draw is by drawing. It is nothing but learning to judge where and how one line intersects with another and recognizing positive and negative shapes. I strongly urge you to read *Drawing on the Right Side of the Brain* by Betty Edwards, as listed in the bibliography, and do all its exercises. Don't bother setting up a perfect still life. Draw a corner of your room, the items on the breakfast table, or your desk. Keep a pad in the car or on the coffee table; keep it anywhere you are likely to spend some free time, and use that time to draw whatever is in front of you. Stay away from doing any shading, since that applies to the painting stage. I just want you to become more confident in drawing the select few lines that will guide your brush during the painting stage. Draw with easy, flowing lines, using arm and body movements instead of just the wrist. With enough of the right practice, you too can draw! Dr. Edwards has certainly proven that.

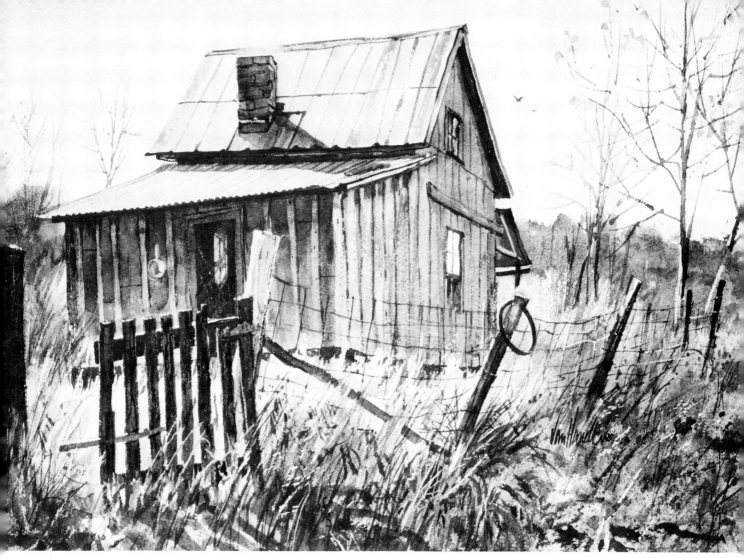

Figure 4-10. *It Had to Go.* 15 x 22 in. (38 x 56 cm). This weatherbeaten house could easily have been established with a Payne's gray wash, but I always prefer working from beautiful colors to dull ones. I painted successive layers of nice colors over a first wash of mauve to obtain a lively gray.

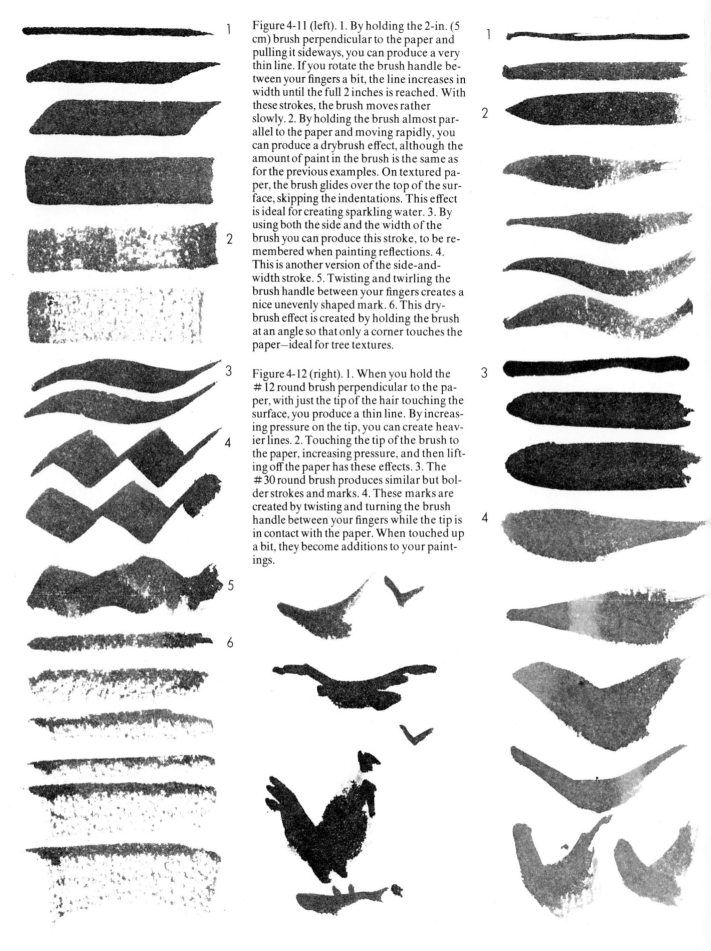

Figure 4-11 (left). 1. By holding the 2-in. (5 cm) brush perpendicular to the paper and pulling it sideways, you can produce a very thin line. If you rotate the brush handle between your fingers a bit, the line increases in width until the full 2 inches is reached. With these strokes, the brush moves rather slowly. 2. By holding the brush almost parallel to the paper and moving rapidly, you can produce a drybrush effect, although the amount of paint in the brush is the same as for the previous examples. On textured paper, the brush glides over the top of the surface, skipping the indentations. This effect is ideal for creating sparkling water. 3. By using both the side and the width of the brush you can produce this stroke, to be remembered when painting reflections. 4. This is another version of the side-and-width stroke. 5. Twisting and twirling the brush handle between your fingers creates a nice unevenly shaped mark. 6. This drybrush effect is created by holding the brush at an angle so that only a corner touches the paper—ideal for tree textures.

Figure 4-12 (right). 1. When you hold the #12 round brush perpendicular to the paper, with just the tip of the hair touching the surface, you produce a thin line. By increasing pressure on the tip, you can create heavier lines. 2. Touching the tip of the brush to the paper, increasing pressure, and then lifting off the paper has these effects. 3. The #30 round brush produces similar but bolder strokes and marks. 4. These marks are created by twisting and turning the brush handle between your fingers while the tip is in contact with the paper. When touched up a bit, they become additions to your paintings.

USING THE BRUSH

Avoid holding your brush like a pen, at the very tip. Other than that, there is no certain way to hold it. You can flip your brush, twist it, go against the hair direction, or smoothly stroke with it. Your very use of the brush becomes your handwriting by which others will recognize your work. The brush is the interpreter of your feelings. The same brush in the hands of an experienced artist can speak a fluid language of its own, while in the hands of a beginner, it may haltingly stutter its way across the paper. Other than some of the basic brush exercises seen in Figures 4-11 through 4-13, brush handling is strictly up to you. Remember—it's not the brush that creates results, it's the thinking behind it. It is the color and value of the paint *in* the brush that counts.

Since most people are tempted to render details too soon and grab the smallest brush too early, I suggest you lay the brushes out like silverware, in the order of use. First put down the biggest flat, next to it place a smaller flat, then the big rounds, and finally the detail brush. Try sticking with the largest brush as long as you can.

Figure 4-13. A long-haired brush often referred to as a rigger is the perfect brush for linear details. Twist and twirl the brush between your fingers and it will take off on its own. Watch it though, don't overdo this technique.

SPECIAL OUTDOOR TECHNIQUES

Watercolor seems to invite innovative uses of the medium. I always enjoy reading the Watercolor Page in *American Artist* magazine and learning about new and different techniques. Those articles, some of which are compiled in the book *40 Watercolorists and How They Work* by Susan E. Meyer, as listed in the bibliography, give you a good overview of methods other watercolorists use. You should know all the tricks and what they do, and then you can select or discard. Out in the field, for instance, I can't see bothering with a masking liquid. You might use it more in the studio, but there is the danger of getting too dependent on it, using masking liquid when it would be just as easy to avoid an area by cutting around it with your brush.

Here are the special techniques I use outdoors, in the order of their most frequent use.

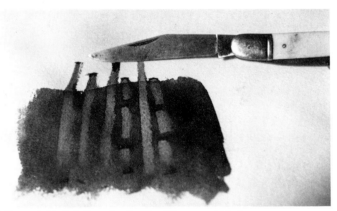

Figure 4-14. A dull pocket knife with a round blade can scrape narrow as well as wide marks. Actually, you're squeegeeing paint out of the way, rather than scraping.

SCRAPING. Scraping is done with a knife, as pictured in Figure 4-14. Actually, what I'm doing might be better described as squeegeeing paint out of the way. The effect achieved is a light line in a dark area. The trick is knowing when to scrape. My favorite answer to that question is, "At the right time." It depends on the kind of paper you're using, what the weather is like, and how heavy your wash is. You could say though that the best time to scrape would be when the wash is in a semi-dry condition—when the wet gloss is off the paper. You'll just need to practice that technique, because if you scrape too early, the paper becomes damaged and pigment will settle there to produce a dark line instead of the desired light one. And if you wait too long, the wash dries and you can scrape but nothing will happen, as seen in Figure 4-15.

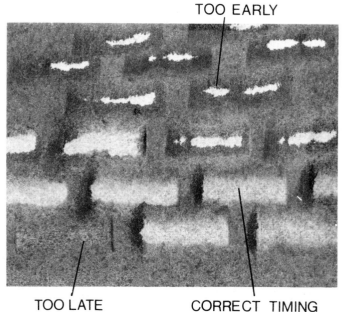

TOO EARLY

TOO LATE CORRECT TIMING

Figure 4-15. You have to learn just when to scrape. The timing should be correct if you wait just until the wet gloss is off the paper. If you scrape when the wash is too wet, you'll damage the paper and the wash will run back into the scraped area to produce dark marks instead. If you wait too long, the scraped marks will not show.

SQUEEGEEING. Provided that you have a nice, rich, and dark wash on the paper, you can—at the right time—use any type of squeegee to push paint out of an area. It establishes a light area, such as roofs or the top planes of rocks. Of course, if you squeegee on a very light, diluted wash, the effect won't be visible. Practice this technique as seen in Figure 4-16. Some artists use plastic spatulas, some use cardboard scraps. I use an expired credit card. That seems the best use for it.

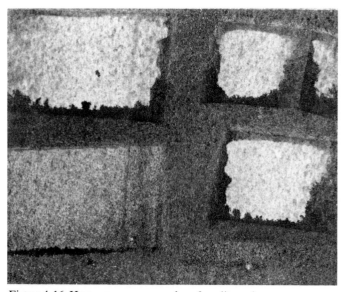

Figure 4-16. Here are some examples of credit card squeegee marks. Some were done too early, some too late. This technique is great for creating textures such as the top planes of rocks.

SPATTERING. When the surface is semi-wet, spattering can be done with clear water in a dark wash to create light, soft-edged spots. Spattering dark paint on a wet surface creates diffused dark spots. Spattering paint when the surface is dry creates textures suggesting pebbles, seed pods, and lichen. Limit your spattering to the foreground areas only, since that's where texture can be observed. Don't overdo this technique or it'll lose its effectiveness. See Figure 4-17 for examples. I use a bristle fan brush and stroke it off my fingers, as shown in Figure 4-18. In this manner, you avoid the danger of spatters falling into areas where you don't want them.

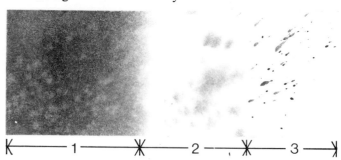

Figure 4-17. Spattering creates effects you simply can't get any other way. Section 1 shows the effect of spattering clear water into a dark, semi-wet wash; in section 2, paint was spattered onto a wet surface; and in section 3, with the same flick of brush, some spatters reached dry paper. These three different effects are possible using one bristle fan brush.

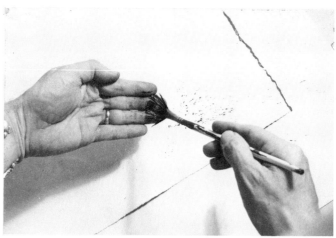

Figure 4-18. To avoid having spatters fall into areas where you don't want them, point into the lower corner of the paper and flip the loaded brush off your fingers. Keep these textural effects just in the foreground area and don't overdo them.

LIFTING. If I forget and paint right over an area which should have remained light, a tissue blotted into the still wet area will remove virtually all the unwanted paint, provided that the color isn't of a staining variety. That was done in step 1 of *The New Inhabitants*, in Chapter Six. I also use a tissue in a positive manner to "paint" the light side of a tree, some wispy clouds, or tire marks on a wet streets, as seen in *City Reflections*, step 2, in Chapter Six.

SMEARING AND FERRULE SCRAPING. To smear, I take my thumb and wipe thick, dark paint into an adjacent dry area. The effect is useful to create the soft edges of trees, as seen in Figure 4-19.

Toward the finish of a painting, to create a different textural effect, I take the 1-inch (3 cm) flat brush and, using its metal ferrule, pick up dark, almost dry paint off the palette. Holding the brush parallel to the paper, I scrape the ferrule over it to deposit the paint onto the surface. The effect is somewhat like drybrush, as seen in Figure 4-20.

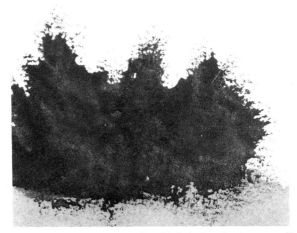

Figure 4-19. With my thumb, I wipe thick dark paint into an adjacent dry area to create a rough edge which effectively suggests foliage and weeds.

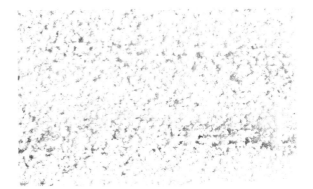

Figure 4-20. To create a different textural effect, I take the 1-in. (3 cm) flat brush and, with the metal ferrule, pick up dark, almost dry paint off the palette. Holding the brush parallel to the paper, I scrape the ferrule over the surface to deposit the paint onto it. This effect, which I use only toward the finish of a painting, is somewhat like drybrush but is more controllable.

SALT AND RESIST EFFECTS. When sprinkled into a dark and semi-wet wash, salt will absorb the wet pigment near it. When dry, you can remove the salt and create light textural effects such as those found on old walls, as seen in Figure 4-21.

Figure 4-21. Salt when sprinkled into a dark, semi-wet wash will absorb the wet pigment near it. When dry, the salt can be removed to create light textural effects such as these.

A wash will resist marks previously made with a white grease pencil or wax candle. The result will be light lines in a dark wash, as Figure 4-22 shows. I seldom use this method, but it might be the ideal way to show something like light reflections of waves dancing through the shadow side of a boat's hull.

I use these special techniques out in the field. In addition, there are other techniques more suitable for use in the studio. I will cover them in Chapter Seven.

Figure 4-22. Marks made beforehand with a white grease pencil or wax candle will resist a wash placed over them. It seems the ideal technique for those light wave reflections dancing through the shadow side of a boat's hull.

TYPICAL STAGES IN A PAINTING

Basically, there are three stages in painting: (1) the early stage, which consists of big, light washes and soft edges that fuse together all over the paper; (2) the establishment of middle and dark values as well as hard edges; and (3) the finishing details.

The early stage in any painting can be quite discouraging. It is the stage when you block in all those early washes, and nothing looks like anything yet. In fact, everything looks like a mess. Everyone has to cope with that stage—Homer did, Wyeth does, and so do you and I. It is the normal way to start. Flip over to the demonstrations in Chapter Six now, and not looking at the final results, concentrate on the first steps. Messy, right? The early stage is when so many students become discouraged and quit. Fellow painter Don Stone calls it the Crucial Stage. I call it the Blah Stage.

What usually happens is that you look at that stage and judge your work as if it were finished, instead of in its normal course of development. Steel yourself against that little inner voice telling you that you can't do it. Don't listen to negative talk. Professionals have learned to ignore that voice of doom. In fact, they don't even hear it anymore—or at least not at that time. They see the messy stage as one step toward the finish.

So take heart. Don't give up too soon. Coldly analyze instead. Remember, don't be arty. Be a light meter instead. By battling on for a little longer, you'll soon find the problem. I know there is a point of no return, when it is better to use your time and energy on another piece of paper. Before you start over, though, analyze what you have down. If all you have are light, early washes, go on! Are the light colors all running together? Go on! Only when you get to the middle dark tones and the hard edges should you begin to judge. Notice I said tones, not details. Save those details till five minutes before packing up.

KEEP YOUR EYES ON THE STAR

One of the major problems of outdoor painting is that you see too much. You find an interesting tree trunk, for instance, and you paint it lovingly. Then you shift your attention to the beautiful sky and paint it. Then on to that adorable house behind the tree. Only then do you see and paint those gorgeous flowers at the base of the tree. Before you know it, everything is in full focus; everything is painted with the same loving care as you gave the tree trunk, which was the original reason for doing the painting.

Another future invention of mine will be a neck restrainer which will keep the head immobile and feature blinders around the eyes. Once a subject is selected, the painter's head will be frozen into position, making it impossible for him or her to see the whole outdoors. Think it will sell? Until that invention is on the market, however, remember what you selected as your star subject and spend all your loving care on it. Treat all other areas as supporting actors only.

RELAX AND HAVE FUN

In painting, if you never want to make a mistake, don't touch the paper. The minute you do, you create a problem which requires the next touch for its solution, and so on through to the finish. To solve those problems, you have to be relaxed. Only if you're relaxed can you think and function properly. Like an hourglass can drop only one grain of sand at a time, so our mind seems to handle only one problem at a time. While you're busy being tense and worrying about a failure, you can't possibly concentrate on how to solve the immediate painting problem.

I would like you to try and develop a "who cares?" attitude. Ask yourself what the worst thing is that can happen if you mess up. You ruined a piece of paper, that's all. But if you look at your mistake as a stepping stone to future successes—which it is—you're ready to turn that paper over and have another try on the other side. It isn't important how many times you mess up. The important thing is how many times you pick yourself back up and try again. Quantity leads to quality. The shortest way to successful paintings are stacks of less successful ones from which you have learned something. The good paintings don't come right away, but luckily, there are those happy accidents that boost your spirits and keep you going until, gradually, they are replaced by solid knowledge.

Relax. Don't act as if you're doing a painting. Paintings are done by Artists, with a capital *A*. Call your work a sketch instead. A sketch is a little nothing you'll just throw away. So messing it up isn't as important, right? Wonder why so many sketches are more exciting than the final paintings? Because they are "just sketches." You didn't worry so much about them. You relaxed and let your mind do the job it can do alone.

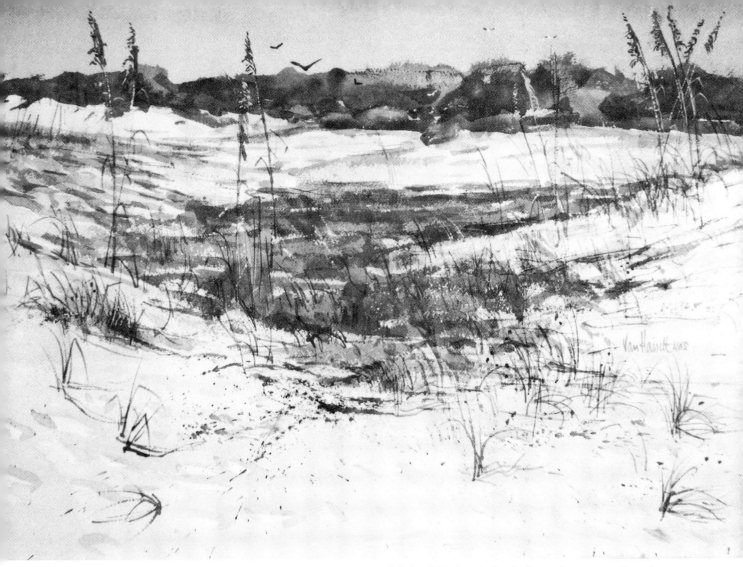

Figure 4-23. *The White Sands of Pensacola Beach.* 15 x 22 in. (38 x 56 cm). It might be difficult to find a shady spot in open terrain such as this; but with the board in an upright position, you can always have the paper in the shade. *You* will have to make do with a good shade-giving hat in such a circumstance.

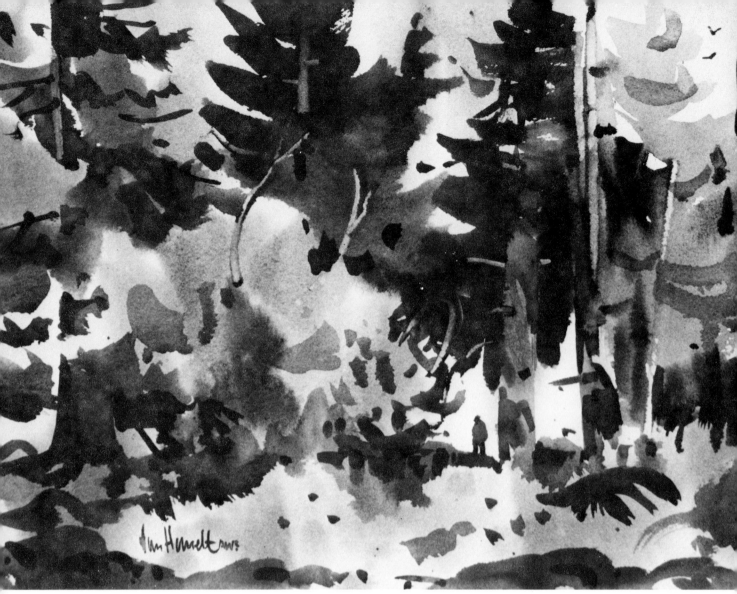

Figure 4-24. *A Woodland Walk.* 11 x 15 in. (28 x 38 cm). This very fast demonstration, which I did to get a student over the scare of painting in watercolor, has more of that medium's spontaneous sparkle than some of my more "serious" efforts. Notice the little figure I added to indicate scale.

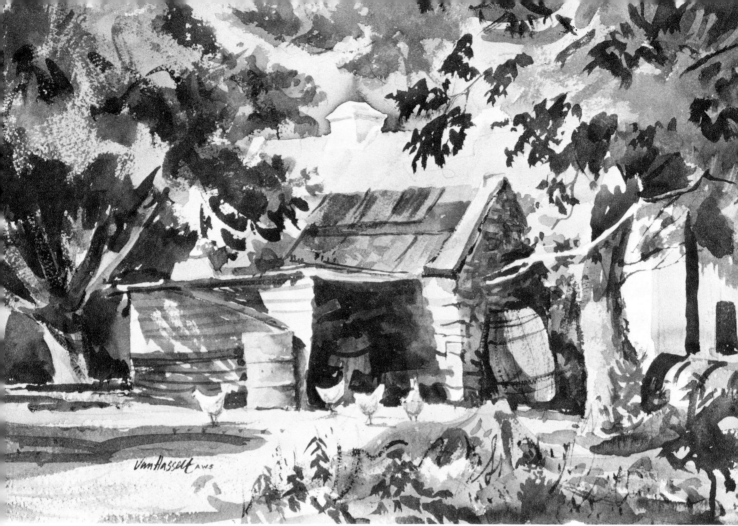

Figure 4-25. *County Mayo.* 15 x 22 in. (38 x 56 cm). Because the dark opening to the shed was quite square, I made the shape more interesting by adding the white chickens. The opening is no longer square. I could also have angled the cast shadow more to get even farther away from the square shape.

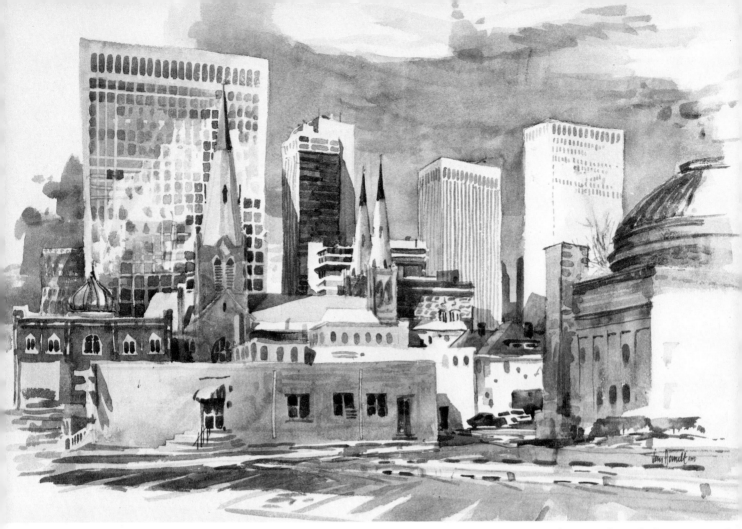

Figure 4-26. *Overshadowed.* 22 x 30 in. (56 x 76 cm). On a partly cloudy day, it is fascinating to watch a city scene change before your eyes. I left white edges to create a vignette effect, with the darks linking each other through the painting.

Chapter 5
Outdoor Color Problems

So far, we have looked at many parts of painting, but only here and there have I alluded to color. In this chapter, therefore, we'll take a closer look at what color is all about, how you can mix what you want, and how to face some recurring problems. Since correct color use is so important in creating the illusion of depth, we'll explore that field as well.

Color is such an interesting and all absorbing aspect of art that we could easily become color research scientists and forget all about painting. Many books have been dedicated to color. Some are listed in the bibliography and I urge you to study them. Once you know basic color theory, everything else will fall into place. So, let me have a go at explaining it. If it is too basic for some of you, by all means skip a few pages.

THE BASIC IDEA

The word *color* actually means three things at once. When someone asks, "What color is it?" he or she should actually ask what the family name of the color is, how light or dark it is, and how bright or dull it is. But that's too much, so instead everyone asks, "What color is it?" The answer can be misleading—imagine telling someone over the telephone that your newly purchased garment is brown. His or her mental image of that color might be shades off from yours. So you come up with cherry pink and apple-blossom white; but although the names are imaginative, they are far from accurate. Just look at paint manufacturers' colors and how some differ from others, although they have the same names.

There are several color-describing systems, the most popular of which is the Munsell system, which assigns letters and numbers to a color according to its hue, its value, and its chroma. These three qualities together give the full dimension to the word *color*. I have painted these words in the meaning which applies to them so that you can visually remember them at a glance, in Figure 5-1.

HUE. Hue refers to the family name of a color. There are only a few. Just remember Roy G. Biv (Red, Orange, Yellow, Green, Blue, Indigo, and Violet) and you've got them in the right spectrum sequence. For our purposes, let's forget about indigo, although it makes Roy's last name a bit easier to pronounce. Look around and see if you can pick the family names of surrounding objects. The clear-cut ones are easy, but what about questionable ones, such as beige? In those cases, go down the list of family names and see which hue fits the closest. For beige, the choice leaves out red, green, blue, and violet, thus giving you either yellow or orange. Take another look at your beige and decide which of the two hues comes closest to being its family.

Red, yellow, and blue are primary colors; that is, they can't be obtained by mixing one color with another. When you mix red and yellow, however, orange comes into existence. Green is created from yellow and blue, violet from blue and red. Since these are mixed from the primary colors, they're called secondary colors.

VALUE. Value simply means how light or dark a family member is. Pink, for instance, is a light-value member of the red family, while brown could be a dark-value member of the yellow family. As Figure 5-1 shows, the red family can run from the lightest-value tint to the darkest-value shade in a gradated scale.

CHROMA. Chroma, or intensity, means how bright or dull a color is. Fire-engine red tells you that it is a highly intense, bright red (subject to interpretation, however, since in my town fire engines are wine red).

Olive drab already tells you that the green is a dull one, or of low intensity. The colors in tubes of paint that you buy have optimum chroma. You can't mix a brighter red than tube red. You can only neutralize that red or reduce its intensity by adding some color from the opposite side of the color wheel (see Figure 5-2). Going back to the chart in Figure 5-1, you see the first letter of *chroma* painted bright red, while the last *a* is bright green. Those are two opposite hues. When you intermix those families, you get variations of dull red, grays, and dull green, yet all remain at their same value. *You don't change value when you change chroma.* Squint at the word and you'll see that it has an even value throughout, quite a difference from the word above it. I have chosen two opposite hues at mid-value, but could do the same with lighter or darker values of those hues, as seen in the two bars below the word chroma.

Once color's trinity of meanings is solid knowledge to you, once there is no room for misunderstanding, most of your color mixing problems will be over, and many other factors will fall into place as well. Therefore, make sure you understand the above. If you need more explanation of these basics, consult other books until you *do* understand. That's how important it is!

Figure 5-2. The color wheel wraps the spectrum colors around a circle at full intensity. Colors located across from each other, when mixed together, gray or neutralize each other. When placed *next* to each other, those same colors are enhanced. In theory, all colors mixed together make the neutral gray at the center of the wheel. There are many varieties of gray, and I prefer using the ones which lean slightly more toward the main colors from which they originated.

KNOW YOUR OPPOSITES

As you have seen, the intensity of a color is reduced by adding the color opposite it on the color wheel. You could say, therefore, that opposites gray or neutralize each other. However, opposites, or complementary colors, can also brighten each other up if they are placed next to each other instead of mixed together. Side by side, they will actually enhance each other. Two radically different goals can be achieved just by knowing which colors are opposites.

It is quite helpful, therefore, to visualize the color wheel. But if you can't remember it out there in the field, let me tell you an easier way to get the same results, based on the word *complete*, from which *complement* is derived. Go back a minute to red and green, because you know they are opposites. Breaking those two

Figure 5-1. Hue, value, and chroma are the three qualities of color. To help you remember them, I painted the words in their visual meaning. Hue, for instance, is the family name of a color as found in the spectrum. Since value refers to the lightness (tint) or darkness (shade) of a hue, I have taken the hue red and painted it in its lightest and darkest values. Chroma describes the brightness or dullness of a hue; therefore, I have intermixed a red at mid-value and its opposite on the color wheel, green, also at mid-value to cause them to lose their brightness. They neutralize each other—their chromas are lowered—but their values don't change. The hues of red and green can also be neutralized at a light or dark value, as shown in the two bars painted below the word *chroma*.

colors down to their primaries, you are really looking at red, and yellow and blue, right? And since combined red and green make gray, you can draw the conclusion that *it takes all three primaries mixed together to make a neutral gray.* With that gem of information, all you ever have to do is to find which of the three musketeers are missing, and voilà, you have found the opposite of your original color. Green, for instance, gives you two primaries: yellow and blue. To complete the three, you'll need the missing one—red. To neutralize a yellow, you look at its hue and find it only represents one of the trio. Missing are red and blue. It is true that you could add a little red and a little blue to yellow and neutralize it, but there is a shortcut, since violet already is red and blue. So violet is yellow's opposite or complementary color. Now, using this same system, how about finding the opposite of blue on your own?

HOW DO I MIX THAT COLOR?

I remember a beginners' oil painting class during which I worked back and forth on the palette, dabbing and hoping the intended color would miraculously appear. It finally did, but it sure took more work than if I had known basic color theory. The more you mix, the more you increase your chance of making mud. That's especially true in watercolor. All it takes is a few successive layers of opposites on top of each other. To keep transparency alive, it is best to obtain your desired mixture as directly as possible. One glaze is better than two, and two are better than three.

When Sir William Orpen, a famous British painter, was asked how he mixed his colors, he replied: "With brains, sir." So, to mix a color, you should ask yourself three questions and act on the answers.

1) *What hue does that color belong to?* The color brown, for example, presents a puzzle because you can't find it on the color wheel. So, you tick off the family names to track it down: eliminate blue, green, and violet; but place red, yellow, and orange on the questionable list, since all three could produce a brown. It could be a dark, neutralized red or a dark value of yellow or orange. In this example, let's pick orange as its family.

2) *How light or dark a value of that hue is it?* Brown is obviously a dark value, so in order to mix it, you have to find a way to darken the orange or reach for an orange that is already dark, such as burnt sienna or burnt umber.

3) *How bright or dull is that hue?* If it is a very bright brown, you may have to use straight sienna. If it is more neutralized, you reach for sienna's opposite and mix it into the sienna. What is the opposite?

Sometimes, there is a fourth question. If after answering the first three, the mixture does not look right yet, you may ask: What else does it need? With some mixtures, you may have to add a little more color. With others, you may have to start over by using a different tube of the same hue. For instance, you can mix a pink by diluting vermillion or alizarin crimson, but the pinks will look different: the first one will look warm and the latter cool. You can make a brown by taking scarlet lake red and mixing it with some ultramarine blue, or taking burnt sienna and neutralizing it with a blue, or using burnt umber straight (see the swatches in Figure 5-3).

As mentioned in Chapter Four, beginners tend to overmix, forgetting that they can modify a color with a glaze of a different color applied over it. So when trying to mix a specific color, keep that glazing idea in mind, as well as the fact that colors will dry duller and lighter than they appear when wet. Don't start off with too neutral a color. You can always neutralize it later.

GLAZING

As you saw earlier, you can mix colors on your palette and apply them directly to the white paper, or you can wash a color over one that's already on the paper and

Figure 5-3. There are many varieties of brown, yet there is no brown on the color wheel. Brown is theoretically a dark value of orange or yellow. Pigment characteristics, however, enable us to make browns out of reds and blues as well. Red and green can make a neutralized red which appears brown.

achieve a mixture that way. You'll probably do both in the course of a painting. Any time you add a wash to a dry surface, you're glazing. Watercolor is a glazing medium. Glazing is the watercolorist's way of neutralizing a color that is too bright or changing a hue or value. It's important to remember though, that you can never lighten a value with a glaze. You can only darken it and, as a result, lose some transparency.

To minimize that problem, it is good to know the different personalities of your tube colors. Knowing color theory is one thing, but pigments don't always behave exactly according to that theory. They all have their own traits. Some dig into the paper and won't budge once they're down. Those are the dye colors. Other pigments remain right on the surface of the paper and are easily removed. In a wash, some pigments are so light that they'll float forever, while the heavier ones clunk down into the paper's valleys and create lovely granular effects, as seen in Figure 5-4 and in *Ozark Impressions* (Figure 5-5). Some pigments are very transparent, while others are more opaque. For a good breakdown of paint characteristics, read Tom Hill's *Color for the Watercolor Painter*, as listed in the bibliography.

Experiment to see what different colors will do. You can test opacity by painting all your colors over a band of India ink, for instance, as seen in Figure 5-6. Or for a fun experiment, take some paper and just mingle colors into each other, to become acquainted with how they interact, as seen in Figure 5-7. Glazing stripes of different colors over those minglings will make you familiar with how each color affects the color underneath and how the total result looks. You can have some compositional fun by balancing these colors, glazes, and values and adding a few accents here and there. Compositional good taste is earned through such exercises.

Out in the field, in the fury of racing against the sun, we're all bound to make some mistakes, since we're concentrating on catching those changing shadows. The more you paint, though, the more aware you become of glazing the right colors over each other. Try different colors. Don't rely on the same old formula all the time—that's how ruts are formed. Experiment!

THE GRAY AREAS

As mentioned earlier, color theory is one thing and pigment behavior quite another. You may not be able to obtain a neutral gray by mixing the three primaries together. There are two schools of thought on how to neutralize colors. We are already familiar with the one that uses opposite colors. The other school works from the

1 2

3 4

Figure 5-4. To familiarize you with paint characteristics, I have done a few exercises using the staining dye color of alizarin crimson and the sedimentary color of cerulean blue. 1) I glazed a stroke of cerulean blue over a dry swatch of alizarin crimson. 2) Doing the reverse, I glazed a stroke of alizarin crimson over a dry swatch of cerulean blue. 3) Here the two colors were mixed on the palette and painted directly on the dry paper. 4) Here I mixed the two colors together on the paper.

Sedimentary colors look better when glazed over a staining one. The reverse procedure causes the staining color to dye the granules of the sedimentary color, hiding their beauty.

presumption that since the center of the color wheel is neutral gray, you can use that gray to neutralize any color, instead of always searching for an opposite color. In theory, that is logical and should work. In practice, however, there are very few painters who can keep their work alive and sparkly by using that method. It is too easy to neutralize everything with the same type of gray. Granted, we can't use all colors at full intensity, but there are an infinite variety of gray mixing possibilities. Look at the color wheel once again, but instead of concentrating on the outside rim which places colors at their maximum intensity, look at the center area instead. Dead center is neutral gray. The minute you move off center, the gray takes on the hue in the direction in which it is moving. Therefore, you can have a warm red gray, a yellow gray, a blue gray, and so on. This gives you a nice variety.

Most large areas in a painting should be somewhat

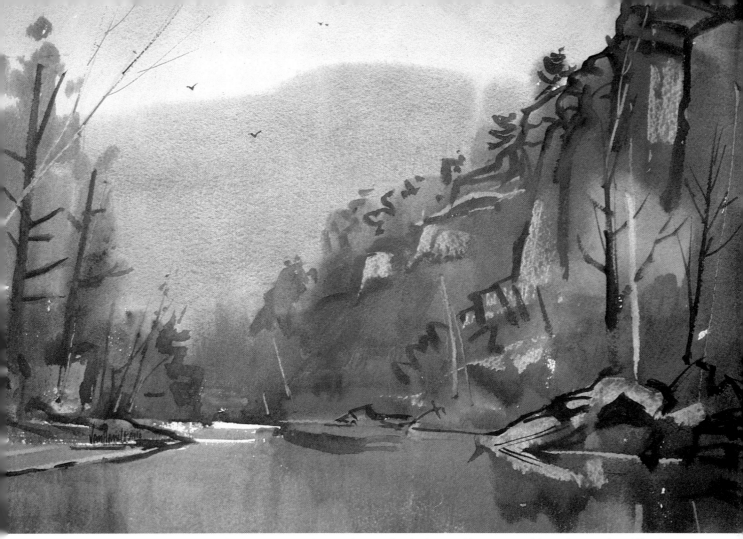

Figure 5-5. *Ozark Impressions.* 15 x 22 in. (38 x 56 cm). Here is a good example of using a sedimentary and dye color together. Alizarin crimson and cerulean blue, mixed on the palette, were used to state the distant mountain shape. Although I painted with the paper in an upright position, the sedimentary color still settled first, while the dye color traveled a bit farther down the sheet. This caused an attractive separation of the mixture at the top of the mountain.

Figure 5-6. To test the opacity of the colors on my palette, I painted a strip of India ink on my paper and then glazed the colors over the dry ink. Although the yellow and orange seem very opaque, I haven't encountered that quality in action, perhaps because the colors I use while painting are more diluted. It also surprised me to see a violet result when I glazed the phthalocyanine blue strip over the black. To see that effect more clearly, try the test for yourself.

Figure 5-7. This is a fun exercise to acquaint you with the interaction of colors. Prewetting each rectangle, I mingle two or three colors together, while keeping a dominance of one color and temperature in mind, as shown in the top four rectangles. Next, I glaze some bars of color over the dry minglings, noting the contrast of the soft-edged minglings and the hard-edged glazes. In the second row of rectangles, you can see how the glazes offset the colors underneath and produce new composite colors. The third row shows glazes overlapping glazes, changing the colors even more. You will become more aware of balancing colors and values.

In the bottom row, I've added some white paper collage and linear darks as accents, keeping balance and dominance in mind. In the first rectangle, the curvilinear S line was a mistake that does not seem to fit. The two center rectangles feature straight lines with accents of the soft, curvilinear underpainting of my first minglings. The last rectangle is a subdued but rich composition. This is a great exercise not just for glazing but for many aspects of painting.

neutralized, while small areas should be saved for the lively intense colors. The neutral grays make those intense colors sing. Look at how Mother Nature painted the animals: the parakeet is a bright splash of color while the elephant is a sedate gray.

Outdoors, I start off with a color which looks more intense than it should be, knowing that colors dry duller. Also, subsequent glazes will further reduce intensity. Again, *it is easier to dull a bright color than brighten a dull one.* I think of black as a dark gray and obtain it by mixing dark values of the three primaries, using burnt umber, alizarin crimson, and ultramarine or phthalocyanine blue. Varying the mixture can give you a warm or cool dark: adding more burnt umber or alizarin crimson will cause it to warm up, while adding more blue will cool it down.

THE LIMITED PALETTE

To get ready for the outdoor challenge, it is great to do some warming-up exercises in the studio, especially if you're new to watercolor. I've already emphasized the importance of drawing and composition, since in representational painting, they are the basis of everything. Assuming, therefore, that you have those problems relatively under control, you can then face the new medium and concentrate on its challenges.

With *one* tube of paint, such as burnt umber, you can acquaint yourself with quite a few of the watercolor techniques. Use the color's full value range by applying it thickly or diluting it to its lightest value. You can learn what happens when the paper is dry or wet, how to cut around and save a white area, and how to glaze a dark value right over a light one.

After doing a few monochromatic studies, you can reach for a complementary palette, such as ultramarine blue and burnt sienna, using the colors separately or in warm and cool mixtures. That way, you will slowly increase the challenges of the medium as you become acquainted with its characteristics and the different tube colors, one at a time.

Outdoors, I find it difficult to force such discipline on a student, although it has great merit. You know your own level of artistic development and should draw your own conclusions, but consider that many of our well-respected painters use a very limited palette. To paint a prizewinner, stay away from "all the pretty colors."

HOW MY PALETTE WORKS

First, let me state that every artist has his or her own favorite way to set up a palette, and each works for that person as long as the setup is consistent. Look at your palette as a keyboard upon which you will play a tune.

Imagine what would happen if a pianist were able to pull out the keys, throw them in a box, and, later, replace them in any order. Or if he or she could say, "I don't see notes like that in the piece I'm going to play, so I'll just leave those off the keyboard." It would be utter chaos. You should not have to search for a color. If you paint a lot and keep the paints assigned to the same areas, your hand will automatically reach for a certain color in a certain place. If you know your palette blindfolded, stick with that setup. It is yours. I have done some night scenes under very bad light conditions—believe me, it sure helped to know what was where.

If you're not yet settled on a palette format, you could consider mine, which actually developed as a teaching tool in the early days of my instructorial career. At local oil painting classes, I found that beginners had a tendency to dip into the white to lighten a color and into the black to darken it, producing chalky paintings. So I searched for a palette setup that would automatically remind students how to lighten or darken a color—how to slide up and down each color's value scale. The present palette is the result. It is best suited for those working in an opaque medium, since in watercolor, all colors can be lightened with water. However, the color theory behind this setup is still helpful, because it places the hues in line with each other so that you are constantly reminded of alternative mixing possibilities.

As shown in Figure 5-8, my palette is based on diagonal movement across it. Moving down lightens a color, while moving up darkens a color. Thalo or Winsor green, for instance, is diagonally across from new gamboge yellow and is lightened by it. Cadmium orange, diagonally across from burnt sienna, is darkened by it.

In some cases, you may wish to move to a neighbor of the diagonal target color. Yellow, for instance, is a very light color and is therefore easily influenced by its surroundings. To paint the shadow on a yellow house, you can't just blissfully dip into the green. But you could reach for its neighbor, burnt sienna, or combine thalo green and burnt sienna to get a good shadow color. Another neighborly example occurs when mixing natural greens. To obtain a natural green, you may wish to dip into the cadmium orange instead of the diagonally placed new gamboge yellow, since orange has a built-in neutralizer—red. In need of a dark orange? Reach diagonally across to burnt sienna, or if you wish to go even darker, head for its neighbor, burnt umber. A dark version of red is alizarin crimson, diagonally across from scarlet lake red. You won't find a color diagonally across from any of the blues, since they are lightened simply by dilution which, of course, applies to all of these colors.

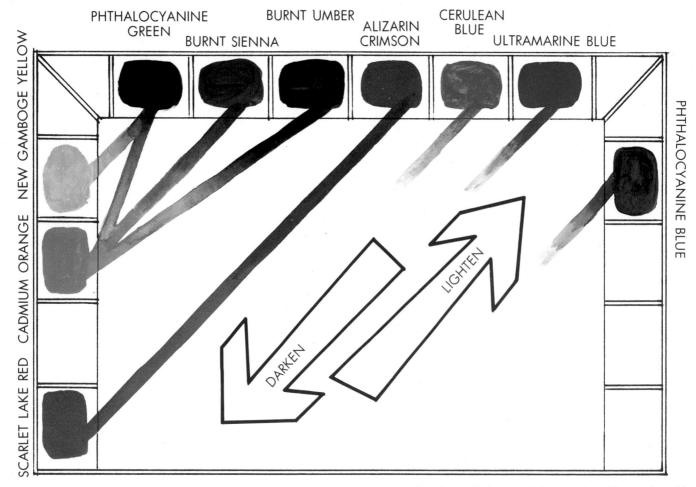

PHTHALOCYANINE GREEN BURNT UMBER CERULEAN BLUE
BURNT SIENNA ALIZARIN CRIMSON ULTRAMARINE BLUE

NEW GAMBOGE YELLOW

CADMIUM ORANGE

SCARLET LAKE RED

PHTHALOCYANINE BLUE

LIGHTEN

DARKEN

Figure 5-8. My palette was created in order to teach students using an opaque medium how to lighten or darken a color without using white or black. Since I don't change my palette setup when changing mediums, this also became my watercolor palette—although in watercolor any color can be lightened by dilution. I find this setup functional because it places hues in line with each other. The palette is based on diagonal movement across it.

Again, this palette works for me, just as another setup works for another artist. Adopt one that suits you and stick with it. At the same time, don't hesitate to kick a color off your palette if it isn't ever used or add a new one to investigate its characteristics. My palette is "subject to change without notice."

SETTING COLORS OUT

Although this is a personal hypothesis, I believe one of the reasons why watercolors are accused of fading is because there are a lot of insipid, weak watercolors in existence. They looked faded from the start. And a good reason why they look that way is a false sense of economy. People will set colors out and paint, then get busy with other things, and come back to a dried-out palette with cracked paint still in the wells. Not willing to pitch those colors out, they try to revive them by adding water. The mixture looks good, so they start painting with it, only to find that they really just have a weakly col-

ored wash on the paper. So they go over it once more and another time and another. Wonder why some watercolors look tired and overworked? Let's put a lot of blame for that on the condition of the paint and stop being penny wise and pound foolish, trying to revive ten-cents worth of paint and ruining a ten-dollar brush.

Every time you start to paint, take a good look at the condition of the paint. It should be nice and moist. Keeping a dampened sponge in your palette and closing the lid or keeping the palette in a plastic sack will keep your paints moist for a long time. When you start working, add some fresh paint on top of those already in the palette. You don't need to necessarily clean out the old paint, just add new paint and a logical amount of it. For instance, add more new gamboge yellow, burnt sienna, or ultramarine blue than scarlet lake red. Sometimes, you might just skip the staining colors, such as the phthalocyanines and alizarin crimson. Those colors are generally strong enough even in a weak tint.

One drawback: moist paint has a tendency to run

when the palette is not kept flat. Through experience, I have developed the habit of not putting paint out until I'm at the painting location. Since my palette is stored inside the French easel, I make sure that it is lying flat. Only when I carry the easel will the palette be on its side—and not for long.

MIXING NATURE'S GREENS

When you paint outdoors, you can't avoid the greens, so now's the time to concentrate on them. I find most problems stem from either using the same green over too large an area without any changes, or keeping it too intense in color. Although Mother Nature provides an infinite variety of greens, they are all natural-looking and quite neutralized. When you mix a green, keep an eye on the grass or bushes next to your setup and see what a *natural* green looks like. It might not be the value you need, but there is bound to be a family resemblance.

Your task of producing natural-looking greens can be accomplished either by mixing green from yellow and blue or by using any dark green on the market. Why buy a light green when it is so easy to dilute a dark one? Being interested in transparency, I like to use phthalocyanine green, which is available under names such as thalo green or Winsor green. Students shudder when they hear I use so intense a green. Yet, investigate what pigment is used in your emerald, Hookers, or viridian greens. Chances are, you'll be right back to phthalocyanine. Thalo or Winsor green is great, if you handle it with respect. Think of it as the spice, while the dominant flavor of the meal is another color. Give your brain the correct command. If you look at a color and analyze it as green and yellow, for instance, your hand has a tendency to automatically move to the green, and you're in trouble. Instead, reverse the order. Tell yourself the analyzed color is yellow and green. Get some yellow out first; then, barely touching the green, try it somewhere else on the palette before mixing it into your yellow. Experience will soon tell you that if you do it the other way around, you will end up using gallons of yellow to tone down the green. I jokingly tell students they only have to buy one tube of phthalocyanine green in their lifetime—to make the point of using it sparingly.

All the colors on my palette except the blues can produce a natural green, with the careful addition of phthalocyanine green. (Spelling it this often makes me wish I were using sap green instead!) The blues produce other, less transparent greens when mixed with yellow and orange. Figure 5-9 shows how the different combinations using phthalocyanine green look. I urge you to practice some of those mixtures as well.

Seeing these many variations of green, you will be less inclined to mix one green and use it all over. Any continuous color use over an area larger than the palm of your hand is in danger of being boring. You either have to change the color mixture or value or add texture, gradation, or *something* to entertain the viewer. Mix your greens as you go and you'll automatically have variety.

CREATING THE THIRD DIMENSION

"Oh, you mean perspective," you may say, while visions of vanishing points and horizon lines flash across your mind. Yes, but I'll be talking about aerial perspective, and let linear perspective be covered by the abundance of technical (and boring) books on that subject. I know that many of my outdoor students get more confused trying to learn linear perspective than if they had never heard of it. Many seem to feel that they ought to follow a set of sacred rules instead of trusting their own eyes. It is a "Who came first, the chicken or the egg?" situation. I contend that artists were able to see first, and then some decided to add a few rules—to be able to paint some darned stage set or mural back in the Middle Ages. Now we're stuck with those rules and tend to forget that we have eyes with which to see. Architectural renderers and draftsmen might need such rules, but outdoor painters, with their subject right in front of them, don't, if they learn to trust their own eyes.

I'm more concerned with aerial perspective and all the other ways you can make a flat surface appear three dimensional. The phenomenon of aerial perspective is caused by particles of moisture and dust suspended in the air, which enables you to *see* air as long as you are looking through a thick layer of it. Air is a veil which falls over the landscape, differently in different parts of the country and under different weather conditions. Fog or dust storms produce extreme examples of that veil; but even on a clear day high in the Tetons, you will see the veils, although less pronounced. They have some interesting effects you should be aware of, look for, and duplicate in your paintings. Or, knowing about them, you can use them anywhere to increase a feeling of depth.

THE EFFECTS OF AERIAL PERSPECTIVE. Realizing that I am talking about guidelines and not rules, that there are always exceptions, and that you are always free to use your artistic license, let's take a look at what aerial perspective can do.

1) *It neutralizes intensity of color.* A red of a roof in the foreground may be more intense than the color of that same roof in the distance. By progressively reducing intensity as you paint more distant objects, you can increase the illusion of depth.

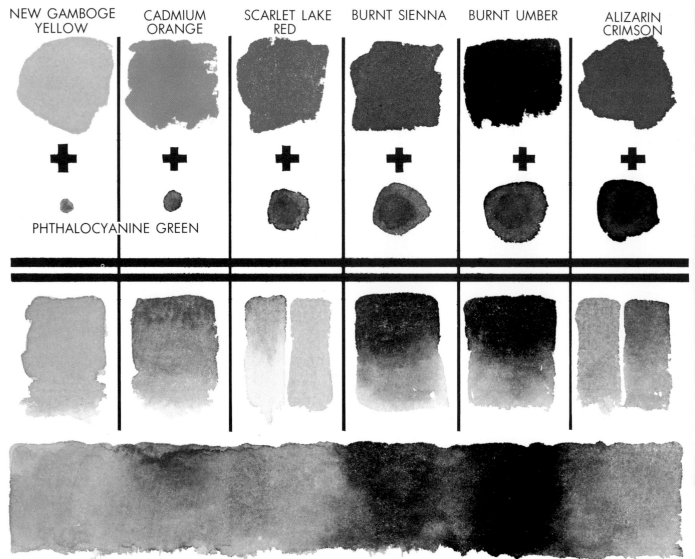

NEW GAMBOGE YELLOW CADMIUM ORANGE SCARLET LAKE RED BURNT SIENNA BURNT UMBER ALIZARIN CRIMSON

PHTHALOCYANINE GREEN

Figure 5-9. Here are some equations for creating natural greens by adding phthalocyanine green. As you can see, any color on my palette can be used except the blues, which mixed with yellow or orange form more opaque greens.

2) *It lightens values.* Not only may the red roof become less intense, it may also become lighter in value. Look at how dark a tree is in the foreground when compared to a distant band of them. If the difference is hard to distinguish in reality, you may have to intentionally make the distant band lighter to force depth into your painting. By lightening a value, you can increase depth.

3) *It reduces detail.* In the foreground you can see the bark of a tree and all its leaves, while in the distance trees become silhouettes without details, as seen in *The Onlookers* (Figure 2-14). If you keep looking at the background, you will see and consequently paint more detail there than you should; you will destroy distance. By keeping details up front and silhouettes in back, you can increase depth.

4) *It softens edges.* The more distant the mountain range, the softer its edges. By painting hard edges up front and softening them as you go back, you can increase depth.

OTHER METHODS OF ACHIEVING DEPTH. In addition to aerial perspective, you should take advantage of the intrinsic advancing and receding quality of colors to create depth. Warm colors tend to come forward, while cool colors recede, as illustrated in *Meadow Flowers* (Figure 5-10). You're generally safe if you paint distant objects blue and stay away from using warm browns in those areas. That advice causes some problems in painting those clear Southwestern landscapes with their yellow, orange, and red mesas; but even there, careful comparative handling—by stating the foreground yellows, oranges, and reds more intensely than the background ones—will gain distance.

Figure 5-10. *Meadow Flowers*. 15 x 22 in. (38 x 56 cm). Here is a good example of keeping warm colors in the foreground and cool colors in the background. Details are also kept up front, while the distant areas are treated more flatly.

There are other ways to gain a feeling of depth, such as by using overlapping shapes, as demonstrated in *Nebraska Farmyard*, (Figure 5-11). You could also reduce the known size of objects such as fences, as shown in *Clouds over Colorado* in Chapter Six, or telephone poles or people. Gradation from a dark on the outside of a painting toward a lighter version at the center will help, as shown in *Stuhr Museum* (Figure 5-12). Another favorite device is the use of directional shadows pointing into the picture plane, as illustrated in *Hidden Cottage* (Figure 5-13). To show how all these devices create depth together, I have made a diagram, Figure 5-14. Note that you have created depth without ever touching on those awful rules of linear perspective.

LIGHT AND SHADE

Thinking about the earth's light source, it is quite understandable that so many cultures based their religion on sun worship. Can you imagine life without the sun? Painting without our natural light? Even being able to see without it? Our whole world would come to an end without the sun.

The artist, not having sunlight on his or her palette, can only approximate the effect of light. Light gives, while our pigments are only able to receive and bounce it back. In an opaque medium, the light bounces directly off the surface of the painting. In watercolor, it travels through the glazes you put down, hits the white paper underneath and returns through the glazes to the viewer's eye. There you have transparency—and a good reason to keep your watercolors clean and direct.

We see light first and have a tendency to forget about shadows. A business executive once commissioned a well-known artist to paint a sunny South American scene. For contrast, the artist silhouetted some figures in shadow against the sunlit scene. The executive promptly objected to these dark figures because "sun was everywhere." Of course, in a way, he was right. After hitting a sunny area, the light bounces into the shadows as well; it can reach anywhere. However, it loses a

Figure 5-11. *Nebraska Farmyard.* 15 x 22 in. (38 x 56 cm). Shapes overlapping each other create depth. The barn shape on the left overlaps the fence, which in turn overlaps the tree; the tree overlaps the silo which overlaps the main barn.

Figure 5-12. *Stuhr Museum.* 15 x 22 in. (38 x 56 cm). This painting clearly shows the use of gradation to create the third dimension. Gradate from dark to light from the edge to the center of your painting.

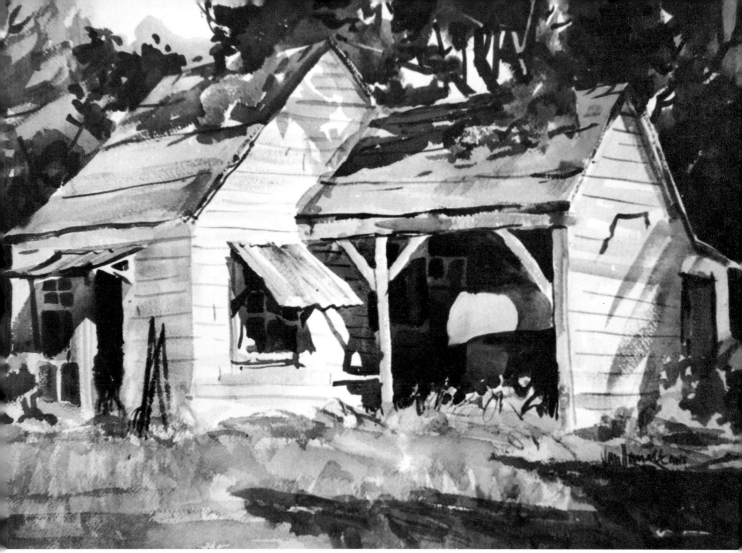

Figure 5-13. *Hidden Cottage.* 15 x 22 in. (38 x 56 cm). In this demonstration, I used the long directional shadows of the early morning to point into the picture and at my subject.

lot of strength after the initial contact with a surface, and consequently it can only modify a shadow. First and foremost, a shadow plane is a plane removed from the direct energy beams of the light source, which means that the plane is dark. Figure 5-15 shows a house painted completely white, on a white ground plane. Since it is an easily influenced color, you can see the theory of reflected light better at work with white. Note that if one plane is in shadow, parallel planes will also be in shadow. See sections A, C, and E. Let's also note that a cast shadow must have a cause, for it to be casting upon another surface. Section B is in the sunlight, but the sunlight is partially blocked by the cast shadow caused by the C plane, as well as the overhanging roof. D also is a cast shadow caused by E. The same parallel-plane principle applies to sunlit areas as well: if one is in the sun, so are the others, parallel to it. See B, D, F.

If you could actually see this scene in sunlight, you would see that the sunlit planes would be light and

warm in color, while the shadow planes—those away from the sun—would be cool and dark. But the shadow areas are not black voids as some underexposed photographs would have us believe. Those planes are still outside, where light bounces over and into everything. The cool shadow planes will have a tendency to be bluish, because they may reflect the blue sky opposite the sun. Looking at the sky, you can notice that as it moves closer towards the sun, it warms up, and it is at its coolest directly opposite the sun.

As soon as a plane changes angle, its value and color temperature change. Angling closer to the sun, the plane become lighter and warmer, while angling away from the sun, it becomes darker and cooler. To put it simply, you could say that sunlight is warm and shadows are cool. You need to modify this statement a bit though, or you'll end up with all blue shadows. That might be all right if the world were totally white, but it isn't, and you should remember that reflected light

Figure 5-14. In this diagram, I've tried to use all the devices to create depth, without bothering with linear perspective. Note that these are guidelines, not rules—they can be broken and constantly are.

First, let's discuss the effects of aerial perspective. 1) Aerial perspective neutralizes the intensity of color. For example, look at the red decoration on the first teepee versus the same decoration on the teepee farther back. 2) Aerial perspective lightens values. Notice how dark the foreground foliage is in comparison to the mid- .dleground clump and the distant band of trees. 3) Aerial perspective reduces detail. You can see the bark on the tree in the foreground but not on the one farther back. In the foreground you may indicate individual leaves and blades of grass, while in the background, you should indicate silhouette masses instead. 4) Aerial perspective softens edges. The light distant mountain disappears into the sky, while the closer mountain is stated with a much sharper edge.

In addition to aerial perspective, color itself can create depth. 5) Warm colors advance and cool colors retreat into the distance. Notice that the mountains are painted blue, a receding color, while the lady in the foreground is painted in red, an advancing color. I used the same idea more subtly on the two tree trunks.

There are other ways to create depth. 6) The use of overlapping shapes suggests receding space. Notice that the lady overlaps the billboard, which overlaps the teepees, which overlap each other. The teepees also overlap the background and the clouds, which in turn overlap each other. See if you can find more of these overlaps. 7) You can create depth by reducing known size, as I did with the teepees, the billboards, the people, the fence, the birds, and the cracks in the sidewalk. 8) Gradation creates depth, as shown in the grass and the sidewalk. I kept the foreground grass dark and gradated it toward a lighter version in the distance. 9) Directional shadows can help your perspective, as seen with the tree shadows that point into the picture. 10) To create depth, it is best to keep the big items in front and the smaller ones in the background, as with the two rocks in this picture. You should consider changing the actual size of objects if there is a possibility that they'll destroy depth if painted the size they actually are. 11) Last, you may consider linear quality. Busy lines are generally found in the foreground, while lines slow down in the distance. For example, compare the edge line of the foreground foliage with that of the foliage covering the mountain in the distance.

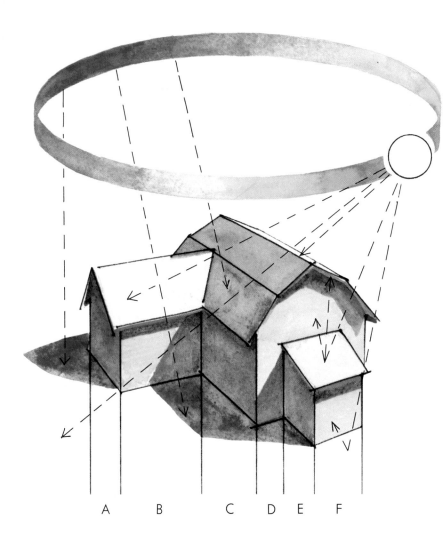

Figure 5-15. The basic cause and effect of light and shade is best illustrated on a white house, since white easily shows the influence of other colors. The sun shines a warm glow over the whole scene, except in the shadows. All shadows are primarily a darker version of their local color and are secondarily influenced by reflected light—from the warm sun, the blue sky, or the earth.

A B C D E F

bounces—much like a ball—all over the place, picking up colors and throwing them onto other planes. Horizontal shadows are most influenced by reflections from the blue sky, while vertical shadows are most influenced by reflections from the earth. The vertical shadows, therefore, have an opportunity to be warmer than the horizontal shadows.

Here is where a little bit of knowledge can sidetrack you from the big idea. Students ask, "Aren't shadows supposed to be cool? Aren't shadows supposed to be more neutral? What color is grass in shadow?" All these questions show that they've forgotten that shadows are primarily darker versions of a local color, and are influenced by reflected light only secondarily. A yellow house does not become a blue violet house as soon as you turn the corner into the shade; however, sky reflections and light bouncing up from the ground may *influence* the yellow shadow value. The shadow may be quite warm at the wall's base and gradate to a cooler color as it moves farther upward, away from the earth reflections. You can observe these color influences clearest with white, since it is so easily affected by its

surroundings. That's why you look at the shadow on a white house and find it so hard to mix. You keep seeing other colors in it. An out-of-view red porch floor may reflect up and warm the shadow, while the blue porch ceiling will have the reverse effect. At the edge of the porch, you may get a green feeling, caused by the reflection of a nearby bush.

Reflected light can be quite strong. Just go out on a moonlit night and you'll be convinced of its power. Moonlight *is* reflected light. Reflected light can help you enliven and enrich drab-looking shadows. But those shadows are first and foremost *darker versions of a local color*, and they are only influenced by reflections of nearby colors.

There is quite an interesting color theory taught by, among others, Milford Zornes, which states that shadow areas should be more colorful. According to the theory, the sun is such a strong light source that it somewhat drowns local color. A red billiard ball illuminated by a light bulb may be used as an example. As you look at its highlight, you actually lose local color. It is drowned by the strength of the light shining on its re-

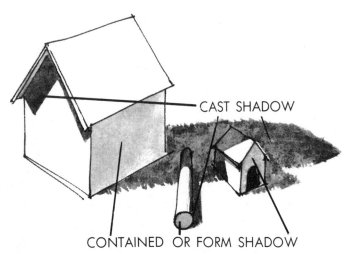

CAST SHADOW

CONTAINED OR FORM SHADOW

Figure 5-16. A contained or form shadow is the shadow which remains on the form and is caused by its changing planes, like the shadow side of a house. A cast shadow is caused by an object blocking the sun's rays; it falls on another surface and takes on the shape of that surface.

flective surface. Outdoors, similarly, you have the power of the sun, and it is very easy to imagine how that light could wash color out of anything it falls on. Luckily, however, there aren't too many reflective surfaces in nature, so you do see local color, only to a lesser degree than if the light were not so bright. To compensate for that loss of color, the theory suggests that you overemphasize color in your shadow areas, where the sun does not reach with its strong powers.

Figure 5-17. Here are some examples of shadow patterns selected from nature as well as from photographs. It shows that you can tell your story just by shadow shapes, even with a minimum of color and value. Try some exercises yourself. On a sunny day, use ink and brush to copy the shadow patterns of your house or a section of the house. But don't be tempted to render details within the shadow shapes.

Personally, I feel that the area where you live and paint has a lot to do with how you respond to such color theories. I find it difficult, for instance, to imagine a painter in New England working as if he or she were in New Mexico, or vice versa. Might it have something to do with how the sun's rays fall glancingly on the northern landscape and almost vertically on regions closer to the equator? An interesting idea, but in any case, I'll stick to painting what my eye observes.

So far, I've talked a lot on the value and color of shadows, but in addition, those shadows are ideal form describers. Try painting a house with both the front and the side equally light. The house doesn't "turn the corner" until one side is darker. So, a shadow describes the form to which it belongs (see Figure 5-16).

Cast shadows are also great form describers, but they don't stick to the surface of the object; they are cast by and take on the shape of whatever they fall on. A shadow can fall on grass, roll over a log, dip into and over ruts in a road, crawl up the other side, and continue its path over the grass until the angle of the sun and the height of the object casting the shadow tells it to stop. Since it describes all the items and landforms it rolls over, it is a wonderful storytelling device for the artist (see *Pueblo Patterns* in Chapter Six). You can take great liberties with these cast shadows, in order to better describe what you want the viewer to be looking at. You

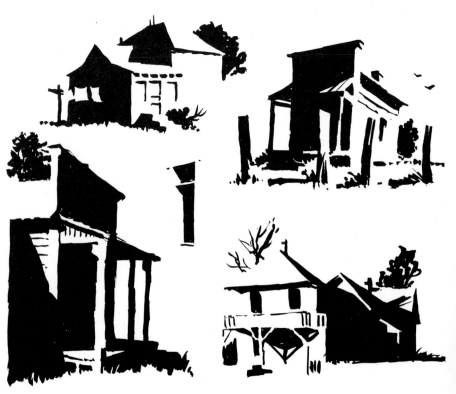

Figure 5-18 (above). *Epworth Gate.* 15 x 22 in. (38 x 56 cm). Here is an example of a cast shadow describing the form it is on. Select your cast shadows judiciously. If, for instance, the cast shadow here had run vertically, parallel to the tree trunk, I would have ignored it. It would not have described the round quality of the tree.

Figure 5-19 (left). When two shadows fall on top of each other, they become one shape, not two glazed over each other.

don't have to copy exactly the cast shadow you see out there. Some cast shadows, in fact, are best ignored if they don't do a good job of describing the form they are falling on.

To become familiar with shadows as form describers, on a sunny day you should take a bottle of India ink, some drawing paper, and—without doing any pencil drawing—just copy shadow shapes as they fall over a window frame, into the recesses, and up over the other side. Look at Figure 5-17 to see some of my shadow studies and note that there are no details within the shadows. You should do many of these studies, and you'll be amazed at how much shadows can tell about the form on and from which they fall.

Looking around outside, you'll see cast shadows falling on tree trunks and describing their forms to the viewer. "I am round," says the tree trunk in *Epworth Gate* (Figure 5-18), by means of the wrap-around cast shadow. You'll observe that some cast shadows are sharp edged, while others are soft edged. That is because one cast shadow is closer to its cause than another. The "rule" is: the farther its distance from the object, the softer the edge of the cast shadow. The value of a cast shadow also has a tendency to lighten as it moves away from the object. "Oh, but I thought all cast shadows were supposed to be darker," you may say. Yes, quite often they are, when close to their cause; but they do change as they get farther away. Remember the rule, but trust your eye first!

One more thing about shadows. If they fall on top of each other, they cancel each other out. They become one shape, not two shapes glazed over each other. That's a common outdoor error. Figure 5-19 shows you what is not possible, and what the shadow should look like instead. Observe this effect for yourself—it will stick in your mind that way. Sometimes it is fun to watch as the sun begins to throw the side of a building into shadow, as seen in *Pueblo Patterns* in Chapter Seven. The wall slowly gets darker, but you can still observe the shadow of the roof overhang being cast upon that half-light plane. The minute the side is in complete shade, however, that cast shadow will be gone. Observe and learn. Nature will teach these things to you outside; you won't learn them inside.

On a sunny day, it is easy to describe form with shadows. But even on an overcast day, there still are some ways to describe form. You know the sun is hidden above the clouds which diffuse its light. With that light, there are no definite, hard-edged shadows, only an observable variation in tones; for example, one side of a house is darker than the other. Cast shadows are completely gone, replaced by gradual darkening under a tree or eave. That soft, diffused light is the charm of an overcast day. In fact, whole schools of painting have been based on such shimmering light.

George P. Marsh is quoted as saying, "Sight is a faculty; seeing is an art." Volume after volume may tell you about all the ins and outs of painting, but it takes a discerning eye to observe what Mother Nature has to teach. And it takes an undaunted attack of the watercolor paper to get yourself going.

Chapter 6
Catching the Changing Scene

To help you cope with the different light and weather conditions outside, I have selected a few typical situations and subjects, and showed my approach in each case. I generally stick with the guidelines I've already explained, but I don't let myself be locked-in by them. They are a great help and absolutely logical, but art isn't all systematic. It deals with feelings as well. The same subject may affect me one way today and a different way tomorrow. That's why it is fun to go back to the same spot a number of times. Try different approaches to the same scene.

As in sports, you need to do some warm-up exercises. Since I can't think of a better one than doing a series of sky paintings, I'll start with that. Next, I'll discuss the sunny day, and I'll show you how to handle the problems of two different subjects. You'll learn how to paint the partly cloudy day, with its roving spotlight of sunshine, as well as the late afternoon, with its rapidly changing light. I'll discuss and analyze the overcast day which presents a totally different situation. Last, I'll cover the rainy day with its special painting and drying problems.

Before starting these step-by-step demonstrations, however, let me point out that my way is just that: my way, not the only way.

Figure 6-1. *A Tarahumara Sky.* 15 x 22 in. (38 x 56 cm). This quick and very wet-into-wet demonstration was done on a relatively inexpensive, machine-made paper, to get a student over the fright of the blank paper. The board was flat on the ground and, with the largest brush, colors were applied and allowed to intermingle freely. While the sky was still wet, I established the ground plane and, last, stated the mountains over the dried sky. The roof shapes were squeegeed out of the wet mountain wash with a credit card. In the studio, the foreground and mountains were restated and strengthened, and details such as birds and buildings were added.

Demonstration 1
Skies and Clouds

Clouds Over Colorado

Since the sky sets the mood of your landscape, it is a very important part of it. As an outdoor painter, you'll need to know how to paint the plain sky as well as the cloud-filled one. You have already observed that the sky gradates across from cool to warm as it moves toward the sun. It also gradates down from dark at the zenith to light as it nears the horizon.

Although to the untrained eye the sky looks blue, to paint it with a straight tube blue is an obvious error. Upon close examination, you will find the most subtle color variations in that plain blue sky. I often find myself starting with a diluted cadmium orange wash all over the sky and then, while it is still wet, adding a variety of blues; thalo or Winsor blue at the top of the painting, gradually shifting to cerulean or manganese blue, and diluting that mixture as I near the horizon, where occasionally I will add a touch of alizarin crimson.

Let's observe what is basically taking place. More than likely, you'll see some very light areas where the sun is shining on the clouds; then you'll notice some shadow sides and the clouds' darker and warmer underbellies. Look for the "sky holes" and notice that the shadow value of the cloud and the blue sky next to it are often the same all the way down to the horizon. Since clouds are soft edged, colors can easily mingle together in those areas. The cloud nearest you is usually the largest shape. As the clouds overlap and march into the distance, they become smaller and flatter. Due to aerial perspective, they also become lighter and bluer, finally disappearing into the distant haze. You should think of clouds as being predominantly soft edged, but there's always the relief of the occasional hard edge, best noticed where the lightest part of the cloud is outlined against the deep blue sky.

With these cloud paintings, I seldom do a pattern sketch or draw on the paper, since the shapes change so quickly. My sky never looks exactly like the one above me, yet it has the feeling of that sky, which is the important thing. Just approximate, and resist the temptation to "fix it"—to make it look more like the sky you see. You might end up with cement clouds. Reason the situation out before touching the paper. Then dive in, make your statement, and get out!

Your first efforts may look great while wet and then turn out to be weak statements when dry. To quote watercolorist Edgar A. Whitney, "If it looks right when it is wet, you know it is wrong." On your next attempts, add more pigments to the wet sky, more than you think you need. Learn to catch that fast-moving cloud formation and sky impression. There is no better way to loosen up in watercolor than to do a stack of cloud paintings when there is an interesting sky overhead.

Figure 6-2. This photograph of a dramatic sky over Colorado gives you an idea of what I am looking at during this demonstration. After locating the sun, I set up in my regular manner, placing my board so that it will be in shadow at all times. Before I came on location, I washed all the paper down to remove the sizing, as explained in Chapter One. I have squeezed out fresh colors on the palette, and all my equipment is readily available for the instant it will be needed.

Step 1. I usually don't even bother doing a pencil sketch for such a fast-moving subject, but to give you an idea of what will be going where, I made an exception and drew a few lines. You can still see them through this first wash, which consists of a mixture of ultramarine blue and burnt sienna. It is applied with my largest, 1½-inch (4 cm) brush, to quickly establish the general cloud shadows. I also add some water to weaken the mixture here and there, and with that much water on the paper, of course, there are bound to be a few drips. If you don't catch the drips before they run, don't worry. You're still in the light, early wash stage.

Step 2. I add some clear water to wipe out the drip and weaken the wash even further. Although the wipeout is clearly visible at this point, I will cover it with darker washes later on. While the big gray wash is still wet, I add a more concentrated mixture of ultramarine blue and burnt sienna to form the underbelly of the clouds. That has to be done right away, since all these edges have to be soft. Although the mixture looks too dark at the moment, I know it will dry lighter.

Step 3. I can't resist going back into the cloud to reclaim some lights. That is done with a tissue, but too much touching up is not a good idea. I also add some darker darks to the left. The ideal way to paint such a sky is to go in, make your statement and get out quickly. The more you develop those clouds, the more it will show, and you will lose spontaneity.

Next, I establish the blue sky with thalo or Winsor blue in the upper part of the painting. Notice that I use a warm and cool approach here. I use the warm ultramarine blue for the nearer clouds, while I paint the more distant sky in the cool thalo or Winsor blue. That immediately creates a three-dimensional effect. Try it! The blue is diluted to paint in the lower section of the sky. I'm still working with the big brush and painting long, horizontal strokes in the distant area which will partially disappear behind the darker mountains. When you try this, don't carefully stop at the edge of the mountain range. Paint right over it, because the mountains will be darker anyway.

Because that area is still wet doesn't mean I have time for a break. There's no time for that. Instead, I see where I can safely work next. I decide to paint the green meadow with a mixture of new gamboge yellow, cadmium orange, and a slight touch of thalo or Winsor green. Coming to the tree, I switch to my smaller, 1-inch (3 cm) flat brush and simply paint the tree over the dried sky. There's no need to be careful since the tree is darker than the sky anyway.

Step 4. With the 1-inch brush, I state the mountain range with a mixture of ultramarine blue and a touch of alizarin crimson. Since that seems too purple, I neutralize it with some burnt sienna glazed over the still wet wash. This mixture seems to push the mountain back enough. Next, I strengthen the meadow's foreground with some textural drybrush strokes, gradating from dark at the bottom to light in the center of the meadow.

Switching now to my smaller, round brushes, I add a shadowed side to the tree, as well as a cast shadow. More modeling is done to form the roundness of the foliage clumps. Mixing a dark blue green from burnt sienna, thalo or Winsor green, and ultramarine blue, I establish the distant tree shapes at the foot of the mountains. Finally, switching to a warm, dark mixture of burnt umber, I add a few trunks and branches on the tree with a small round brush.

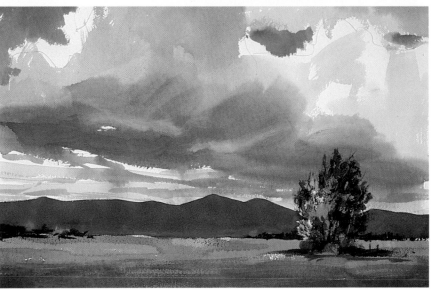

Although this painting is not finished, I have indicated enough to take it back home for further refinement. In the meantime, if you're working out there, look up and see how that sky has changed. Only twenty-five minutes have elapsed and there's a whole new subject there waiting for your next attempt. So, grab another sheet of paper and try again. How else will you get warmed up? Certainly not by dawdling and worrying. Who cares how the results look. Just have fun hitting that paper with the big brush.

Demonstration 2
Sunny Day, Simple Shadows

The New Inhabitants

The sunny day is generally thought of as the most popular day for outdoor painting, especially for those who are new to doing outside work. Since it presents the most favorable weather conditions, it is a good day to be introduced to Mother Nature. You'll soon notice that your washes dry much faster than you would like, although this depends on temperature and humidity. Whenever I go to a different part of the country, it takes me a day or so to get used to the drying conditions. That's why I like to start with a series of quick studies; they serve as a warm-up exercise, and they familiarize me with the local drying factor. If you have a wash that is slow in drying, use solar power—put your paper in the sunshine. Also, if you paint with your board in a vertical position, you'll notice that the top of the painting dries first. If you wish some soft-edged variations in that area, you'll need to state them almost immediately.

On a sunny day, I use the pattern sketch instead of the value sketch and approach my watercolor in one of two ways, explained in this and the next demonstration. If the subject has a few simple shadow shapes, I'll first put in all the big, light washes and then glaze the shadow values over them, as seen in Demonstration Two.

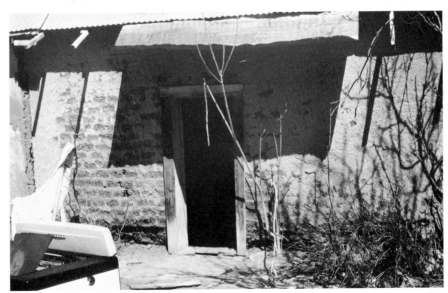

Figure 6-3. This section of an abandoned building offers a good center of interest with delightful textural possibilities. I like the foreground shadows angling toward my focus. There are also some problems here. For instance, the thin twig outlined against the dark door will be difficult to cut around with watercolor. This would be a good place to use masking liquid, but since the twig isn't crucial to the subject, I plan to eliminate it instead. I will also eliminate the junked stove and rags. Without the twig, the door becomes a rather dull rectangle, so I'll have to think of a way to make it a more interesting shape. I wonder what suggestions the inside of the building has to offer. A window perhaps?

Step 1. Very little drawing is needed for this painting, so I only locate the door and roof and indicate the support beams, since I will have to cut around those, avoiding them to keep them light. I also draw a baseline. Here I have a great opportunity to start with a big wash and cover almost all of the painting. I mix cadmium orange and a bit of burnt sienna, and with my 1½-inch (4 cm) brush, I start at the edge of the roof, cutting around the support beams. I dilute the mixture a bit as I move farther down the wall. Realizing then that the door is marked with some white paint remnants and that the window is light, I reestablish the whites there by quickly blotting the wet paint with a tissue.

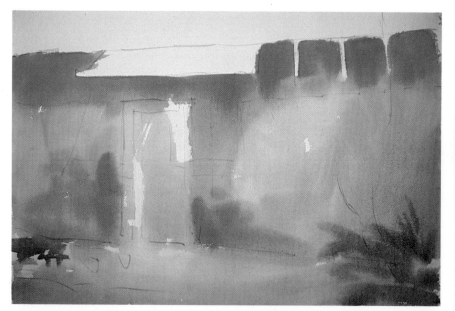

While the orange wash of the building is still wet, I strengthen it once more under the eaves and add for variety some scarlet lake red in the area where the adobes will be showing through. For the basic foliage wash, I take a mixture of cadmium orange and thalo or Winsor green and paint it wet-into-wet in the area where the greenery will be. I don't mind the soft-edged diffusion since I'm in the lightest washes anyway. As long as a wash is soft edged and light in value, you have not made a commitment. When you have a hard edge and a dark value, then you're committed and the wash has to definitely describe something. Look at this stage as a time when you establish the big base washes upon which you will place future glazes and textures.

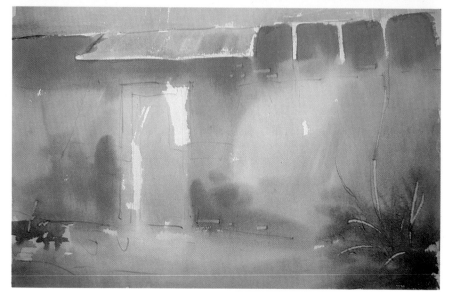

Step 2. Honestly, I don't think my knife could cut butter. But it sure is a great tool to scrape—or actually squeegee out—some lighter marks in a semi-dry wash. In this step, you can see where I start some bricklike marks as well as indicate some light twigs or leaves.

As soon as the top of the first wash is dry, which is almost immediately in this hot and dry climate, I proceed to establish the roof color. In actuality, it happens to be a new piece of corrugated roofing, but we'll have to do better than that. First, let's keep in mind that this area is the lightest since it receives most of the direct sunlight. Then, with so much warmth in the rest of the painting, it might be good to use a cool color here. Also, to balance the green at the bottom, I could introduce a greenish tint at the top of the painting. In other words, when the subject isn't the greatest, draw on your previous experience to make it better. The more you paint outside, the more previous experience you can draw on.

Switching to my 1-inch (3 cm) flat brush, I mix some ultramarine blue with a bit of new gamboge yellow, and I neutralize it with burnt sienna and dilute the mixture to a light greenish tint, just right for the roof. It is applied in a slightly gradating wash from the edge to a lighter version in the center. The overhang above the door is charged with some stronger blue mixture. That should look good, since blue is the opposite of orange.

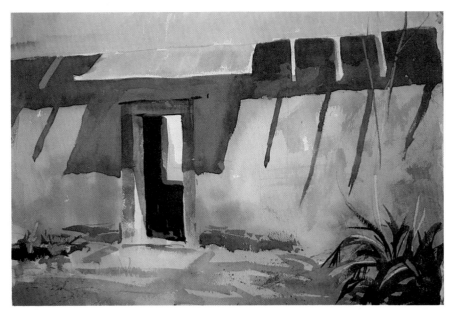

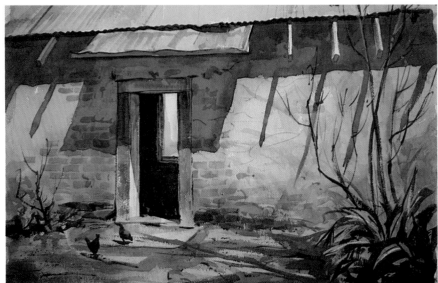

Step 3. It is now time to proceed to the smaller, darker, and hard-edged shapes. Taking burnt sienna, cadmium orange, and a bit of alizarin crimson, I mix a dark version of the wall color and with my big round brush, apply it all over the shadow area of the building.

As my shadow wash approaches the door area, I switch to a cerulean blue mixture to create the white paint in shadow as well as the weathered wood. Where the door frame has a chance to reflect the ground plane, I dip into straight cadmium orange and charge it into the wet shadow wash. I don't actually see that much reflected light, but know it should be there and overstate it to make the colors more alive. What I have done so far is to place a dark wash over all the shadow areas and change colors while applying the wash. As a result, a soft-edged fusing of colors occurs.

While this shadow wash is still wet, I scrape some of the light twigs out of the shadow area above the right bush. The scraped out color is squeegeed right into the roof area, which happens to be just right—a lucky break.

As soon as the first dark wash is dry, I establish the cooler inside color with ultramarine blue and alizarin crimson. This mixture seems too light, so I apply a darker wash of ultramarine blue, burnt sienna, and a touch of alizarin crimson. With a smaller round brush, I start delineating the framework of the door.

A dark green, mixed from burnt sienna and thalo or Winsor green, is used to create some darker foliage passages. To focus more attention on the door, I scumble some neutralized warm color over the wall above the right bush and break the foreground up with a mixture of ultramarine blue and alizarin crimson. With the fan brush, I spatter some of that mixture over the ground, to create textural effects.

Step 4. Here comes the fun part. With my ½-inch (1 cm) flat brush, I stroke in the bricks, darkening the mixture in the shadow areas, where I add some more scumbling. Then, switching to a small round brush, I mix a good cool dark and paint the corrugated roof edge. A lighter blue shapes the turned-up edge of the overhang. Light stripes are painted on the roof and gradated from the left corner.

With my long-haired round brush, I paint the twigs and delineate the window sill, door, and cracks in the plaster. I also darken the wall area behind the right bush, to form the lighter leaves, outlined against it. The cast shadows of the twigs and foliage are mixed with ultramarine blue and alizarin crimson and more dry-brush marks are scumbled over the wall to create a textural effect.

As if on command, a few chickens round the corner and take their proper place in the scene. Although the painting will need some refining here and there, it is time to take it inside.

Demonstration 3

Sunny Day, Complicated Shadows

Arroyo Seco

When facing a complicated subject with shadows that will quickly and drastically change their shape, I still do a pattern sketch, but while doing the painting I use an approach different from the one shown in the previous demonstration. Instead of establishing all the light tones first, I now concentrate first on the shadow shape and start off with mixing the lightest tone within that area. I indicate the whole shadow shape with that first wash. That way the shadow pattern is established and I can concentrate on the lights next, as seen in Demonstration Three.

Figure 6-4. Here's a small, dried-out arroyo with a pleasing distribution of lights and darks, although they will have to be changed somewhat. For instance, the background rocks are the same value as the foreground ones, but I will need to make them appear lighter to create more depth in the painting and, at the same time, focus the viewer's attention on the foreground.

Step 1. With my 2B pencil, I carefully indicate where the rock shapes will be as suggested by the pattern sketch. The other components of the painting are also roughly placed with a few lines. There is no need to draw every crack and crevice. I'll save those details for my brush.

Since the pattern of sunplay over the rocks attracted my attention, I'll need to make sure that this pattern is recorded before it changes. Therefore, I have to approach this subject differently from the previous one. In this case, I look for the lightest color in the dark shape and with my 1-inch (3 cm) flat brush, reach for pure cadmium orange to paint it over the entire shadow shape. This will be the base color, although here and there I strengthen it with more cadmium orange, some alizarin crimson, and burnt sienna. The only area I avoid is the shadow part of the wooden log, since it is much cooler and will be stated with ultramarine blue instead.

I have now, very quickly, recorded the shadow shape as it is at this moment and no longer have to worry about it changing. So let's back up a minute and note that I have still stuck with the first two guidelines, light to dark values and big to small areas, but this time, *within* the dark shape. Notice that I also applied guideline number four—remember that one? Students usually are quite shocked by such a pure orange wash, but it ought to enable me to retain a nice warm glow underneath all the successive darkening glazes and details which are yet to come.

Step 2. Now that the shadow shapes have been recorded, I turn my attention back to the light areas, starting with the sky. To begin, I stated it with a cerulean and thalo blue mixture, smoothly taking it into the distant rocks, where a slight touch of alizarin crimson, added wet into wet, creates a mauve tone. I also placed this same general mixture over the rocks in the lower right as well as on the sunlit log. The remaining light area is the grass, which is washed in with a light mixture of new gamboge yellow and thalo or Winsor green. While wet, this wash is partially strengthened with burnt sienna.

After establishing all the major light tones in their base colors, I concentrate next on the general tree value, which is placed over the dried sky, as seen here. I'm still working with the 1-inch brush and mix cadmium orange with thalo or Winsor green to state the basic green, varying it here and there and darkening with ultramarine blue as I work toward a corner. Note how the opening between the trees forms a gentle path out of the picture. Here is where you may rearrange nature a bit, since in actuality, there is no opening.

Step 3. The distant rock shadow is stated with a cerulean blue and alizarin crimson mixture, creating a nice violet tone which is also applied to some of the areas in the lower right rocks. A wash of burnt sienna is added to the bottom of the canyon and a bit of the wet-in-wet color breaks up the grassy area. Later, when that area is almost dry, I'll scrape in some knife marks to simulate light weeds. Careful though: I must remember that this area is in full sunlight. On the pattern sketch it reads as white. Outdoors, however, you may start looking into such an area, see all the details within it, and start to render them. This will make the area darker and you'll lose that strong contrast of sunlight and shade.

I next begin to break up the large shadow area of the foreground rock with darker tones of ultramarine blue and here and there some alizarin crimson and even more cadmium orange. Of course, blue is the opposite or complement of orange, so it will neutralize it. I'll need to neutralize, but must avoid muddiness. After all, that nice warm glow was part of what attracted me to this scene in the first place.

Brushes progress from big to small, so I switch to the #30 Goliath and #12 round to continue modeling the shady area within the foreground rock with more glazes of an alizarin crimson and ultramarine blue mixture.

Step 4. In this finishing step, I use the smaller #12 round as well as the long-haired brush to go after the details. Yes, finally the cracks and crevices you have been waiting for. We are after all in the final—little and dark—stage, right? So with a mixture of ultramarine blue, alizarin crimson, and burnt umber, a good dark is mixed and used to delineate the rocks and cracks. Areas which are too colorful and seem to jump forward from the plane they are on, are pushed back with a neutralizing glaze.

I then add some foreground grasses and do quite a bit of adjusting on the lower rocks, so their value is in keeping with the rest of the picture. I also add some drybrush strokes to the sunny top planes of the foreground rock to avoid a glaring all white feeling.

Once again comparing the pattern sketch with the painting, I feel a darker area is needed at the lower right, so I darken the arroyo floor a bit and add a tentative soft shadow to the lower part of the log. The distant foliage receives an addition of dark trunks and branches; and in the foreground, I scrape in some light weeds with a razor blade, to break up the dark area behind it. That's it. I've done enough on the spot. Perhaps even too much on this one. Let's take it into the studio for further analysis and development.

Demonstration 4

In-and-Out Day

Killarney Blarney

In the painter's jargon, this is the partly cloudy day, when your subject is sunlit one minute and in shadow the next. It is a day with dramatic lighting possibilities. The sun, shining between the clouds, plays a roving spotlight over the landscape, and shadows roll over mountain ranges to describe them as well as foreground undulations.

It is a very frustrating day for painters, since the spotlighted areas keep changing, depending on where the sun is shining. You really need to select your center of interest ahead of time and assign a light condition. I make it a point to set up as if it were a sunny day, so if by chance the sunlight starts streaming down, the board will still be in shade. There are actually three approaches you can use on an in-and-out day:

1) *You can paint the landscape as if it were completely sunlit.* To do so, you'll need to record the shadow shapes in your preparatory sketch, by doing a line drawing first and, when the right light condition exists, quickly painting in the shadow shapes on top of that drawing. In the painting, you can lay in all the light colors all over and follow the shadow shapes of your sketches for the darker values, much like the late afternoon demonstration, *Pueblo Patterns*.

2) *You can paint the landscape as if it were completely overcast.* Just do a value sketch without shadow indications. Then proceed to the painting, referring to the sketch whenever your subject is bathed in sunlight, much like my overcast-day demonstration, *Bayou Black*. I've found that I need to work rather fast with this second approach, since it is difficult to paint a gloomy scene when it in the meantime has changed to a sunny one. In watercolor it is easier to change a sunny scene into a gloomy one with some neutralizing glazes than it is to turn a gloomy scene into a sunny one.

3) *You can paint the landscape in shadow, with just the center of interest in sunlight.* That's the approach I prefer and will concentrate on in the next step-by-step demonstration. Look at your landscape and decide where your center of interest will be. Then, make a line drawing of your subject, and when the right effect comes along, indicate it quickly with a few washes placed over the pencil sketch. Also keep your camera handy to take some backup information. In your preparatory value sketches, test-hop the problem a bit, perhaps even in color. Let's give it a try right now.

Figure 6-5. I didn't catch the actual light condition in this photograph, but it is dramatic enough for me to attempt to reproduce it in a painting. The sunlight is beaming down on the distant peninsula and then slowly rolling over the water toward me. This subject has some very good value contrasts and would be fun to paint under any condition. After locating the sun, I set up as usual, with the board upright. Then, should the sun reach me, the paper will still be in the shade. The weather and locale spell humidity, but the wind should help dry the wet washes rather quickly.

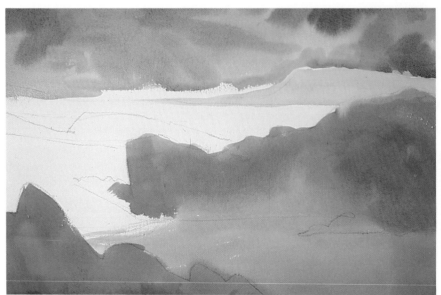

Step 1. After drawing in the major lines of the composition, I'm in a bit of a quandary as to where to start first. I decide to use guidelines one and four and begin with the lightest, most colorful area, which is the distant peninsula. I state it with a light green mixture of new gamboge yellow and thalo or Winsor green but keep it cool to create distance. When painting in that area with my #30 Goliath round brush, I'm rather careful with the top edge of the shape; but where it will disappear behind the dark lower rock, I paint the green right over that area. Why be careful if there is no need?

Step 2. Next, I must make up my mind where to go from here. The green is still wet, so I can't establish the sky area, since it will run right into that delicate color. But the lower rock area doesn't matter. I don't mind a light green running into that area, since it will eventually be darker anyway. Therefore, I take my 1½-inch (4 cm) flat brush and wash a mixture of burnt sienna, alizarin crimson, and ultramarine blue over the middleground rock area, diluting it for the lighter beach part and strengthening it once again for the foreground rocks. As you can see, some of the green does indeed run into the rock area, but it is nothing to worry about.

As soon as the peninsula is dry, I add the sky with a mixture of Ultramarine blue and burnt sienna, and while that is still wet, I strengthen the mixture to create varied cloud shapes and the beginning indications of the distant rain squall. Notice how dark the sky is when wet, but it will dry lighter.

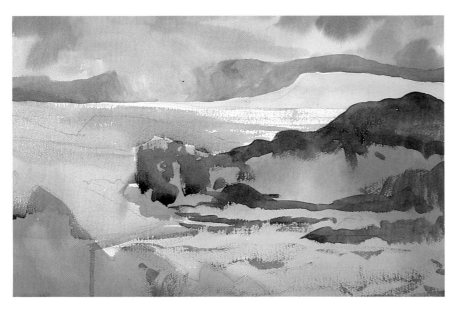

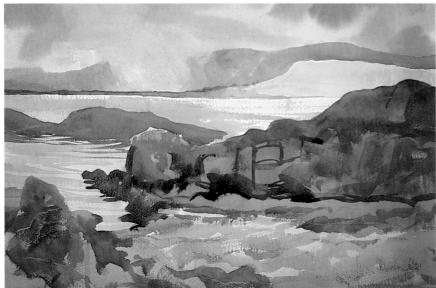

Step 3. I paint the water next, with a mixture of ultramarine blue and burnt sienna again, since it basically reflects the sky color. As I near the focal point of the peninsula, I use a drybrush technique to simulate sparkly water, dragging it right over the rock area in parts. You can see this especially in the foreground rocks. Again, why be careful if you don't have to be? Those rocks will be dark anyway. That's also why I don't worry about the drip in that same area.

While waiting for the water area to dry, I start indicating some darker parts of the middleground rock, still working with my 1½-inch brush. A few drybrush marks on the beach area begin to break it up as well. This dark mixture still is burnt sienna, alizarin crimson, and a bit of ultramarine blue.

Next on the program is the distant mountain shape. The sky is dry, the water as well, so it is safe to go into that area with a mixture of cerulean and ultramarine blue. As I approach the rain squall, I dilute the wash to clear water and carefully watch the action of the paint, so it will remain in the angle of the squall. The same procedure is used on the other side of the squall, where the mountain continues. While this shape is still wet, I add a nearer peninsula shape with some ultramarine blue, which will diffuse and create only a soft-edged suggestion.

Step 4. While the distant mountain is drying, I establish the rock shapes in the water with the same mixture as the foreground rocks, but add a little more ultramarine blue to force more distance on the subject. Although you may not see such a color variation, it is wise to keep the foreground much warmer than the areas behind it. Note that I take the rock shape and immediately paint the reflections as well. A dilution of this same mixture is used to break up the foreground beach area a bit more, keeping the corner more simple and leaving some of the earlier parts showing through so they can become top planes of rocks.

I add more washes to the middleground and foreground rocks, where I also use a credit card to create a few varied marks or top planes. A very dark mixture of burnt sienna, alizarin crimson, and ultramarine blue states the dark rocks at the water's edge as well as their reflections. (Oops, I have to watch out for that shape which at the moment looks like the Loch Ness Monster. We're in the wrong country for that.)

In the distance, I mix a dark green and place it at the water's edge, gradually lightening it as I work toward the sunny area. That area is also slightly reduced in value close to the edge of the paper. My # 12 round brush is used for some rock delineations here and there, and to add a few light-colored waves in the water.

Step 5. In this final stage, I switch to the smaller round brushes as well as the fan brush, to create textures in the rocks and the beach area. It needs another darkening glaze since it seems to be as light as the sunny peninsula. Some ferrule scraping is also done in this area which consists of small pebbles. More dark values of burnt sienna, alizarin crimson, and ultramarine blue are added to the foreground rock and that mixture is also used to paint in all the cracks and crevices in the middleground rocks. In the distance, I indicate a few more rock shapes sticking out of the water and with a cool, dark green, indicate some of the distant tree silhouettes. In the foreground, note that I have changed the dark reflections to eliminate the monster shape.

Now I can take this painting inside to see what else, if anything, it needs.

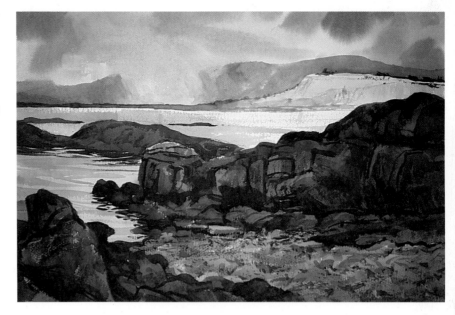

Demonstration 5

Late Afternoon

Pueblo Patterns

I really haven't even discussed when the best time for painting is. My answer, of course, is "Anytime!" But, let's face it, the early morning and late afternoon, with their long, drawn out shadows are ideal light conditions for the painter, although they change much more rapidly than you think. The morning light, generally thought of as cool, doesn't create the pressure to finish a painting like the warm evening light does. You can always continue painting on into midmorning, but in the evening, that light will be gone, so you're really racing the sun.

Having done that and lost the race too often, I developed another technique. I keep my eyes open for a good evening subject with pleasing shadow shapes. But rather than frantically setting up and doing a whole painting, I just try to do a few compositional pattern sketches. Then I note the time and place and, if the weather permits it, return the next day, about an hour earlier. In that hour, you can get yourself comfortably set up and establish your line drawing, since it won't change. And with watercolor's transparent advantage, you can even paint in the sunny values all over the painting. Once that is done, the shadows will more than likely be close to what they were the previous evening when you were attracted to the scene. So that is the time when you paint in those long shadows and glaze their value and colors over the dried, sunny values.

Figure 6-6. The Taos Pueblo has been the subject of many paintings, and there is good reason for it. This picturesque place is the oldest inhabited village in our part of North America, dating back over six hundred years. When visiting it late one afternoon, I wandered all over the area, and coming upon this scene, I kicked myself for not bringing my paints and equipment. However, I vowed to be ready the next day.

Step 1. With a regular 2B pencil, I make this rather detailed sketch. Notice that I don't bother indicating door and window-frame details. I do move a stack of wood closer into the picture, to break up an otherwise dull area. This was also done in the pattern sketch, as you will notice. No shadow lines are indicated, since those will change quickly and drastically in the later afternoon situation. A chance figure was caught in the narrow street, so I quickly indicate it, catching its size relative to the door; I hope I can remember what it looks like, later.

Step 2. Since the clouds in the sky will be affected by the lower rays of the sun, I'm reluctant to anticipate them at this time. I'd rather wait a bit longer. But since it is safe to paint the sunny values all over, I start with a light cadmium orange and burnt sienna wash and, with my 1½-inch (4 cm) flat brush, paint it over all the buildings and the foreground area. I strengthen the wash here and there and pick up excess paint along the edges with a tissue. If I don't do this, the wash will run back into the painting and form blooms or curtains, as they are called.

Next, I switch to the 1-inch (3 cm) flat brush and apply the basic wash for the distant mountain, which is a mixture of cerulean blue, new gamboge yellow, and some more cadmium orange. It is slowly getting closer to the time when those shadows are like they were the previous day, but I will not be tempted to put them in until they are right.

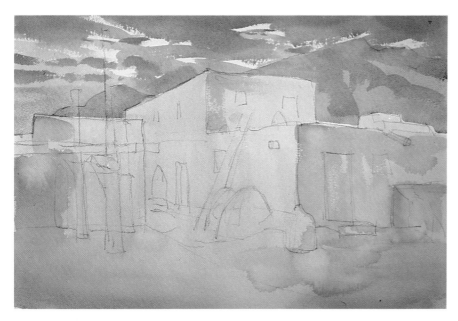

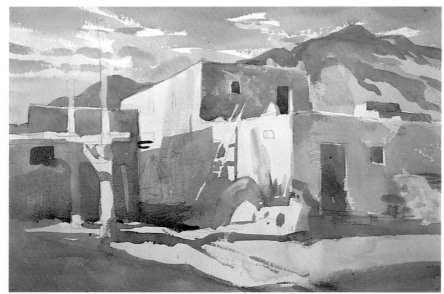

Step 3. As I mentioned, I strengthened some of the adobe color, and as you can see, those additions did form blooms or curtains. Some students, seeing those marks, give up in despair, when they really shouldn't. It all depends on where the marks appear. I wouldn't like any marks to be in the sky, but in this area, it doesn't matter since many other statements will be made on top of those washes.

Next, I tackle some of the half-tone shadows of the mountain, with cerulean blue and new gamboge yellow. I also state the smaller distant mountain shape at this time.

After that area is dry, I concentrate on the clouds and sky. Still working with the 1-inch flat brush, I mix ultramarine blue, burnt sienna, and a touch of alizarin crimson to suggest the clouds in a zigzag movement, leaving some white showing for the highlights where the clouds still receive a bit of sunlight. With a wash of cerulean blue, I indicate the sky as it peeks through the clouds and gradates down to the buildings. The shadows are getting better every minute.

Step 4. I mix cadmium orange, scarlet lake red, and some alizarin crimson to create a shadow color for the adobes, tempering it with cerulean blue. With the 1-inch flat brush, I apply that wash over all the shadow areas, avoiding the poles in the sunlight, the ladder, and the door and window frames. This is the only time when you have to be careful.

The two-story building is a bit tricky, since it is in half-light and you still see some nice long shadows on it. While that shadow wash is still wet, I add a bit of cerulean blue in the area where the figure is indicated, as well as in a few other places where a bit of neutralization is required. For the smaller shadows, I switch to the #30 Goliath round brush and indicate the cast shadows of the ladder and the poles.

While this area is drying, I return to the mountain with a mixture of ultramarine blue and burnt sienna to create the shadow patterns there. In the smaller mountain, I cut around the foreground poles. I notice that when the mountain shape was covered in its base color, I accidentally painted over two chimney shapes which should have been stated in the light adobe color. This time, with my darker blue wash, I do avoid them, but don't know yet if that will solve the problem. Meanwhile, the shadows aren't going to wait for me.

Returning to the dried adobe area, I mix a darker version with burnt sienna, alizarin crimson, and some ultramarine blue to indicate the dark doors and windows with a ½-inch (1 cm) flat brush. The adobe shadows of the distant two-story building are also indicated, but in a slightly cooler tone to create depth. As the shadows of the building approach the light, I darken them a bit and also add a few dark washes to the street in the center of the picture. Tracks are also added to the dusty street. All these items are stated in nice warm colors.

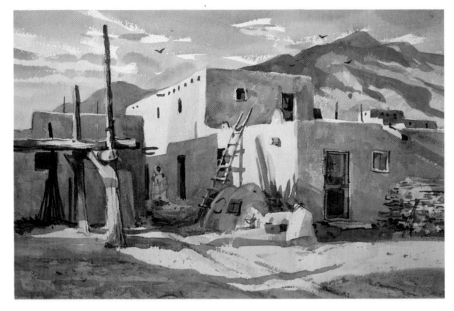

Step 5. Switching to the smaller brushes and darker colors, I indicate deeper shadow areas in the doors and windows and add yet another layer of the ultramarine blue and burnt sienna mixture over the mountain to bring out the adobe building in front of it. I also decide to eliminate the adobe chimneys and cover them with the darker mountain wash. I paint in the darker sides of the poles, as well as their long cast shadows which crawl over and describe the ground contour. I decide to add another cast shadow of a pole in the foreground to make that shape more interesting.

I develop the foreground even further with spattering and drybrush marks and add similar textural effects on the buildings. I place long cast shadows on the building in half-light and state the wood pile in more detail with the help of small strokes. Little dark spots simulate doors and windows of the distant two-story adobe and a dark burnt umber rectangle placed to the left of it, gives the impression that you see another part of an adobe building, but serves more as a value separation to distinguish the adobe from the mountain. They were too similar in value at that spot.

I develop the ladder, rungs, cast shadows, and general supportive textures and add a blue wash basket. I model the figure further, but unfortunately, it looks more like an Eskimo than a pueblo dweller—I'll have to change that back in the studio. The rectangular window in the left adobe seems isolated, so I add the stack of poles to tie it together with the rest of the scene. I add birds to create a three-dimensional feeling to the sky.

In the meantime, the sun has gone down too low, and perhaps it is trying to tell me something. So, I take its cue and call it a day.

Demonstration 6
Overcast Day

Bayou Black

The overcast day can range from being very light and luminous to very dark and moody. You might even hesitate to go out and paint under such threatening conditions. But to quote John Ruskin, "There is no such thing as bad weather, only different kinds of good weather." My method is to go out anytime it is dry and paint until the rain stops me from working. You'll be amazed at how few times you'll actually be forced to quit and how many more paintings you will be able to do. Those efforts will be especially appealing, too, since everyone paints the sunny day and it soon gets tiresome.

Since there are no strong dark and light shadow patterns, you must find contrasting local values when selecting your subject. I like to look for water reflections, since they show the light sky. Note that although the sky may be dark, it still is lighter than the earth values, since under all conditions, the sky is the light giver and the earth, the light receiver. If you make the earth values lighter, you destroy the overcast feeling. The charm of the overcast day is also reflected in the richness of colors, since the sun can't drown them with its strength. So, squint and look for value contrasts.

If I can find where the sun is hiding, I set up my easel so that the board will be in shade, just in case. You never know if and when that sun might suddenly appear. I hate to move the easel in the middle of a painting. With the absence of shadows, I resort to value sketches instead of pattern sketches. My watercolor approach depends on the humidity. If the paint seem to dry quickly, I'll start placing light washes all over the paper. But if the weather seems very wet and slow drying, I might approach the scene in a more piecemeal manner, as outlined in the rainy-day scene, *City Reflections.*

This demonstration, however, will be done in the first method.

Figure 6-7. The Cajun country of Louisiana reminds me a lot of my native Holland's lowlands and canals, although the foliage and weather in Louisiana are far more tropical. This photograph shows you a bayou scene in Houma, taken on an overcast day during a recent workshop.

Step 1. On the dry paper, from which I have previously removed the sizing, I carefully draw the scene's key lines, not bothering with the indefinite reflections. I then realize that I've fallen into the half-and-half trap along the waterline, but being reluctant to redraw everything, I remember that I can always trim off some of the top afterwards, if it really bothers me. Scissors are great painting tools. I must officially warn you that this isn't the ideal way to work. However, outside—with the pressures of light, time, and what have you—these things can happen. Relax and don't let it worry you too much.

With my first wash, I want to start off creating the overcast mood and therefore tone the whole paper, applying a gray mixture of ultramarine blue and burnt sienna with my 1½-inch (4 cm) flat brush. Toward the bottom, I fuse a stronger mixture into the wash so that it will form a gradation and a soft-edged wave effect. While that basic toning wash is drying, I try to scrape in a few marks, but find that they are really not needed at this point. I should wait until this rather dark wash is completely dry before going on.

Step 2. Once the wash is dry, I'm amazed at how much lighter its murky color has become. In fact, it even seems too light, but I can relate to it better than to white paper and can always darken it later if I need to. My next wash ignores guideline one, in this case. According to the guideline, I should paint the water shape next and then the darker areas. However, I feel the need to judge just how dark to make those houses and therefore reach for my darkest dark to state the trees. This is done with a heavy wash mixture of burnt sienna and thalo green. When dealing with such shapes, it is best to take your 1-inch (3 cm) flat brush and first establish the straight edges which will delineate the roof. Once that is accomplished, you can then relax and loosen up with the foliage shapes which don't have to be as exact.

Now that the tree values are stated, and while they are drying, I concentrate on finding the basic, lightest reflection in the water and paint this value all over the total area of reflections. I'm back to heeding the first two guidelines once more, but applying them within the shape. I paint the lightest value over the largest area, using a mixture of ultramarine blue, a bit of thalo green, plus some burnt sienna.

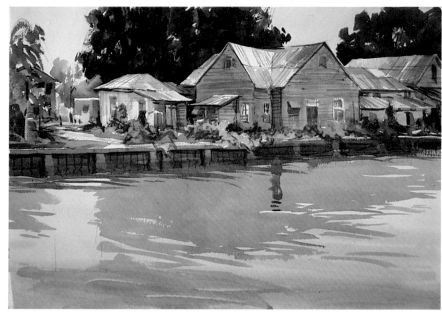

Step 3. Now that the largest areas are established, it is easier to judge the value of the buildings which are quite dark and not exactly a pretty color. Not wanting to commit myself as yet, I mix a gray with ultramarine blue and burnt sienna, and with the ½-inch (1 cm) flat brush, I paint in all the vertical planes, dropping some slight variations into that wet wash here and there. It is wise to keep your roofs light as long as possible. Many beginners tend to start off painting a rusty red roof and, because they are judging it against the white paper, get it much too dark. Keep in mind that roofs are tilted planes, receiving more light than vertical planes. If you keep your roof areas untouched until other parts of your painting are finished, you'll be able to tell more easily just how dark they ought to be stated.

The bulkhead and its reflections are applied with the ½-inch flat brush, still using the ultramarine blue and burnt sienna mixture, but leaning toward the warm tones. In the center area, some cutout shapes will take care of the overhanging foliage. I add a basic green wash of new gamboge yellow, cadmium orange, and thalo or Winsor green for the foliage masses, varying them constantly. The red building cuts around some of the foliage, and I immediately use that same red to add a roof at the right side of the painting for balance.

Step 4. Before tackling the reflections, I want to define the forms that cause them and therefore concentrate on the land at this time. My round brushes are used to delineate all details from the bulkhead boards up. The red roofs are stated with the ½-inch flat brush. Please note that when the red roof appears against the sky, it is dark, whereas, next to the dark tree, it is light. This value reversal happens quite often in nature and you should become aware of it, so that when it doesn't happen, you can *make* it happen.

I add small dark spots to form windows and doors, distant people, and lamp posts, while deeper darks added to the trees form branches and twigs.

Step 5. The water reflections, at last: with a mixture of ultramarine blue and thalo or Winsor green, I apply the reflection shapes with the #30 Goliath round as well as the ½-inch flat brush. I constantly refer to what is happening above the water so that the reflection will ring true. I apply a diluted form of the color mixture over the light areas to break them up a bit more. Since you can easily make water reflections too busy, and I'm doing just that, that's the sign for me to end this painting for now.

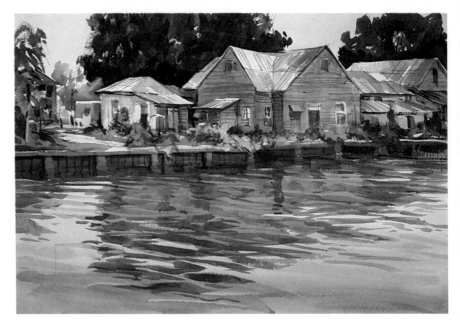

Demonstration 7
Rainy Day

City Reflections

I remember once landing in the Schiphol airport, where a sign proudly proclaimed that Holland had something like 250 days of rain a year. So to me, the rainy day is the Dutch-weather day. I don't like a real downpour but find light, drizzly rains exhilarating. And just look what they do to all those drab scenes you'd normally ignore—rain turns them into sparkling jewels just begging to be painted.

The humidity on a rainy day requires an approach different from my usual watercolor technique. You can't cover the painting with wet washes and expect to work into them right away. You'll either have to work in a more piecemeal fashion or wait forever until a wash dries. Luckily, the diffused light on a rainy day is more stationary than on a sunny day, so values remain relatively constant.

Because of the humidity, I make it a point to start on dry paper. I still try to establish a few large areas of wash, but I also leave large areas untouched. I can work in those white areas while the first wash is drying. Where needed, I keep a small, thin white space between the wash areas, so they won't run into each other while wet. At certain times, you'll just have to take a break and wait until an area is dry before going on.

The rainy day is also ideal for working in acrylics. You can start out in a watercolor manner and then go into a wet area with thicker, opaque paint. That way, you have less of a waiting period.

Let's make some general observations about the rainy day. First, your light source is diffused by the clouds, but the sky is still the lightest value. All the wet ground planes are almost as light, since they act as reflective surfaces. All the upright planes, with the possible exception of reflective windows, are darker than the sky. Tree branches hang down heavily and their trunks are much darker than normal. Notice that street reflections do not match the height of the objects being reflected; instead, they stretch out much longer. Puddles are great fun to paint and give you plenty of chances to practice reflections. Move them around a bit and place them at strategic locations where they'll reflect strong value changes. Think light against dark at all times. If your puddle reflects a light, make the dry surrounding area dark; then gradate the surrounding area back to light when it is next to a dark reflection in the puddle. It is good to observe the rainy-day effects exactly, so that when you start using your artistic license to move things around a bit, they'll still look believable .

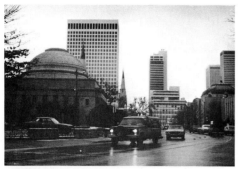

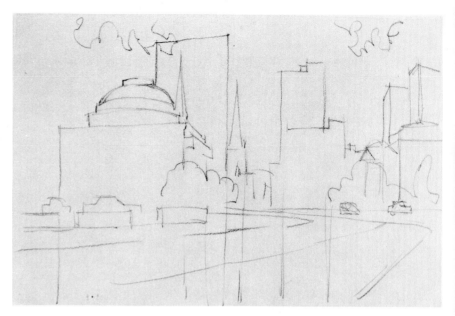

Figure 6-8. To find a good scene on a rainy day is one thing. Finding a parking spot from which to paint that scene is quite another. I didn't think that would be much of a problem on a Saturday afternoon though, and I headed for a scene I had spotted on a previous rainy day. Take advantage of rainy days to go scouting even if you don't paint. Then, when it rains again, you'll immediately know where to go. This picture was taken as an afterthought rather than to start with, so it catches the scene at a later time of day than my painting does.

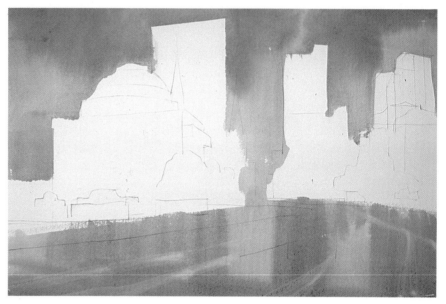

Step 1. On a wet day like this, it is important to start out with a dry sheet of paper. Make sure that the sizing has been removed before going on location, so the paper will have had a chance to dry. Draw the key lines in your cityscape, but don't bother drawing everything with the pencil, especially on a day like this, when the atmosphere is more suggestive than the details.

Step 2. To establish the rainy-day mood right away, I take ultramarine blue and burnt sienna to mix a blue gray, and with my 1½-inch (4 cm) flat brush, I paint it all over the sky, cutting around the buildings this time. If I don't avoid the buildings, I will have to wait much longer for the total sheet to dry. Since the road is a reflective surface, I paint it at the same time. While this wash is slowly, very slowly drying, I add a stronger mixture of the blue gray to the sky to indicate cloud variations and to the road to show building reflections which will all be soft edged. So you see, I still use guideline one and begin with the lightest value. I take it over the largest possible area, guideline two, and state items which shoud be soft edged, guideline three.

Next, I take a tissue to make some of the early tire marks, which may not even be noticeable in the finish but will still be part of the total effect. And now I just have to wait until that wash dries, because the buildings are hard edged and I don't want to risk having their edges bleed into the sky. A battery-operated hair dryer sure would come in handy at a time like this, when the wash never seems to dry. The best thing to do is to just take a break and come back later. Luckily, the light will remain virtually the same.

Step. 3. As soon as that first wash is dry, you can concentrate on the next large section of the painting, which consists of all the buildings lumped together. I paint in the base tones with my ½-inch (1 cm) flat brush, varying colors constantly as dictated by the local colors of the buildings. Don't worry about these colors blending together softly, as can be seen on the right side. I only concentrate on having the values dark enough against the sky and keeping the warm colors up front and the cool ones in the background. I also take some of the colors directly into the street again, rewetting parts of it with clear water to soften edges. Note that I have cut around and saved a few car shapes and edges, as well as some early puddles. I'll need to take another break to wait for this wash to dry, but after that, I'll only be working in small areas and will be able to paint without stopping.

Step 4. Just before the last wash dries, I scrape in with my knife some tire marks, which you see in the bottom part of the painting. In this stage, I begin adding smaller glazes to turn corners, as in the domed building and again, at the right time, scrape in a cornice detail. With the ½-inch flat brush, I add some calligraphic indications for windows and other marks to give character to the buildings, making sure that these additions do not jump the plane; that is, that they remain light enough to belong to the buildings. If you use too dark a value on the details, they will advance more than the plane to which they belong.

I add the dark curb as well as the round traffic markers in the street, to make the street lie flat and create a flow into the painting. I make a very dark green from burnt sienna and thalo or Winsor green and use it to separate the domed building from the background structures as well as to indicate foliage, which breaks up the uninteresting foreground rectangle. Luckily, the foliage was there, but if it hadn't been, I could have invented it to make my shape more interesting. While in the area, I add darker burnt sienna washes to create the rectangles of the foreground wall and delicate horizontal strokes to give texture to the road. I changed my mind on the overhanging foliage and feel that the bare branch is more in keeping with the mood of the painting.

Step 5. The finishing details. With the smaller round brushes, I add more calligraphic marks to the buildings. The tallest building is somewhat of a problem, since all its windows are clearly seen; but if I paint them all meticulously, the area will become too busy and will move forward, thus destroying depth. I'll leave that area alone for a while and concentrate more on the foreground. It is always a good idea to do the foreground details first and then paint the background in relationship to them.

Since the foreground wall is made of some big stones, I hit the area with my ½-inch brush whenever there is some color in the brush that comes close to those stones. This slapdash approach is better than concentrating only on the wall and rendering it. I add the church towers with a small round brush, paint the windows in the domed building, and add linear details as well. I add windows to the green-domed building, which is another church, and with the long-haired brush I indicate some trees in burnt sienna, smudging an edge here and there with my thumb.

I guess now is the time to concentrate on that tall building, and I'm amazed at how few details need to be added with my ½-inch flat brush to suggest the windows. The intense dark I use in the cracks of the road and in the decorative ironwork is mixed from burnt umber, ultramarine blue, and alizarin crimson. Finally, I add some birds to the sky and buildings to create distance. It has been a nice painting day inside my traveling studio—up to now. A policeman just stopped to inquire why I am parking in this spot. I hope I can make a friend out of him and avoid a ticket; if not, the price of this painting just went up!

IN RETROSPECT

In this chapter, I have tried to re-create some actual outdoor experiences for you and talk about them as if you were watching over my shoulder. In fact, in some ways, I've been able to give you more information than during an actual demonstration, since the explanations were written afterward, based on seeing these step-by-step photographs. I can always recall what I did, but in the midst of the battle, the artistic mind has to fully concentrate on the painting problems and as a result, the verbal dialogue leaves a lot to be desired. Such is the makeup of our brain, as you'll understand after reading Dr. Betty Edwards's book on the subject, as listed in the bibliography.

It is generally known that it takes two persons to paint a painting: one to actually paint it and one to knock the painter over the head so that he or she will stop. My students often tell me they liked a painting better at an earlier stage. I remember seeing other artists' demonstrations and thinking the same thing. It is a good idea, therefore, to never complete a painting on the spot. Avoid the danger of overfinishing it. Outdoors, after you have been battling the elements and constantly tossing decisions around in your brain, there comes a time when your mind gets tired and can give you the wrong advice. Normally, if I work one hour to one and a half hours on a painting and then stop, to finish it later, I'm less likely to ruin it. So when you're tired, quit and take a rest. Get away from your work for a while, even for five or ten minutes. When you come back with a fresh eye, you may just see what needs to be added or corrected. And if you don't, take the painting home and let it sit around the studio for a while.

Chapter 7
The Indoor Aftermath

There will always be the painters who only work in the studio, or those who only work outside. But, really, you need to do both. You need to go outside to see nature under different light and weather conditions, and you need the studio environment to get away from the confusion and the temptation to add all those details. Once you know everything about a subject, you can eliminate the unessential and even go after a more creative interpretation of it. As an example, I would like to use *The Bathers* (Figure 7-1) and *Stream Impressions* (Figure 7-2). I couldn't have done the more interpretive version if I hadn't taken the subject apart and examined it piece by piece realistically first.

But since this book is based on the first week of my workshop teaching format, I only intend to cover representational painting now and leave creative interpretations for another time. In this chapter, let's concentrate on what happens to your unfinished outdoor efforts after you return to your studio. I'll talk about the quiet analysis period that takes place, the salvaging efforts, and how to add those finishing touches, before signing and framing your work.

THE ANALYSIS PERIOD

When I come back from an extended painting trip, my "catch" usually consists of goodies, problem children, and lost causes. The goodies may be few and far between, but they sure boost my spirits! Paintings in that first category go through a final analysis which usually lasts a few weeks, and then they are signed, photographed, and framed.

The problem children I pin up around the studio for further evaluation. Even if I only glance occasionally at them, it will keep their problems in the back of my mind. If no quick solution presents itself for a particular painting, I might just put it away for a while and bring it out again a month or two later for a fresh view.

The lost causes I place in a bin labeled "Use Other Side." Or, if it is a 300-pound paper, it goes into another bin, labeled "To Be Gessoed." Don't ever throw a good painting surface like that away, because it is ideal for acrylics. If you were able to look underneath my acrylic paintings, you'd likely find the remnants of two previous watercolors. I usually wash most of the paint off the watercolors and then apply two coats of acrylic gesso on both sides of the paper, to keep it from curling. Occasionally I have even used this surface to paint other watercolors. But I worry about their permanency. On an acrylic gesso base, it's probably safer to stick with acrylics and, if you like, do them in a watercolor manner.

Since the problem children are the concern here, you first need to ascertain if the problem painting really needs anything more, and then, what it specifically needs. Don't touch the paper until you know what you need to do. The idea might not come right away. It may take a few months, but it is better to leave the painting untouched than to dab at it, hoping something will happen. You may ruin the good you accomplished before.

I find it useful to get a different look at a painting when I'm having a problem with it. Sometimes, I will look at a painting in a semi-dark room. If it reads well there, it will read well under regular lighting. Or, I might turn a painting upside down, or look at it in a mirror. Looking at your work in different ways will help you locate a problem which has been nagging you, but

Figure 7-1. *The Bathers.* 15 x 22 in. (38 x 56 cm). Waterfalls hold a great fascination and present a challenge to artists. I studied this one, in Woodstock, New York, section by section in order to learn the action of the water. It's all cause and effect, but as the water madly rushes by, you have the impression that the forms are constantly changing. I don't recommend such a subject to beginners.

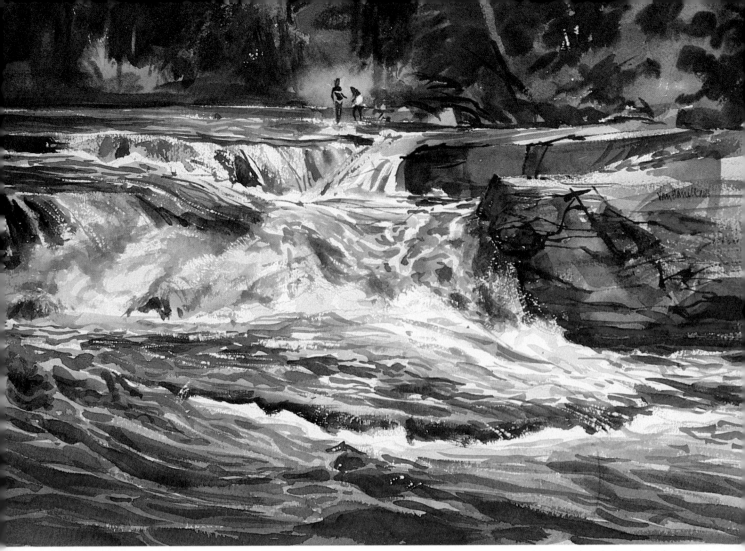

Figure 7-2. *Stream Impressions.* 15 x 22 in. (38 x 56 cm). Here's a more artistic version of the same stream, painted after I had thoroughly explored the scene in a realistic rendering. Realism is the base, your takeoff point. You need to master it to be able to state the essence of your subject.

which you couldn't readily see when viewing the painting in the normal manner.

A working mat not only lets you view your efforts in their best light, but it enables you to make better judgments about them as well. I use a medium gray mat with a white liner, since that seems to go with just about anything I pop into it.

Another analysis method I frequently use is to select a small section of a painting and eliminate the not as successfully handled areas with a pair of L-shaped mats, as seen in Figure 7-3. Although your goal is to present a subject within a selected painting format, salvaging at least part of a less successful effort may be a helpful boost to the morale.

Figure 7-3. A pair of L-shaped mats can be moved around to view different cropping possibilities and eliminate areas which don't please you.

GENERAL QUESTIONS

While analyzing your outdoor work, away from the actual scene, you ought to ask yourself some general questions: What do I want that painting to express? Is it doing that? How can I express it even better for the viewer? Is my composition balanced? Does it actually need balancing? Do I have a dominant shape, color, or temperature, or should I increase dominance somewhere? Should I add figures to express mood or give scale to the scene? Should I trim the painting and mat it smaller? Should I strengthen a value here and there? Do I really have to touch the painting or is it finished?

Don't underestimate the advice of nonpainters. Although they might not know how to correct something, their reactions are similar to those of experienced, prospective, but silent, buyers. Pose some nontechnical questions and see how they answer. Then it is up to you to accept or disregard their recommendations. I've found it pays to listen.

PREVIEW POSSIBILITIES

Once you know what needs to be done to finish a painting, you may first wish to try it out on a sheet of workable or wet-media acetate. It is a specially treated acetate that accepts watercolor paints. Without committing yourself on the actual painting, you have a good idea of the resulting effects. I used the acetate on *Killarney Blarney* (see Figure 7-16), to see what would happen if I were to eliminate the distant rain squall and pop in a few figures. The rain squall elimination was vetoed for the finished painting (Figure 7-17).

Another preview possibility is shown in Figure 7-9, where I snipped white paper into roof shapes and moved them around to see where they would look best. Once you have decided on what you need to do, you may have to remove a section of the watercolor and repaint it.

REMOVAL TECHNIQUES

SPONGING OUT. My favorite way to remove paint from an area that needs repainting is to use a small, natural sponge. I wet it and lightly lift the paint off the paper, while constantly blotting with a tissue. *Arroyo Seco* (see Figures 7-14 and 7-15) had two areas which I felt needed repainting. Unless dye colors are used, most paint can be removed quite easily.

MASKED-OFF SPONGING. This method is a variation of the one above, but in this case, you are actually creating an effect that needs little or no repainting. All the light roofs in *Clouds over Colorado* were first masked off with three postcard-sized sheets of paper, and then the paint was removed to create the final effect (see Figures 7-10 to 7-12). Once dry, the darker details can be added to complete the painting. In *One of These Days* (Figure 7-4), I reclaimed all the boards and papers on the wall with the help of masks. Actual postcards make ideal masks, since the writing side doesn't slip easily and the plastic-coated side is water resistant. That's, of course, the side you'll use face up. Another variation of masked-off sponging is to tear the postcard and place it slightly separated on a dark green area. Remove the paint in the visible area and the effect creates a light trunk or limb, as seen in Figure 7-5. Some artists even cut out acetate masks of bird shapes in order to wipe them out of a dark area. That might have been a good idea to use in the big rock area of *Killarney Blarney* (Figure 7-17).

LIFTING. Some very nice effects can be achieved by painting just with clear water. Simply take a small round brush, dip it into clean water, and "paint" a limb, twig, or grass into a dark area. Turning it sideways so

Figure 7-5. Whenever you have a dead, dark area, you can liven it by tearing some paper and placing it slightly apart over the dark area. Remove the visible paint with a sponge and you create a tree. The limb was added in the same manner, with the same pieces of torn paper.

that you can see the wet shine, take a tissue, and vigorously wipe the area just after the shine disappears completely. The result, as seen in Figure 7-6, will be lighter lines within a dark area, providing the area wasn't painted in a dye color. Sometimes you might wish to soften a hard edge here and there. To do that, take an old, clean, bristle brush and with clear water, scrub the area you want to soften, as seen in Figure 7-7.

RAZOR BLADE SCRAPING. When I needed to show the thin light edge of the wall in *City Reflections* (Figure 7-21), I used a single-edge razor blade to scratch the paint off, making the white surface of the paper show through. It can only be done when the paper is dry and is safest on the heavier papers, although I use the technique on 140-pound paper as well. Small weeds can also be created this way, as seen in *Clouds over Colorado* (Figure 7-12) and *Arroyo Seco* (Figure 7-15).

SANDPAPER SCRAPING. Although I've done it only a few times, a nice, coarse-grained piece of sandpaper used in one swipe—not with the usual circular motion—over an area can create a patch of light weeds in a grassy field or the effect of a splashing waterfall or wave, as seen in Figure 7-8. The paper has to be dry and the effect is best displayed in a dark area.

REPAINTING TECHNIQUES

GLAZES. The most often used repainting technique is probably the glaze, which, as seen in *Bayou Black* (Figure 7-19) can darken a painting. After seeing the outdoor effort in the studio, I didn't feel that it conveyed

the overcast day enough and therefore added some blue gray glazes to emphasize the mood. At another time, the glaze can be added not only to darken, but also to neutralize an overly colorful area, as was done in *Arroyo Seco* (Figure 7-15), where the main foreground rock area just seemed too light and colorful.

ADDING DARK DETAILS. Oh, the awful temptation of details and the sheer beauty of an understated area. However, in *Clouds Over Colorado* (Figure 7-12), I had to add the fence to gain depth and the buildings to offer a size comparison. Birds in the sky also create the feeling of depth. All those details are added with darker, more concentrated paint.

ADDING LIGHT DETAILS. Although I seldom resort to using opaque paint, I'm not against it. Sometimes there are effects that simply can't be achieved any other way. The danger for a beginner, or someone switching from an opaque medium, is that you might depend too much on it and lose the idea of transparent watercolor. A student once visited the studio to show me some of her work. She apologized for the white paint here and there, saying, "I know I shouldn't use that." Reaching for my books on John S. Sargent and Winslow Homer, I told her she was in good company and showed her where those great masters had used it. That old purist controversy dates back over a hundred years and really isn't even worth talking about. You're after the end result—and how you obtain it is your own business. When I need to state some small area in an opaque manner, I mix Chinese white into the watercolor mix-

Figure 7-6 (left). You can even paint with clear water. This lifting works best on a hard surface paper and with nondying pigments.

Figure 7-7 (right). To soften a hard edge, take a clean bristle brush and clear water and scrub the area you want to soften, then blot with a tissue.

Figure 7-10. Next I placed three postcard-sized masks around the roof shape and removed the paper cutout. With a small sponge, I lifted the paint and blotted the area with a tissue to remove excess water. I used white masks here because they would show up clearly in the photograph. In practice, I prefer to use actual postcards, since their writing sides do not slip and their picture sides have a water-resistant, plastic coating.

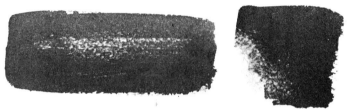

Figure 7-8. A coarse-grained sandpaper, swiped in one motion, can create a patch of light weeds in a grassy field or the effect of a splashing waterfall.

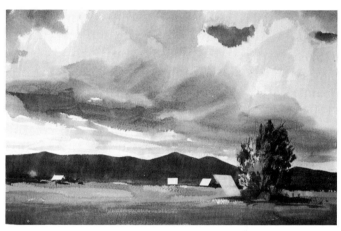

Figure 7-11. After the mask and paint have been removed, this is the result. Although the sponged-out area is much larger than needed, I can repaint it up to the roofline. Some artists like to use transparent acetate masks to see where they are in a painting. That is a good idea for exact work.

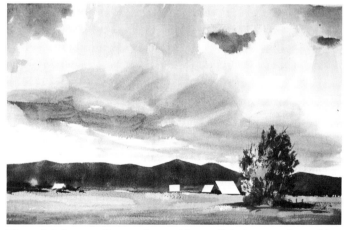

Figure 7-9. Because I wanted to see if some light barn roofs would enliven the landscape but did not want to commit myself yet, I snipped some roof shapes out of paper. Using this trial method is better than just hoping the result will look right.

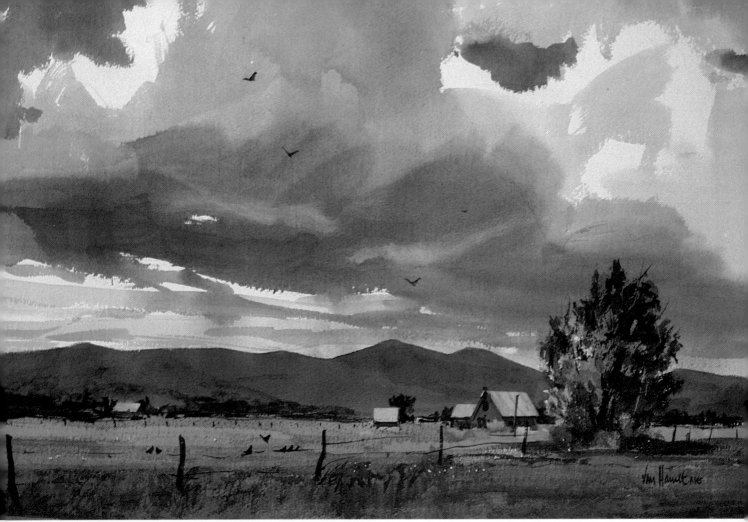

Figure 7-12. *Clouds Over Colorado.* 15 x 22 in. (38 x 56 cm). After finishing the barns, I darken the foreground with some additional green drybrush scumbles, creating the effect of a cloud shadow rolling across. I add fence posts to give depth. When you paint fence posts, don't just make them smaller in the distance, make them thinner as well. Also don't bother indicating wire in the distance; you wouldn't be able to see it anyway. Note that the slight linear indications in the distance make a believable fence because I have fully described a fence up front.

I paint more trees at the foot of the mountains and glaze delicate neutralizing washes over the mountainsides. I place birds in the sky so they form a line to the main focal area. I erase some of the pencil marks where they show on the white paper, but I don't dare touch the ones underneath the cloud washes. While removing them, I could also remove paint, and that would show up more than the pencil lines. As a last touch, I can't resist adding the birds on the fence.

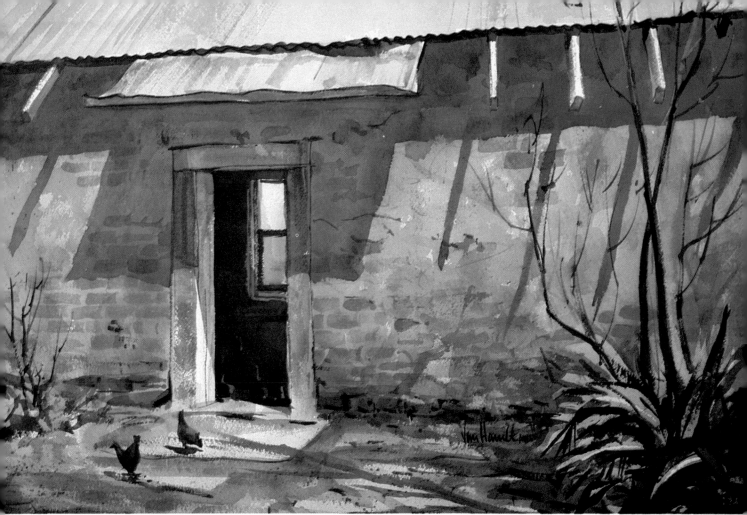

Figure 7-13. *The New Inhabitants.* 15 x 22 in. (38 x 56 cm). After
looking at this painting for quite a while, I feel that more of a value
difference between the vertical wall plane and the roof is needed. I
scumble more warm but neutralized tints of yellow and orange over
the wall to give texture and darken it at the same time. If you look
back at step 4, in Chapter Six, you'll see that the brick marks form
an even diagonal shape in direct opposition to the diagonal shadow.
I don't like that, so I indicate more brick textures to completely lose
the shape. One of the chickens blends in too much with a dark line
of the door jamb, so I sponge out some of the background. Next, I
remove the paint off the left roof support beam with a razor blade,
so that it will match the other three. Last, I add a window frame in
the opening and place a light wash over it to indicate dirty glass.

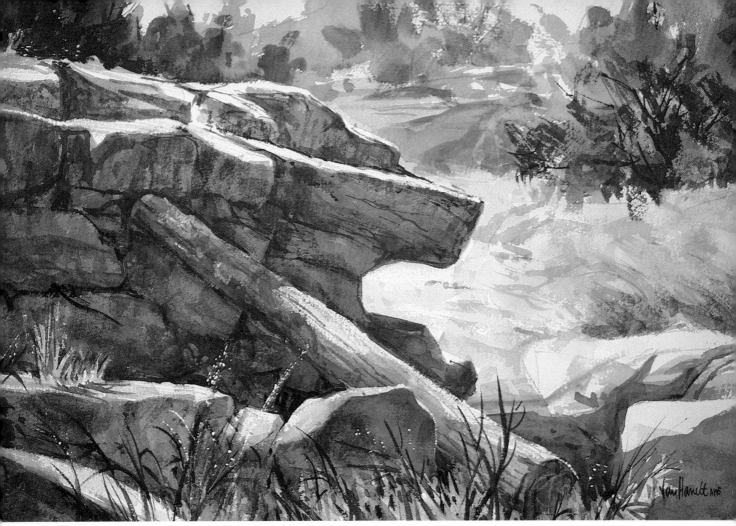

Figure 7-15. *Arroyo Seco.* 15 x 22 in (38 x 56 cm). If you look back to
step 4 of this painting, you'll see that I somehow created two tangent
areas which are disturbing. I promptly sponge those out, as can be
seen in Figure 7-14, and then repaint the foreground rock to make it
prominently overlap the log. Where the log touches the main rock
shape, I extend a vertical crack so it will continue in the area under-
neath the log. Also, I add a bit more texture to the log and smudge
an edge here and there to show its roughness.

Although I do it reluctantly, I darken the main rock shape once
again, since it still seems a bit too light in comparison to other dark
areas in the picture. I add more darks in the cracks and crevices. I
also add a big shadow shape over the lower right rock to break up its
dull square shape and help balance the darks. Note how I cut
around some foreground grass at the same time. In watercolor,
you're always doing two things at once with a shape. In this case, I'm
indicating a shadow falling over a rock while delineating light fo-
liage in front of the rock. In an opaque medium, you could just
come back later with a light grass color and add it on top of the
shadow. To finish this painting, I add some razor blade scrapes and
flicks here and there, bringing sparkle back into dull areas.

Figure 7-17. *Killarney Blarney.* 15 x 22 in. (38 x 56 cm). Referring to the idiomatic meaning rather than the geographical location of the place, I couldn't resist this title for my painting. The Irish landscape always manages to present itself at its best and talk any visitor into staying longer. As you can see, I decided against eliminating the rain squall. How else does Ireland stay so green?

Looking at step 5 in Chapter Six, I feel the rain cloud needs to show more of an underbelly. I take my 1½-in. (3 cm) flat brush and with clear water carefully moisten the sky from the left corner of the paper over to the light peninsula and down to the water's edge; I make sure that no section within that shape is skipped over. I then add the darker horizontal underbelly with a blue-gray mixture of ultramarine blue and burnt sienna, which nicely diffuses into the moist surface. This type of addition has to be very controlled and carefully done.

Next, I paint the figures which seem to be at the right spot on the rocks, although they are rather centered in the painting. I add the birds and boat at the same time, but lightly, so they will appear at the right distance in the picture plane. I then continue analyzing the middleground rocks and finally change their shape a bit, adding darkening washes over them and some accents of very dark cracks and crevices. The pebble beach shape seems too straight, so I add a large foreground rock to break it up for more interest.

After another analysis period, I decide to add a dark blue glaze over the distant mountain above the peninsula, to emphasize its light even more. I add a mixture of ultramarine and cerulean blue very carefully and "lose" it in the rain squall; that is, I gradually dilute the mixture to clear water. That addition seems to really make the painting pop.

Figure 7-18. *Pueblo Patterns.* 15 x 22 in. (38 x 56 cm). After having this painting around the studio for a few days, I first decide to sponge out the Eskimo with the help of a few protective masks over the neighboring areas. I then start my search for better clip-file information on Taos inhabitants, since my fleeting glance of the man just wasn't enough to go by. I then give the man another try, add a sweeping woman,

After several more days of contemplation, I decide to add a darkening glaze over the foreground shadows, so that their values won't be similar to the vertical ones. As a last touch, I place a couple of brooms next to the door and add a shadow at the same time.

Figure 7-19. *Bayou Black*. 13½ x 22 in. (34 x 56 cm). The more I
looked at this painting in step 4, Chapter Six, the less it convinced
me of the type of day I remembered. My first teacher and friend, Jay
O'Meilia, always admonished us to "overstate" everything. So the
only thing for me to do here is to darken the whole painting and
knowingly lose some of the sparkle now present. How else can I
show a moody, overcast sky?

I mix an ultramarine blue and burnt sienna wash and glaze it all
over the water, then over some of the sky areas, and even over some
of the buildings to darken them. You can't just darken one area;
you must move all your value relationships a few notches down the
scale. For example, I find that I have to darken the reflections in the
water to be consistent with the darker houses above them. I add a
wash of neutralized red to the light roofs and even tone down the
path a bit. Now at least I've achieved the gloomy feeling of the day.

After a few more days of analyzing, I decide to reclaim some
lights on the roofs by masking off with a few postcards and remov-
ing paint with a sponge. Since the dark bulkhead and the waterline
have become one dark shape, the half-and-half division is no longer
obvious. Your eye now sees the light grass instead. However, I still
decide to trim off some of the top of the painting, to make the water
area more dominant.

There is a Bayou Black in the area, although it may not be this
one, and that name seems to fit well with this moody rendition.

Figure 7-21. *City Reflections.* 15 x 22 in. (38 x 56 cm). This painting is virtually finished as seen in step 5, Chapter Six. I only feel that the domed church needs to be pushed back a bit, and therefore I add a blue-gray wash to dull and darken it. Consequently, I need to darken the reflections as well. I add the reflection of the building in the puddle and one more traffic bump on the road. A few touches of cerulean blue help to push back and separate some of the distant buildings.

I feel then that the road should be a slightly different value from the sky, so I add a light blue-gray wash over all of the road surface. I consider adding a figure with an umbrella and locate my clip-file information for it, but then I decide against it to keep the deserted feeling of the scene. I also consider the idea of adding some angled razor blade scrapes to simulate rain drops, but reject the idea. Why say more? A few dark reflections placed underneath the cars and smudged with my thumb are the final marks on this painting.

Oh yes. The policeman? After showing him what I was doing, I got off with just a warning.

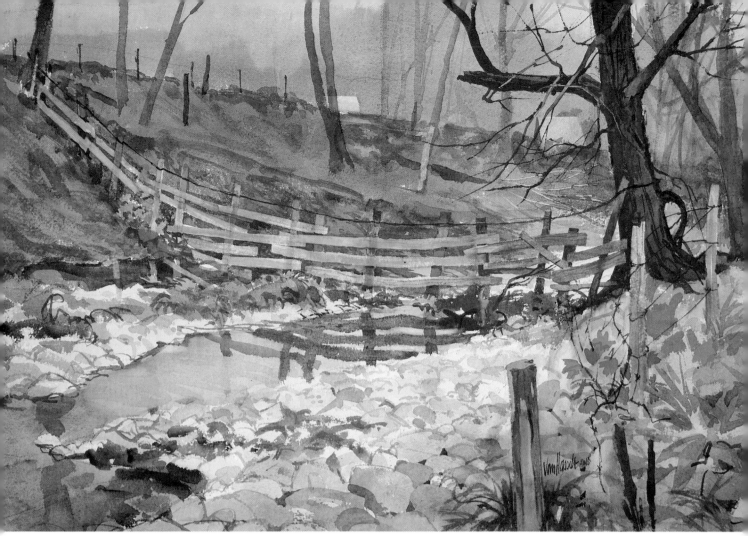

Figure 7-4. *One of These Days.* 22 x 30 in. (56 x 76 cm). Many of the pieces of wood, as well as the papers on the wall, were reclaimed with cardboard masks and sponges. This painting is another example of indoor subjects you can find for a rainy day. The window did not exist but was added to balance the large light area on the left.

Figure 7-14. Sponging out is the easiest and quickest way to remove paint without damaging the paper. I use a small sponge and blot the area with a tissue to remove excess water.

Figure 7-16. Wet-media or workable acetate has a special surface which easily accepts watercolor and gives you a wonderful opportunity to preview any changes you have in mind. Just lay the acetate over your painting and paint the changes on the acetate. In this case, I wondered if I should eliminate the rain squall and just show mountains in the distance. I also added a few figures, birds, and boats.

ture to create the desired color. Sometimes I'll use straight Chinese white if the effect can't be achieved by scraping with a razor blade.

On occasion, a dark mass which seems too heavy, may be brought back to life by covering sections of it with pastels. I've never done it myself—since pastels and I don't seem to get along—but some watercolorists seem to have very good luck with it. Again, it is the end result that counts.

SWITCHING MEDIUMS

If you have a bad painting, but aren't willing to give up on it, you might want to consider turning it into an

Figure 7-20. Single-edged razor blades are fine painting tools for reclaiming small white areas in a dry painting. In this case, I carefully scraped the top plane of the wall to make it look wet and sparkly. I could never have retained that sparkle from the beginning unless I used a masking solution. I also reclaimed the white birds in front of the tall building in the same manner. But be careful not to overdo these special techniques.

acrylic, especially if you are working on a 300-pound paper. The watercolor base mixes very compatibly with the acrylics on top, and you can slowly paint more opaquely to solve your problem. Once you have solved it, you can always repaint the subject in watercolor.

THE CLIP FILE

The clip file is commonly referred to by artists as the morgue, but that makes me visualize drawers of dead bodies with labels tied to their toes. Each artist has his or her favorite way to organize reference material clipped from newspapers and magazines. I keep the most often used subjects in files labeled "Birds," "Dogs," "People," and so on. Then for small incidental items, I refer to books, magazines, and issues of the ure 7-18), I refer to books, magazines, and issues of the old faithful *National Geographic*. To save research time, buy the National Geographic index, which covers decades of material. Let me make clear that I only pick up incidental parts from a photograph, and no more. Don't copy a published photograph verbatim, since everybody will know where it originated. Besides which, most published photographs are protected by copyright laws. If you have to copy a photograph, use one of your own instead of one that is widely available.

FINISHING TOUCHES

Let's take the outdoor work and see how it can be finished by using some of the techniques discussed in this chapter. On the following pages, you'll see reproduced the final steps of my demonstration paintings. I'll discuss just what finishing touches were used where and the reasons for doing them.

KEEPING TRACK

Once a painting is finished, I make a photograph of it for my file. The photo doesn't have to be the best, just good enough for me to recognize which painting it is. I tape the photo to an index card and write on the back information such as title, medium, size, awards, frame cost, sales price, and current location. I used to just list the title of a painting, but being visually oriented, I couldn't remember just which *Still Life with Vase* was which. The photograph, no matter how bad, eliminates that problem. When I have sold a painting, I pull its card from the "available" file and note the sale date and price on the back, as well as the name and address of the owner. At the end of the year, I also use this information for income tax purposes.

FRAMING

If you're like me and don't own a great mat cutter or are not the most handy person in the world, it is most important to establish a good working relationship with a framer who has the knack to present your painting at its best. A frame shouldn't steal the thunder away from your efforts. It should, in fact, focus attention toward the center. I prefer double or even triple mats, using tasteful combinations of colors. A sheet of neutral-PH-factor paper should be placed as a barrier between the painting and the backing board, to protect the painting from the chemicals in the board. As to frames, I like both metal and wooden ones, depending on the subject. The more contemporary subject material, for hanging in offices or modern homes, looks perfectly well in a metal frame. For other decors, the wooden frames look better, as my framer will wisely suggest. I usually agree with her suggested style and color combinations. If I don't, we work together to come up with a better combination. I avoid nonglare glass because I don't like the unfocused look it creates when you view the painting from an angle. However, when a large painting must be hung in an area with reflecting windows, it may be best to use nonglare glass. In such a case, keep the glass as close as possible to the art, to minimize the unfocused effect. I use a single mat between the glass and art and linen liners on the *outside* of the glass.

In my opinion, the best framing buys on the market today are the metal frame sections which you can fit together quite easily. Precut mats in stock watercolor sizes can be bought or ordered by mail, so even on a small budget, your work can be tastefully framed. Since the frame strongly affects your painting, it is well worth the time, money, and effort you spend to fit it properly.

A FINAL CHAT

Well, we are about to part company for a while. I hope you've had as much fun reading this book as I have had writing it. Naturally, no book is ever complete, but I hope this one will *really* get you started to paint outside. And now it is time to turn you over to the greatest teacher of all, Mother Nature. Make time to go out and paint. Have all your gear packed to go at a moment's notice. If you like, find a painting buddy and go together regularly each week. You may find it best to start off in the morning. Paint first, and then do all those other things you need to do. Don't feel guilty. That old saying "First work and then play" doesn't apply to us artists, since painting *is* our work. Believe me, if you start the day off doing something you enjoy, the other drudgery goes much easier and you're in a better frame of mind. Besides that, you'll be a nicer person to be around.

Naturally, there will be some discouragements along your artistic path. But they at least show that you did something rather than just talk about painting. There are a lot of talkers in this field. Don't be one. Be a doer instead. After each discouragement, pick yourself up and try again. Search for the reason why the work didn't turn out right and avoid those same mistakes. Art is honest. You do get what you pay for. No boasting, politicking, or social climbing will make you paint better. Only honest effort will do that. Hard work is the shortcut most people look at as taking too long. Don't you make the same mistake. The fun, enjoyment, and happiness far outweigh the little disappointments here and there.

Until we meet in some beautiful corner of that great studio without walls, let me pass on a nice little saying by a fellow Dutchman:

> *Use what talents you possess.*
> *The woods would be very silent*
> *if no birds sang there except*
> *those that sang best.*
>
> *—Henry Van Dyke*

Good luck and good painting!

Bibliography

We're extremely lucky to live in an era and in a country in which art books proliferate. I read them all and learn something new every time. These books give you a chance to get to know how your favorite artists think and operate. A better opportunity than this does not exist except in a few—a very few—art schools. Therefore, read! Don't just look at the pretty pictures. Study these books and do the exercises the authors suggest. Here are some of my favorite titles.

FOR GENERAL READING

Henri, Robert. *The Art Spirit*. Philadelphia: J. B. Lippincott Co., 1960.

Franck, Frederic. *The Zen of Seeing*. New York: Vintage Books, 1973.

Hawthorne, Mrs. Charles W. *Hawthorne on Painting*. New York: Dover Publications, 1960.

Miller, Henry. *To Paint Is to Love Again*. New York: Grossman Publishers, 1968.

Shahn, Ben. *The Shape of Content*. Cambridge, Mass.: Harvard University Press, 1974.

FOR ARTISTIC GROWTH IN REPRESENTATIONAL PAINTING

Edwards, Betty. *Drawing on the Right Side of the Brain*. Los Angeles: J. P. Tarcher, 1979.

Clifton, Jack. *The Eye of the Artist*. New York: Watson-Guptill Publications, 1973.

Carlson, John F. *Carlson's Guide to Landscape Painting*. New York: Dover Publications, 1973.

Graves, Maitland. *The Art of Color and Design*. New York: McGraw-Hill Book Company, 1951.

Whitney, Edgar A. *Complete Guide to Watercolor Painting*. New York: Watson-Guptill Publications, 1974.

Reed, Hal. *How to Compose Pictures and Achieve Color Harmony*. Tustin, Cal.: Foster Art Service, 1970.

Munsell, A. H. *A Color Notation*. Baltimore: Munsell Color Company, 1946.

Birren, Faber. *Creative Color*. New York: Van Nostrand Reinhold Co., 1961.

Hill, Tom. *Color for the Watercolor Painter*. New York: Watson-Guptill Publications, 1975. Rev. ed., 1982.

Pike, John. *Watercolor*. New York: Watson-Guptill Publications, 1966.

Kautzky, Ted. *Ways with Watercolor*. New York: Van Nostrand Reinhold Co., 1963.

Pellew, John C. *Painting in Watercolor*. New York: Watson-Guptill Publications, 1976.

Kent, Norman. *100 Watercolor Techniques*. New York: Watson-Guptill Publications, 1968.

Meyer, Susan E. and Kent, Norman. *Watercolorists at Work*. New York: Watson-Guptill Publications, 1972.

Meyer, Susan E. *40 Watercolorists and How They Work*. New York: Watson-Guptill Publications, 1976.

Index